Time Lapse Photography,
Long Exposure & Other Tricks of Time:

From
Snapshots to
Great Shots

John Carucci

Peachpit
Press

Time Lapse Photography, Long Exposure & Other Tricks of Time:
From Snapshots to Great Shots
John Carucci

Peachpit Press
www.peachpit.com

To report errors, please send a note to errata@peachpit.com

Peachpit Press is a division of Pearson Education

Project Editor: Valerie Witte
Production Editor: Danielle Foster
Development and Copy Editor: Anne Marie Walker
Proofreader: Steffi Drewes
Composition: WolfsonDesign
Indexer: Karin Arrigoni
Cover Image: John Carucci
Cover Design: Aren Straiger
Interior Design: Mimi Heft

ISBN-13: 9780134429083
ISBN-10: 0134429087

9 8 7 6 5 4 3 2 1

Printed and bound in the United States of America

Dedication

To the memory of Windee and Okee

Acknowledgments

While taking these pictures was a personal experience between some time and myself, making it into a book was a team effort.

First, I would like to give a shout-out to my teammates at Peachpit. Thanks to Valerie Witte, who had the confidence that I could put a book like this together and gave me the green light to do it. Thank you, Anne Marie Walker, for your amazing editorial guidance and gentle prodding. Danielle Foster and Lisa Brazieal gave their keen eye making the book look spectacular, and I appreciate that immensely. And finally, I want to thank everyone else who worked behind the scenes to turn words and pictures into a book.

Thanks to my agent Carol Jelen for continually getting me to the right place at the right time.

I would also like to thank everyone that appeared in the book, including Alice, Anthony, Ashley, Christine, JC, Jess, Johnny, and anyone I missed.

And finally, thanks to Jillian, Anthony, and Alice for providing a base.

Contents

Introduction

Breaking free of the boring shutter speeds of snapshot photography will liberate your creative soul. Instead of grabbing a quick moment, you can capture something more impressive when you play with time. This includes the ultra long durations that collect a bunch of time in the same long exposure; a group of images shot in succession that imitate a quickly played movie; and the really fast moments that freeze action in the blink of an eye. These types of photography get my juices flowing, and hopefully reading about them and seeing the crisp photographs in *Time Lapse Photography, Long Exposure & Other Tricks of Time: From Snapshots to Great Shots* will do the same for you.

Although diverse, the tricks of time you'll learn about in this book come from my early influences. My first encounter with time exposure happened at age six when I saw the wall of my favorite ice cream parlor adorned with large black-and-white prints of automotive light trails. That image stayed with me for years, and when I finally figured out how it was made, I was hooked on capturing time.

My formal training began at film school where the world moves at 24 frames per second. Not long after, I dabbled in three-dimensional animation, which captured each step of action a single frame at a time. After transferring into a photography program, I became fascinated by sports and action photography, where moments are frozen in a fraction of a second.

Those influences helped me find my personal vision, and my hope is that after thumbing through the pages of this book, you'll find your personal vision too.

Q: What do you have against snapshots?

A: Nothing. They serve a purpose, although an aesthetic one escapes me at the moment. All kidding aside, the problem is that snapshots usually capture the world at 1/60 of a second, give or take, and that doesn't always produce the most captivating pictures.

Q: What's wrong with shutter speeds like 1/30 or 1/60 of a second?

A: They're fine when you're capturing live subjects that don't move. But if they do move, they'll often render a slight blur. Conversely, 1/30 or 1/60 of a second is not usually enough to expose a dark scene or show a creative use of motion. But here's the kicker: Anyone who has ever seen a shutter dial on a DSLR knows there are at least 50 time settings, not to mention the B setting (it keeps the shutter open for as long as you want). So use them to interpret the exposure and motion in the scene as you see fit.

Q: Must I read the entire book to get the information I need to take great shots?

A: Not really, unless you want to make me very happy. However, each chapter discusses techniques you can use in your photography. Chapters 1 and 7 deal with equipment and composition, respectively. Those are important for everything you do. The remaining chapters focus on more specific interests. Chapters 2 and 3 explore long exposure photography; Chapter 4 explains manipulating time in a different way using electronic flash; Chapter 5 talks about the various techniques for capturing time lapse sequences; and Chapter 6 targets high-speed photography.

Q: What should I expect from reading this book?

A: You should acquire a sense of confidence that comes from understanding how to approach a particular situation after reading succinct information and looking at sharp, illustrative photographs.

Q: What kind of camera do I need?

A: This book does not discriminate: It provides examples captured with various DSLR, point-and-shoot, GoPro, and smartphone cameras. Not every camera works in all situations, but as you'll see with the included photographs, each has special functions.

Q: Does this book tell me everything I need to know?

A: Of course not. First, it does not contain enough pages to describe every trick of time. Second, each camera requires an understanding that can be described in a book of its own. So coming to the process with an idea of how to use your camera will expedite your ability to manipulate time.

Q: Is long exposure a new thing?

A: No. In fact, it's an old thing. If you were a photographer in 1870, long exposure photography was the only game in town. And I mean very long due to incredibly slow materials that could barely register an ISO setting in the single digits; so even some brightly lit scenes could take hours to expose.

Q: Is time lapse photography a new technique?

A: It shares much in common with the infancy of motion pictures, which were created from a series of progressive images, much like a time lapse sequence.

Q: Is there anything else I should know before getting started?

A: In addition to everything you'll find in the book, I've provided a short video that illustrates how I made a cool time lapse video with a GoPro camera mounted on my car.

To access and download the bonus video:

1. Visit peachpit.com/register.

2. Log in with your Peachpit account, or if you don't have one, create an account.

3. Register using the book's ISBN, 9780134429083. This title will then appear in the Registered Products area of your account, and you can click the Access Bonus Content link to be taken to the page where the video is available for easy download.

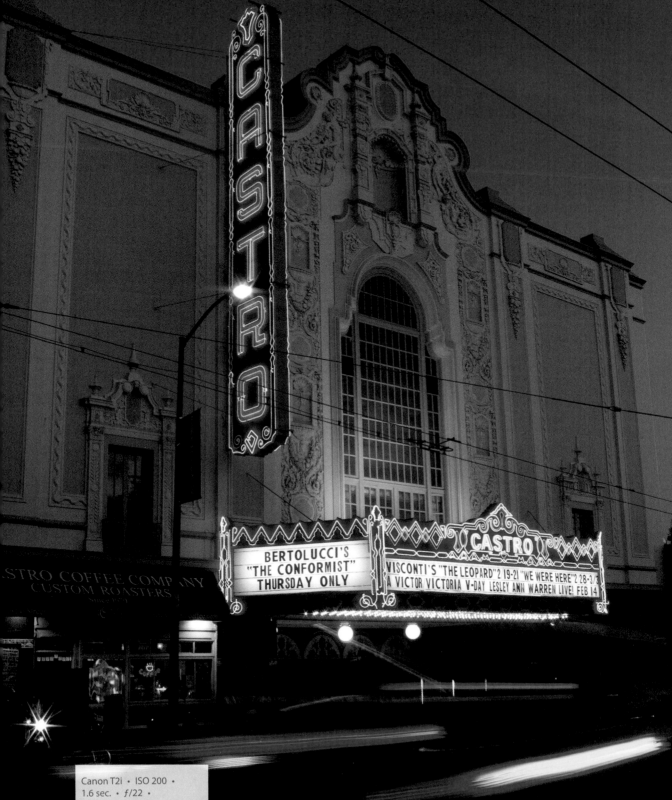

Canon T2i • ISO 200 •
1.6 sec. • ƒ/22 •
Canon 20-35 ƒ/2.8L at 25mm

1
Having the Right Equipment

Gearing Up for Creative Photography

There's some truth to that popular saying about using "the right tool for the job," or the one that claims, "You're only as good as your tools." You'd be hard-pressed to find an auto mechanic, carpenter, butcher, or any other professional who would argue this point, and that group includes photographers. Yet, unlike some of those other professions, the lines are a little blurry—no pun in intended—when it comes to the right equipment for taking photographs.

This scene of a night sky in the Berkshires was nearly pitch black on this summer evening. But the camera has the ability to accumulate light from the scene and make details more recognizable. Using a relatively long exposure and a high ISO setting to increase sensor sensitivity, the camera opens up an unseen world.

Using a 20mm lens (32mm on the APS-C format), there was some flexibility when it came to composing the scene.

Due to the absence of light in the scene, I had to manually set focus to infinity. This prevented the AF from searching for something to focus on because it was too dark to register. It also prevented the lens from focusing on an area too close and rendering the rest of the image out of focus by limiting depth of field.

The 30-second exposure required the camera be mounted on a tripod. To reduce vibration, I used a remote cable to activate the shutter. Every time you physically interact with the camera, you run the risk of causing vibration.

Because the scene was so dark, I had to shoot with a wide-open aperture of f2.8. The ISO was set to 1600 to increase sensitivity but not add much noise to the picture.

Canon T2i · ISO 1600 ·
30 sec. · $f/2.8$ ·
Canon 20-35 $f/2.8$L at 20mm

This picture of a tripod set up to capture a nautical scene represents some good advice when capturing long exposures.

Canon T2i • ISO 200 •
2 sec. • ƒ/6.3 •
Tamron 14mm ƒ/2.8L

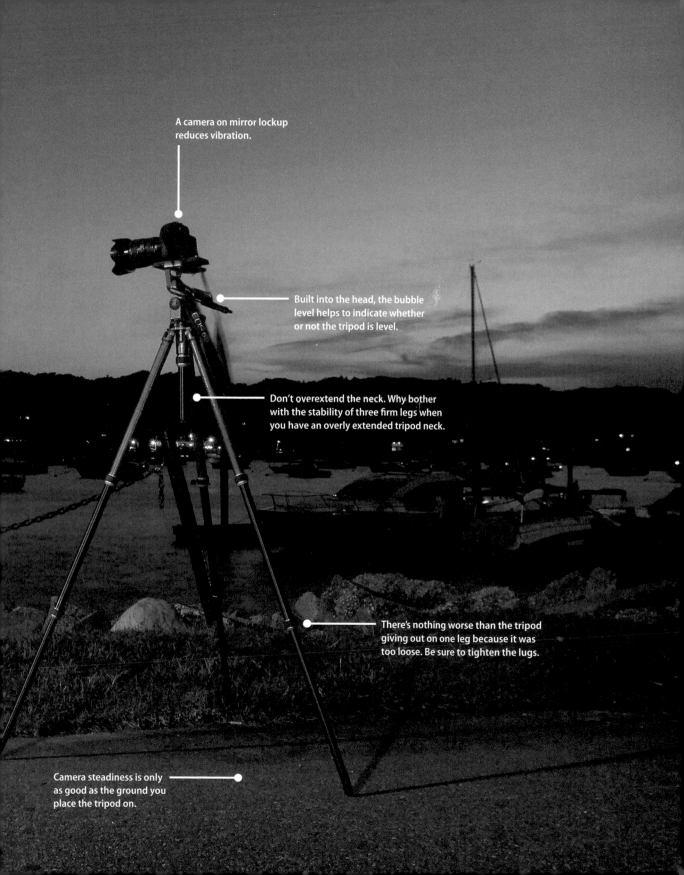

A camera on mirror lockup reduces vibration.

Built into the head, the bubble level helps to indicate whether or not the tripod is level.

Don't overextend the neck. Why bother with the stability of three firm legs when you have an overly extended tripod neck.

There's nothing worse than the tripod giving out on one leg because it was too loose. Be sure to tighten the lugs.

Camera steadiness is only as good as the ground you place the tripod on.

Not that long ago, the 35mm single-lens reflex camera, better known as the SLR, had a digital makeover and emerged as the DSLR. The same happened to the 35mm point-and-shoot camera, which became significantly better than its name implies. But digital photography alone has not been the sole leader of the renaissance: A group of disrupters has entered the field. They include the GoPro Hero line of action cameras along with another category of cameras that has changed the game. The reason is that these days the most popular means for taking a photograph—though not the best—ironically come from the same tool we use to make phone calls. Although the quality is no match for a dedicated camera, today's smartphones at least ensure that everyone is carrying a camera at all times.

Just 20 years ago it would have been hard to imagine that today's cell phone would not only take a picture, but could also provide relatively acceptable photos as its features continue to improve. It's difficult to ignore this disruptive group, especially with its time lapse capabilities, low-light ability, and adjustable shutter speeds.

But in no way, shape, or form does it supplant a dedicated camera like a DSLR when it comes to seriously manipulating the universe of time in a single exposure. So although the smartphone doesn't disqualify you from having fun with exposure duration, it does have some limits.

For time lapse and long exposure photography, the camera alone won't do the trick. In this chapter, I'll discuss several pieces of equipment you need to have and know how to work with. When you're dealing with keeping the camera steady for a very long exposure or maintaining continuity for an image sequence, your photography can benefit from a tripod or a monopod. And when you consider even higher speed capture—sports being the most common—and the extreme telephoto nature as well as the effectiveness of composition, it's nice to control the frame.

That's why it's important to understand how to effectively use accessories like your tripod and flash unit. And after you take your pictures, downloading, organizing, and enhancing them in Photoshop is also an essential part of the plan.

Being Properly Equipped

Having the right camera and accessories when it comes to long exposure or time lapse photography lets you pursue each situation with confidence. But there's wide latitude for selecting those components based on your own preference. So don't think that another photographer with a different camera or tripod than you're using immediately has an edge. Instead, make sure you have all the necessary tools and are comfortable using them.

Deciding on which camera and equipment to use is not much different than your favorite baseball player selecting equipment for use on the field. Every player must use a bat, glove, and cleats to play the game, yet each has his own preference when it comes to style, comfort, or endorsement. The same applies to you, with the exception of the latter. But you get the idea.

What I Carry in My Bag

There's that old saying about "No man is an island." Well, the same applies to your camera. When you take photographs that play with time, it takes more than a camera to get the job done. You'll need lots of accessories too, and I've got the camera bag to prove it. **Figure 1.1** shows the contents of my camera bag, well, sort of. Actually, not all this gear is with me at all times. If so, I would need a Sherpa or at least a good chiropractor on retainer. After a brief explanation, you'll get an idea of what you need and when you need it.

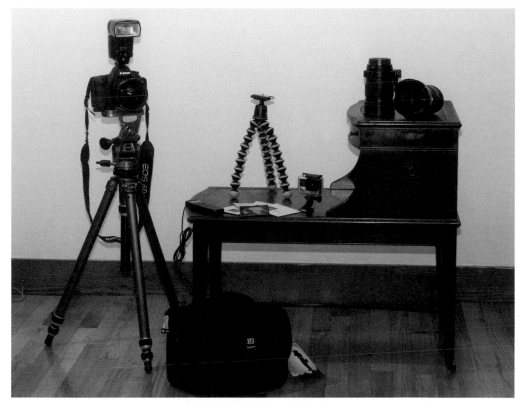

Figure 1.1
Although I carry the essentials all the time, these are the accessories in my bag when I'm going all out.

Canon 6D · ISO 1000 · 8 sec. · f/16 · Canon 50mm f/1.8

Essential Accessories

Now that you've seen what I carry, I'll describe what each piece can do. The camera captures the scene on the media card, and the focal length of the lens lets you fill the frame exactly as you want. The tripod keeps the camera steady, and accessories allow you to get closer to your intention with every photograph.

Here's a brief rundown of some of the gear you'll need:

- **Camera:** For serious photography (like long exposure and time lapse), I like using a DSLR because it includes the most controls and flexibility for focal length and accessories. But because I always carry my iPhone, I'd be remiss to not include it as an important tool (at times) for me. I'm also pretty keen on carrying a GoPro because it's small, light, and can do some amazing things, such as attach to almost anything and record subjects underwater.

- **Tripod or other stabilization device:** Unless you like blurred motion in your photographs, you'd better mount your camera on a tripod. Time lapse and long exposures make it very difficult to handhold the camera, so it's necessary to use a tripod to keep the camera steady. Although these three-legged tools share a similar experience, they come in a wide range of models from affordable to quite expensive.

- **Various lenses:** Having a selection of lenses that ranges from ultrawide angle to extreme telephoto is a nice luxury when it comes to selecting the proper lens for the situation.

- **Filters:** Not as popular to use these days as they were back in the conventional days of photography, filters still play a role. For example, a polarizer filter increases color saturation and reduces glare from nonmetallic objects. Another useful filter is the neutral density filter, which lets less light into the lens so you can intentionally increase exposure. But if you forget either filter, you can always count on postproduction in Photoshop.

- **Flash media card:** As the digital equivalent of film, without a media card there is no picture. Exceptions include cameras with built-in memory, like a smartphone.

- **Remote trigger:** The modern-day version of the cable release, a remote trigger allows you to press the shutter without touching the camera. Some models let you set the duration for time lapse and provide a display.

- **Flash:** One of the most important tools in photography, a flash provides a burst of light just where you need it. It comes in various sizes and strengths, and runs the gamut from costing a few bucks to the price of an inexpensive DSLR model. Flash also adds the potential for creativity.

Knowing Your Camera

It's possible to use a camera for months without truly knowing its potential. That's a shame because it's not some mysterious device when it comes to its operation. At its most basic, the camera is a light-sensitive box that allows you to let in small amounts of light through a lens, which in turn forms an image on a light-sensitive surface. Sounds pretty simple, right? Well, yes and no. Although every digital camera works on this premise, the controls and features to help you fine-tune capturing your subject differ with each model. So whereas one camera will allow you to intuitively pick it up and take a picture, another might require a crash course in learning how to operate it. For that reason, your first order of business is understanding how to use your camera proficiently. Why? Because it's imperative to use the camera fluently if you want to successfully embark on a photo adventure. To be sure your true intention for the subject becomes a reality, remember that it's not only about taking the picture, but also controlling its outcome.

Let's break down some of the cameras you can use:

- **Digital SLR:** A DSLR provides the most options for you to control your intentions in the picture. This includes the most technical settings thanks to a host of interchangeable lenses and supporting the most accessories. The name comes from its ability to allow you to put your eye to the viewfinder and look through the lens. Derived from its film-based cousin, the SLR, this type of camera can vary in price from a few hundred to many thousands of dollars. And that's just for the body. The sensor in the higher-priced models is the same size as a 35mm film frame, and the more affordable DSLRs use a smaller sensor, such as APS-C and Micro 4/3 formats. **Figure 1.2** shows a Canon 6D with a 14mm ultrawide-angle lens.

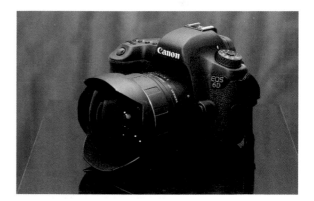

Figure 1.2 Canon 6D DSLR with a 14mm lens. This full-frame camera captures an ultrawide image with the 14mm lens.

- **Advanced point and shoot:** Although a more compact, often less expensive camera, don't be fooled by the point-and-shoot name. It's no longer limited to mindless automated photography. Even more basic models have some controls for making adjustments to your image capture, whereas others are nearly as sophisticated as a DSLR. Some models offer many of the same options as a DSLR. On the downside, the lens is not interchangeable, and the zoom range rarely goes wide enough. Also, the sensor on these models is much smaller than those found on a DSLR.

- **GoPro:** A small, compact, waterproof camera with a fixed ultrawide-angle lens, you can mount a GoPro on almost anything to capture just about everything. Used primarily for video capture, the GoPro (**Figure 1.3**) also has excellent still photo capability. And because you can mount it in unusual places and use it remotely through Wi-Fi over your smartphone, the possibilities are endless.

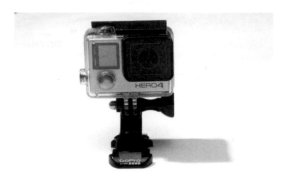

Figure 1.3 GoPro Hero 4 Silver Edition. Whether you're making movies, taking wide-angle still photographs, or creating the most unique time lapse, GoPro is worth a shot.

- **Smartphone:** It seems the major improvement in your phone every year lies in its ability to capture better photography and video. Included are improved exposure control, larger image capture, and a host of specialized functions, as shown on the iPhone 6 in **Figure 1.4**. The improved image control allows you to keep up with your photography in between phone calls. Time lapse, slow motion, and panoramic photography (**Figure 1.5**) are now common on many smartphones.

Figure 1.4
The photo control on an iPhone 6 puts a little more control into your hands when adjusting exposure for still images, time lapse, panoramic shots, and movies.

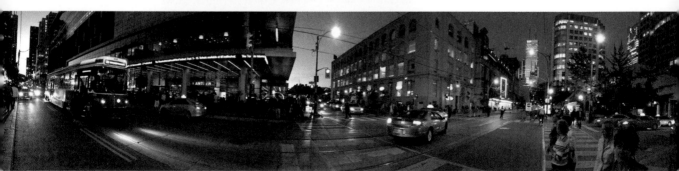

Figure 1.5 The iPhone has a great panoramic photo mode and records a substantial file size. Recording the image requires an even, balanced rotation with the iPhone.

DSLR Sensors Differ

DSLR cameras look and feel like their conventional single-lens reflex counterpart, but not all are created equal. The higher-end models use a full-frame sensor that matches the frame size of a 35mm camera. The lower-priced models use an APS-C sensor, which is slightly smaller than a 35mm frame. Others use a Micro 4/3 format, which is an even smaller sensor. When using the same focal length, the smaller sensor will record a tighter portion of the scene.

Sensor Sizes

The image of Ellis Island at twilight in **Figure 1.6** was shot with a full-frame DSLR. But depending on the DSLR model you choose, the sensor size will cover only a portion of the scene.

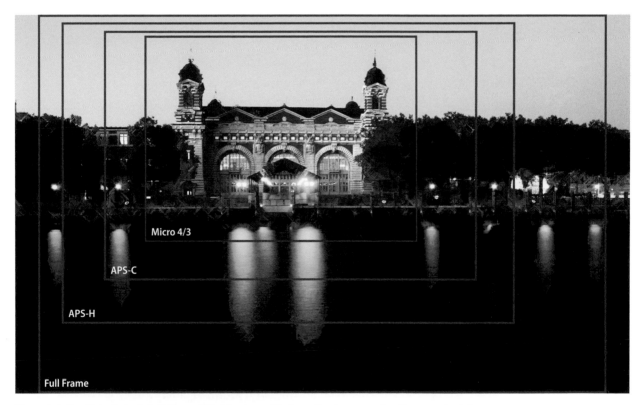

Figure 1.6 The Main Arrivals Building at Ellis Island provided an effective example of how much of the scene each type of image sensor would capture using the same lens.

Canon EOS-1 · ISO 100 · 2 sec. · ƒ/16 · Canon 50mm ƒ/1.8

The crop marks in Figure 1.6 show how much of the scene each type of camera sensor will capture:

- **Full frame:** Shooting the Ellis Island scene from across the water with a full-frame sensor captures the Main Arrivals Building and the tree to the side.

- **APS-H:** If the Ellis Island photo was shot using a camera with an APS-H sensor, the sensor would capture a slightly narrower view with a crop factor of 1.3x.

- **APS-C:** Most common in consumer-level DSLR cameras, the APS-C sensor captures a smaller portion of the scene than that of a full-frame sensor. Its crop factor differs between Nikon (1.5x) and Canon DSLR (1.6x) cameras.

- **Micro 4/3:** The Micro 4/3 sensor found on some Olympus and Panasonic cameras is much smaller than the other sensors and captures a scene using a 4:3 aspect ratio.

See the table below to get an idea of the size of each sensor type.

Crop Factor of Sensor Types			
Sensor Type	**Frame Size**	**Coverage**	**Crop Factor**
35mm frame	36mm x 24mm	864mm	-
APS-H (Canon)	28.7mm x 19mm	548mm	1.3x
APS-C (Nikon)	23.6mm x 15.7mm	370mm	1.5x
APS-C (Canon)	22.2mm x 14.8mm	329mm	1.6x
Micro 4/3	17.3mm x 13mm	225mm	2.0x

The Magic of Lenses

The versatility of attaching the best lens for the job is clearly one of the coolest benefits of using a DSLR. The right focal length lets you capture the subject as you see fit. Selecting the perfect lens for each situation as opposed to using the one fixed on the camera or on your smartphone allows you to create perfect composition. The DSLR provides a great deal of flexibility. For example, if you're covering a sporting event, you can use a telephoto lens to bring the action closer. For people photography, you can slap on a short telephoto to render a proportionately pleasing portrait. And for those times when you feel like getting creative, try an ultrawide-angle lens to get a little funky (**Figure 1.7**).

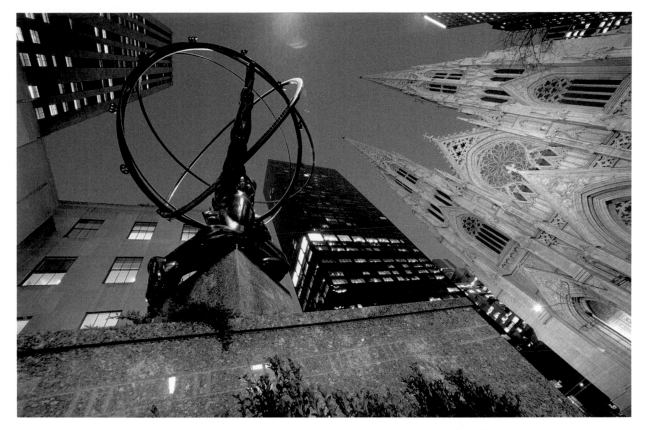

Figure 1.7 An ultrawide-angle lens on a full-format camera captures an unusual and expansive view of the statue of Atlas and St. Patrick's Cathedral.

Canon 5D Mark II • ISO 100 • 2 sec. • ƒ/11 • Canon 20-35mm ƒ/2.8L at 20mm

Focal Length Is Not What It Used to Be

These days, focal length is more confusing than setting up Bluetooth in your car the very first time. Thanks to a variety of sensor sizes, image magnification will differ when you're using the same lens. Unlike the days of conventional 35mm film photography when the area being exposed on the film frame was consistent, DSLR models vary in sensor size based on cost and manufacturer. The more professional models include a sensor that shares the size of a 35mm frame, whereas the consumer models offer slightly less real estate, which affects the magnification of the image. Check out the difference between the shot in **Figure 1.8** and the one in **Figure 1.9**. In both a 14mm lens was used, but due to each camera's sensor size, the scene was rendered at different levels of magnification.

Figure 1.8
This interior was captured on a full-frame camera. The Canon 6D mounted with a 14mm lens was a few feet from the chairs.

Canon 6D • ISO 1000 • 10 sec. • f/5.6 • Tamron 14mm f/2.8L

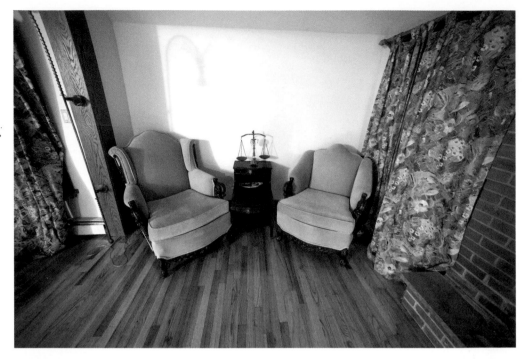

Figure 1.9
Without moving the tripod, the 14mm lens was mounted on a Canon Ti2, which has an APS-C sensor with a crop factor of 1.6x.

Canon Ti2 • ISO 1000 • 10 sec. • f/5.6 • Tamron 14mm f/2.8L

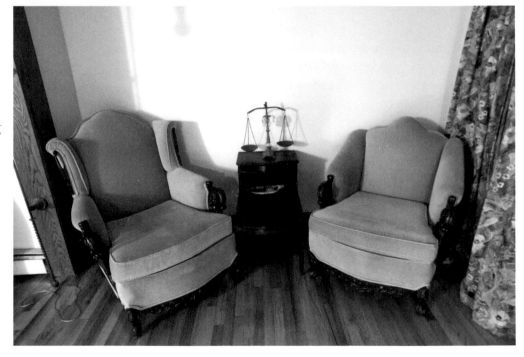

True Focal Length

The true focal length of a lens has nothing to do with the camera or sensor size. Instead, it's based on the distance in millimeters from the optical center of a lens to the imaging sensor when the lens is focused at infinity. The magnification of the lens remains the same, but the size of the area it records will differ depending on how much real estate the camera's sensor has to offer.

Here's a breakdown of focal length categories:

- **Normal:** Although one of the most ambiguous terms on the planet, the Normal lens refers to one angle of view that appears proportionately natural to human vision. Goldilocks might describe it as the lens that is not too wide and not too close. Generally, that means it covers an angle of view of about 46 degrees; when you're using a camera with a full-frame sensor, that's a 50mm lens. But on an APS-C camera, it's more like a 28mm lens.

- **Wide angle:** As the name implies, a wide-angle lens covers a much wider view of the scene by recording an angle of view greater than 65 degrees. On a full-frame camera, that represents a focal length of 35mm or less. For an APS-C sensor, it translates to approximately 20mm.

- **Ultrawide-angle:** A subcategory of the wide-angle lens, this group covers an extremely wide-angle view that includes fisheye. But depending on the camera's sensor, the same focal length will not be as wide on some cameras. Generally, ultrawide-angle refers to an angle of view greater than 95 degrees. That's approximately a 20mm lens on a full-frame camera and a 12mm lens on an APS-C. A fisheye lens on a full-frame camera can record a 180-degree view of the scene but as a circular rendering. An ultrawide-angle lens corrected to fill the frame edge to edge and keep lines as straight as possible is called a *rectilinear lens*, which is generally 14mm or less.

- **Telephoto:** A telephoto lens brings the scene closer to you. Like wide-angle lenses, they vary in range and have an angle of view narrower than a Normal lens. That means anything from a 70mm lens and larger has a narrow angle of view. Obviously, a camera with a smaller sensor increases the true focal length of the lens and can allow you to bring the subject much closer than a full-frame camera. So a 100mm lens on a full-frame camera behaves as a 160mm on an APS-C model. This is one advantage of using the smaller sensor camera; price is the other.

Conversion Chart of Popular Focal Lengths

Now that you understand the relationship between focal length and sensor size, let's examine the categories of each and use the 35mm frame of reference. The table below shows the true focal length of the lens and its equivalent when using cameras with various sensor sizes.

Focal Length Conversion Chart				
Full Frame	**APS-H 1.3x**	**APS-C 1.5x**	**APS-C 1.6x**	**Micro 4/3 2.0x**
8mm	10.4mm	12mm	12.8mm	16mm
10mm	13mm	15mm	16mm	20mm
14mm	18.2mm	21mm	22.4mm	28mm
17mm	22.1mm	25.5mm	27.2mm	34mm
20mm	26mm	30mm	32mm	40mm
24mm	31.2mm	36mm	38.4mm	48mm
28mm	36.4mm	42mm	44.8mm	56mm
35mm	45.5mm	52.5mm	56mm	70mm
50mm	65mm	75mm	80mm	100mm
70mm	91mm	105mm	112mm	140mm
85mm	110.5mm	127.5mm	136mm	170mm
100mm	130mm	150mm	160mm	200mm
135mm	175.5mm	202.5mm	216mm	270mm
200mm	260mm	300mm	320mm	400mm
300mm	390mm	450mm	480mm	600mm
400mm	520mm	600mm	640mm	800mm
500mm	650mm	750mm	800mm	1000mm
600mm	780mm	900mm	960mm	1200mm

Having the Right Media Card

A media card stores your photographs like a roll of film, only it's much smaller and has a greater capacity. After taking the picture, the camera processes the image and stores it until you're ready to download it to your computer. Not having a media card in your camera creates the same awkward moment that forgetting to put film in your SLR used to evoke. Of course, unlike the old days, the camera will show an error message if it fires at all.

Most camera models use either an SD (Secure Digital) or CF (CompactFlash) card. **Figure 1.10** shows these two most common types. Although your camera uses one of them, not all cards are created equal. Here is some information to consider:

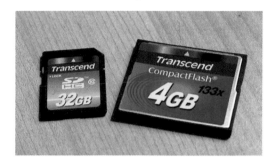

Figure 1.10 The SD card (left) is gaining popularity with many cameras and electronic devices, whereas the CF card is used in more advanced cameras as well as for storage.

- **Size matters:** The most apparent difference in size lies in how much data the card will hold. As cameras continue to create bigger, more detailed files, the need for larger storage requirements also arises. Newer-model DSLR cameras can shoot files larger than 20 megapixels in the RAW and JPEG file formats. For that reason, you should consider using at least an 8 GB card, but don't resist splurging for a larger one. It's worth the investment.

- **Carry an extra card:** In the past you wouldn't just carry a single role of film, so why would you have just one card? Two good reasons to carry more than one card include shooting so many great images that you fill up your card, and having a sudden malfunction.

- **Faster is better:** Some cards are faster than others, allowing the card to capture consecutive frames without camera lag. Fast cards also allow you to capture HD video without any lag time. Try to not use a card rated less than Class 10.

- **Don't cheap out:** Sometimes you get a bargain; other times you get what you pay for. Buying a good media card is a time when you shouldn't spare a few bucks. Nothing is worse than a card that goes bad in the middle of a shoot.

A Very Brief Explanation of JPEG vs. RAW

Is shooting RAW always better than JPEG? Well, not really. When you need to shoot a lot of images and the reproduction needs are not critical, it's perfectly legitimate to shoot in JPEG. And the quality is not that much different than RAW.

A JPEG is more of a compression scheme than a file format, and yet it's most commonly used in just about every type of camera. After taking the picture, the camera processes the information and applies a variety of preset adjustments to areas like white balance, sharpness, and HSL (Hue, Saturation, Luminance). Before saving the image to the card, JPEG compresses the image into a much smaller file size. Unfortunately, it uses lossy quality, which means it discards image data each time it's opened. Although the data is unrecoverable, most of the time you won't notice any change in quality, but it still doesn't match the quality of lossless compression.

Conversely, a RAW file produces lossless compression and contains minimally processed data. Using a RAW conversion program (**Figure 1.11**), you can fine-tune all the attributes of the image, like exposure, white balance, sharpness, and just about any other necessary adjustment. Benefits of shooting RAW include lossless compression, high bit depth, and increased dynamic range. On the downside, large file sizes mean fewer images can fit on the card, and each image requires processing before opening for the first time.

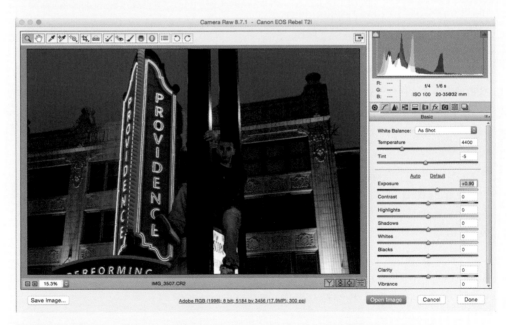

Figure 1.11 When you click on a RAW file in Photoshop for the first time, it opens a conversion program that provides a great deal of control over the image through numerous adjustments.

Making Sure Your Card Is Formatted

Most of the time, the memory card is already formatted when you take it out of the package. Still, it's a good idea to format the card in the camera because every camera is different. Formatting the card ensures that the card and camera are in perfect sync.

Media Card Real Estate

Directly related to the card's capacity for holding photos are a couple of factors that affect the number of images you can capture before the card fills up. Obviously, the maximum file size each camera captures differs slightly and ultimately affects storage. But more often, capacity is directly related to file format and resolution settings.

The DSLR provides the option to shoot and save your images as either a JPEG or RAW file, and most will allow you to save both simultaneously. That clearly limits the amount of pictures you can store on the card.

The resolution and compression settings for JPEG capture will also affect the number of images you can store on the card.

Keeping It Steady

Long exposure times allow you to record detail in even the darkest of scenes, but unless the camera is perfectly steady, you'll get nothing but a blurry mess. So when it comes to long exposures and time lapse photography, it's imperative that the camera remains still, and not just still, but devoid of any vibration.

A Big Sturdy Tripod Saves the Day

No matter what your plans for capturing a scene or how much you spent on equipment, a big, sturdy tripod is an essential piece of equipment for keeping the camera firm and steady for long exposures or time lapse photography (**Figure 1.12**). Yet, besides capturing sharp images of a situation in which you could never handhold the camera, the tripod does something more. It allows you to control composition and framing, letting you capture each subject in a deliberate manner.

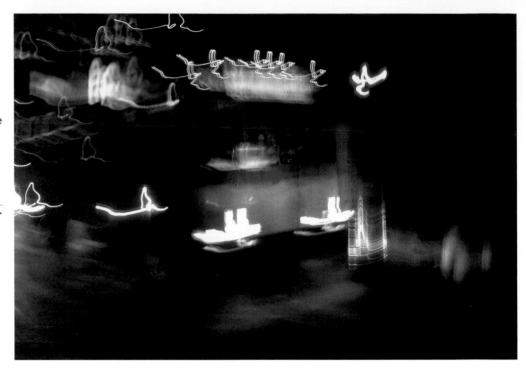

Figure 1.12
This New York City bus was captured at a shutter speed that was too slow to handhold the camera and capture a moving object. The result is an interesting representation, but not what you normally want to capture at night.

Nikon 5000 · ISO 400 · 1/8 sec. · ƒ/4 · Equivalent to 85mm lens

A Good Head on Your Shoulders

By itself, the tripod is simply a three-legged stand, so it needs a means of attaching the camera and adjusting its position. Cheaper models come with a head, whereas the better ones let you select the tripod head that's right for you.

Basically, you have three varieties to choose from:

- **Pan/tilt head:** It's the most common type of tripod head and has controls for horizontal and vertical axis so you can mount the camera precisely at all angles.

- **Ball head:** This more compact tripod head uses fewer moving parts and allows for faster, more accurate adjustments. It tends to be more expensive and flexible than other tripod heads.

- **Fluid head:** Used primarily for video, this dampened head reduces vibration and produces extremely fluid movements. Unfortunately, because it only tilts up and down, it works primarily with horizontal capture, namely for video.

Gorillapod

A Gorillapod is strong, small, and flexible, and one of the more unique stabilization devices available (**Figure 1.13**). Constructed of dozens of segmented leg pieces, you can wrap it around just about anything. It comes in several sizes, and although it's not perfect for every situation, it can help you in a pinch. Not every situation is conducive to lugging a full-size tripod, so it's nice to have a steady one that fits in your pocket. And unlike other portable tripods, it's very steady. On the downside, it won't stabilize the bigger, more pro-oriented DSLR models with a big lens, which are tricky to keep steady. The same applies to shooting verticals, which can also tip the camera over.

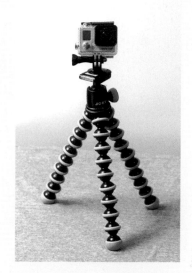

Figure 1.13 GoPro Hero3 mounted on a medium-sized Gorillapod.

Other Ways to Keep the Camera Steady

Camera stabilization comes in a variety of forms as well as techniques. Here are a few to consider:

- **Monopod:** The use of a monopod is not ideal for very long exposures, but it still comes in handy for those exposure durations that are too long to handhold the camera.

- **Beanbag:** Sometimes the only way to stabilize your camera is to place it on firm ground. A beanbag provides a little flexibility to help you position the camera.

- **Firm, flat surface:** Face it, sometimes you see a great subject or really cool lighting but are just carrying your camera and don't have a tripod. For those times, a flat surface and the camera's self-timer can come to the rescue. Adding a matchbook, pencil, or some other small device can level the camera or help adjust the angle (**Figure 1.14**).

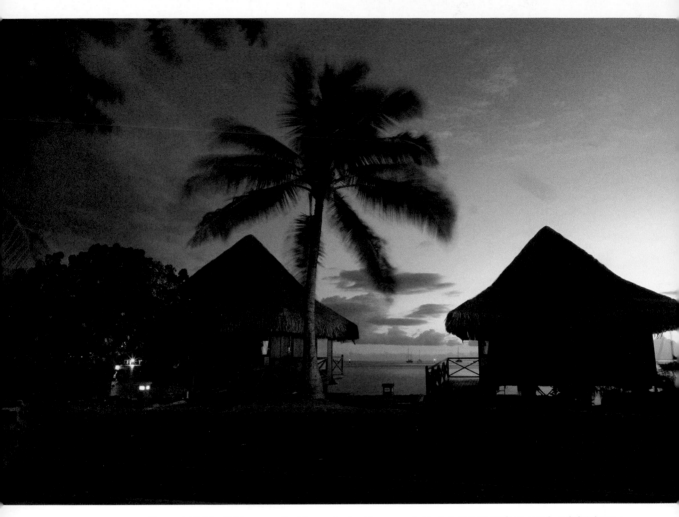

Figure 1.14 The light was perfect for capturing these coastal huts in Tahiti. Unfortunately, I didn't have a tripod, but a palm tree stump was at the perfect height to place the camera. The camera timer was set to two seconds to eliminate the vibration that pressing the shutter would cause.

Canon T2i · ISO 100 · 15 sec. · ƒ/14 · Tamron 14mm ƒ/2.8L

Using Filters

Most digital cameras have a wide array of controls that allow you to adjust white balance, image sensitivity, and push-button effects. And Adobe Photoshop lets you easily control color and effects in postproduction, which limits the need for filters but doesn't make them obsolete.

The following filters still have a place in digital photography:

- **Polarizer:** This circular filter allows you to increase color saturation as well as reduce glare from nonmetallic objects like glass.

- **Graduated filter:** Although you can easily produce in Photoshop the same effects as this filter does, it's still nice to be able to darken a bright portion of the scene with gradual color.

- **Neutral density filter:** This filter reduces the amount of light that enters the lens to control a host of issues, including overexposure, allowing you to deliberately increase exposure by stopping down the lens or increasing exposure duration for effects like motion blur, and increasing exposure to eliminate moving objects—like people walking through the scene during a very long exposure (**Figure 1.15**).

Figure 1.15 Neutral density filters come in a variety of strengths, ranging from one to five stops.

Computers and Software

Production and postproduction have always been the cornerstones of photography. You go out and use capturing techniques to the best of your ability, and then you come back and transform those captured images into a tangible picture. Not that long ago, the process relied on shooting with a film camera and processing images afterward in the darkroom. The process remains similar in the digital age with the camera electronically capturing the scene and the computer and software enhancing it into the best possible image.

Looking on a Big Screen

I'd be lying if I told you that after shooting an assignment I didn't scroll through the preview screen a dozen times to admire (or not) the day's take. But that's a fairly limited way to appreciate your photos, because it pales in comparison to viewing them on your computer screen after you've transferred them from the media card. Just remove the card from the camera, pop it in the card reader, and wait momentarily as the image files transfer over. Then you can enhance the ones you love using Adobe Photoshop.

You Need a Card Reader

Once upon a time, you connected a cable from your camera to the computer to transfer images. It's still possible, though pretty cumbersome, not to mention that it drains your camera's batteries. The more practical solution involves using an inexpensive card reader. That's only an option because many new computers and laptops already include a built-in card reader. If yours doesn't or if you're using a camera that captures images on a CF card, an optional card reader is a must-have accessory.

Operating Systems and Photoshop: Mac OS X and Windows

Are you more Mac than Windows? These days that age-old debate matters less than ever before. The reason is that Photoshop runs smoothly on Macs and Windows, making it more about the platform you're most comfortable using as opposed to which one is better.

Because both platforms continue to refine their operating systems, the result is more power, capability, and speed for your image editing.

Mac OS

These days, Mac OS takes its naming convention from popular landscape destinations. The newest version, Yosemite, simply known as version 10 (it's actually 10.10) provides smoother operation, a redesigned user interface, and better integration with other Mac products.

Its predecessor, Mavericks (10.9), also supports the latest version of Photoshop. Other versions of the image editing software can run on Mac OS previously named after big cats, like Mountain Lion (10.8) or Snow Leopard (10.7).

Windows

On the Windows side, Version 10 is the latest operating system for Windows-based computers, and it includes advanced functionality for media support. Computers running Windows versions 7 or 8 can also run the latest version of Photoshop.

Adobe Photoshop

Having been the standard for image editing since the last millennium, Photoshop has seen nearly two dozen upgrades. Yet when it comes to making basic enhancements to your images, the interface has maintained familiarity throughout its history. Whether you're still running Photoshop 6, Photoshop CS2, or the latest Photoshop CC 2015, the look and feel right down to the toolbox remains consistent (**Figure 1.16**). Of course, along the way, more advanced features and effects found throughout the menus have grown with each version. It's a good idea to use a Photoshop companion guide while reading this book to help you master capturing tricks of time.

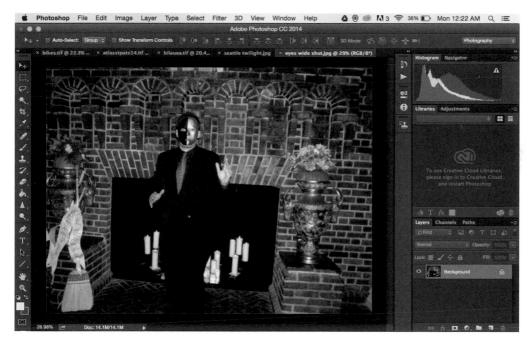

Figure 1.16
The Adobe Photoshop CC 2014 interface.

Photoshop Requirements

Fortunately, enhancing photographic images does not prove the most arduous of tasks for a computer processor, at least not like the demands of video editing. Consider the minimum processer speeds and requirements for using Adobe Photoshop CC 2015.

For Mac OS:

- Mac OS X version 10.10 (Yosemite) or 10.9 (Mavericks)
- Multicore Intel processor with 64-bit support
- 2 GB of RAM (8 GB recommended)
- 2 GB of available hard disk space for installation; additional free space required during installation
- 1024x768 display (1280x800 recommended) with 16-bit color and 512 MB of VRAM (1 GB recommended)
- Internet connection and registration are necessary for required software activation, membership validation, and access to online services

For Windows:

- Microsoft Windows 10, 8.1, or 7 with Service Pack 1
- Intel Core 2 or AMD Athlon 64 processor; 2 GHz or faster processor
- 2 GB of RAM (8 GB recommended)
- 2 GB of available hard disk space for 32-bit installation; 2.1 GB of available hard disk space for 64-bit installation; additional free space required during installation
- 1024x768 display (1280x800 recommended) with 16-bit color and 512 MB of VRAM (1 GB recommended)
- Internet connection and registration are necessary for required software activation, validation of subscriptions, and access to online services.

Chapter 1 Assignments

Understand Your Gear

Unlike snapshot photography, mastering tricks of time requires more than a camera. Take some time to figure out how your equipment works together in a variety of situations, such as low-light photography, random collections of light, and time lapse situations. Also, see how quickly you can set up your equipment and break it down.

Master Your Camera's Controls

The DSLR is a complex camera with numerous controls. If you were to shoot every situation on automatic, it would defeat the purpose of using it in the first place. Instead, take the time to read your camera manual and learn about the camera's many functions. Take a close look at how to set up file formats, adjust white balance, and manually adjust exposure settings.

Practice Enhancing RAW Images

Because the RAW format does not process the image after capturing, it's up to you to set the correct white balance, sharpness, color, and a host of other factors that make up image quality. Although the RAW format provides the most control over the image, it also takes some practice to get it right. And because practice makes perfect, you should experiment as much as possible to get comfortable with the process. One trick is to set your camera to shoot both a RAW and a JPEG image. The latter is already processed, so try to make the RAW image look the same.

Share your results with the book's Flickr group!
Join the group here: flickr.com/groups/timelapse_longexposure_fromsnapshotstogreatshots/

Canon T2i · ISO 800 ·
10 sec. · ƒ/16 ·
Canon 24–70 ƒ/2.8L at 24mm
(equivalent to 38mm)

2
Exposures Longer Than a Snapshot

Got the Time, Get the Picture

Once upon a time, taking a long exposure was a normal part of pho-tography—much like using a public payphone to make a phone call was normal. Or perhaps it's more appropriate to say, as normal as loading film into your conventional camera during the modern era of photography.

The performance of film technology improved over the years, but film emulsions (the sensitive part) in the early days of photography were incredibly slow at accumulating enough exposure to make a photograph. Back when photography was in its infancy, some photographs took several hours to record, even under relatively bright conditions, and that included portraits as well. The prolonged stillness of a living subject no doubt contributed to that zombie-like appearance evident in those nineteenth-century tin plate portraits. Of course, at that time the extended exposure—and obligatory zombie look—wasn't as much a creative device as it was simply a necessary device.

Twilight was the perfect time to capture Pike Place Market in Seattle. The short interval between the sun going down and the sky turning black provided an optimal period for a stunning photograph. The cool rich tones of the twilight sky nicely complement the warm, colorful lighting in the scene.

Vantage point also played a part in the success of the picture. Standing at the top of the hill provided the best angle to capture the scene with more vertical depth.

Twilight provides more than just a great background; it also offers enough ambient light to "open up" darker areas of the scene.

Although the scene is not completely dark, the long exposure duration allowed me to use a moderate aperture to maximize the depth of field.

Using the lowest possible ISO setting (100 in this case) provided the finest detail.

At one second, most people in the scene are sharp, but the ones walking register as a blur.

Canon T2i • ISO 100 • 1 sec. • *f*/8 • Canon 24–105 *f*/4L at 28mm (equivalent to 44mm)

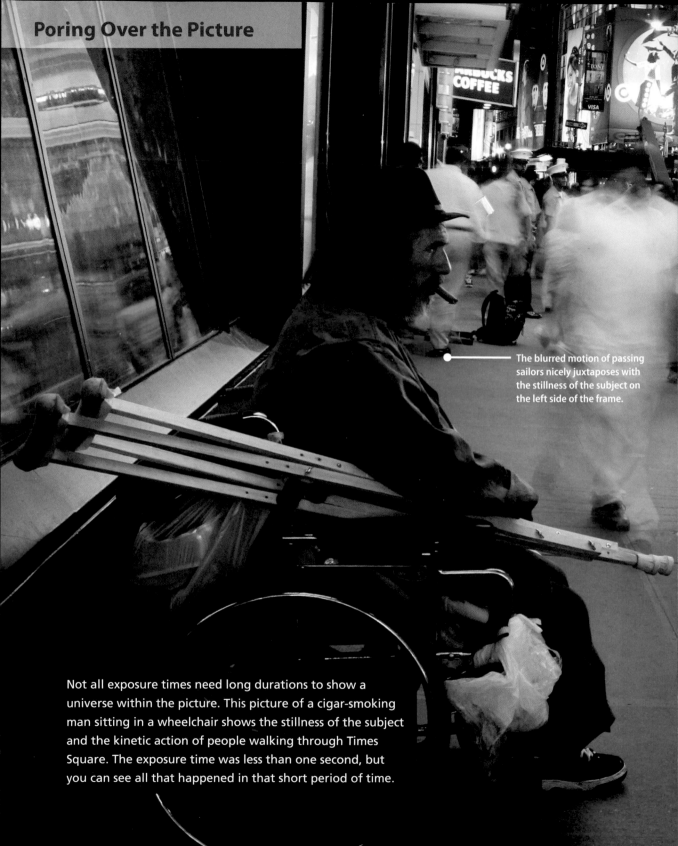

The blurred motion of passing sailors nicely juxtaposes with the stillness of the subject on the left side of the frame.

Not all exposure times need long durations to show a universe within the picture. This picture of a cigar-smoking man sitting in a wheelchair shows the stillness of the subject and the kinetic action of people walking through Times Square. The exposure time was less than one second, but you can see all that happened in that short period of time.

Using a low ISO setting ensured maximum detail in the scene.

Although exposure time was less than one second, most of the people moving through the scene rendered as a blur.

By placing the camera on a tripod, I was able to keep the shot steady and compose all the elements in the scene.

Shooting with a medium aperture on an ultrawide-angle lens provided enough depth of field to ensure focus from foreground to background but was low enough for an exposure duration of less than one second.

Canon 20D · ISO 100 · 0.8 sec. · f/7.1 · Canon 20–35mm f/2.8L at 20mm (equivalent to 32mm)

But times certainly have changed. Many photographs are captured in a fraction of a second, making them a slice of time. But when exposure time increases, so does the photograph's creative potential because more elements are introduced into the single image. But long exposure seems like an arbitrary term. After all, how do we qualify long? Clearly, an hour-long exposure fits the description, and perhaps so does a 30-second exposure. Sometimes even the fractional exposure is not fast enough to render the subject without blurring it. But although the term long exposure seems "loose," the possibility of interesting photography is not.

Regardless of the exposure's duration, when the shutter stays open for a prolonged period, it can break the monotony of capturing the world with your camera. Long exposures can detail a normally unseen world, render moving light into beautifully saturated streaks of color, and provide randomness to the image that can make each one of a kind.

Collect Light in a Single Image

When the exposure duration for a single image is several seconds to several minutes, you're no longer capturing a slice of time, as you would in a snapshot. Now you're collecting a big chunk of time: Everything that happens between the time exposure begins and ends accumulates as a single image. During this magical window, there's great potential for something amazing to happen in the frame. For example, when you're capturing a street scene, the taillights from passing traffic transform into streaks of colored light. Or, darker areas of a scene normally not seen by your eyes are "opened up," making the scene viewable (**Figure 2.1**).

Figure 2.1
Shot in the middle of the night on a south Florida canal during pitch-black conditions with my camera mounted on a sturdy tripod, this scene required a long shutter speed, a wide-open aperture, and a high ISO setting to open up a world unseen by the naked eye.

Canon T2i • ISO 800 •
30 sec. • ƒ/5.6 •
Canon 50mm ƒ/2.8L
(equivalent to 80mm)

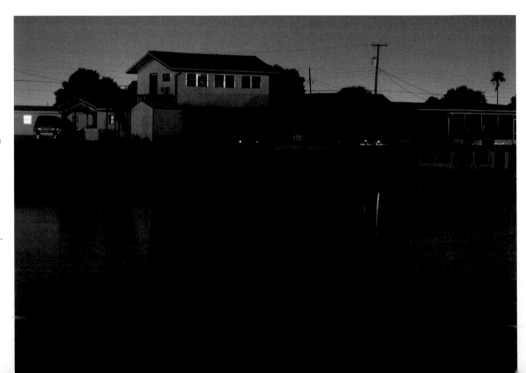

ISO Settings

The ISO setting controls the sensitivity of the sensor. The lower you set the ISO on the camera, the more detail that is rendered in the image. Newer model cameras allow you to manually set the ISO from 100 to higher than 20,000, and those with advanced sensors retain more detail at higher ISO settings (**Figure 2.2**).

Figure 2.2 With the ISO set on automatic for this scene of a tree shot against a twilight sky, the camera chose an incredibly high ISO 12,800 setting and retained a fair amount of detail. The 1/30 of a second exposure would require a 4-second exposure at ISO 100 using the same aperture.

Canon 6D · ISO set on automatic (12,800) · 1/30 sec. · ƒ/10 · Canon 14mm lens

Randomness of Long Exposure

No two fingerprints are alike; neither are snowflakes or human ears. That makes them all distinct and one of a kind. Well, the same can be said for long exposures thanks to all the moving parts in a scene, whether that includes light trails from traffic, painting the scene with a handheld light source (more on that in Chapter 4), or a brightly lit Ferris wheel set against a twilight sky, as shown in **Figure 2.3**.

Figure 2.3
Captured from the front, this brightly lit Ferris wheel is complemented by the rich colors of the setting sky. Subsequent exposures take on a different appearance due to the arbitrary nature of the light source in motion and the rapidly changing colors of the background sky.
Canon EOS-1 •
ISO 100 • 2 sec. •
ƒ/11 •
Canon 24mm lens

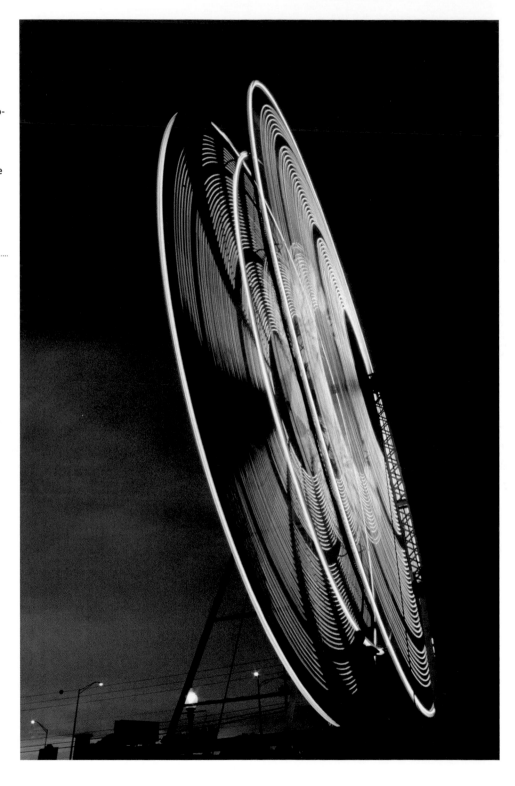

Many moving parts in a scene can ensure randomness with all that happens in the frame to make every image distinctly original.

Random situations include:

- **Traffic patterns:** Photograph the same street a dozen times, and the traffic pattern from passing cars renders the scene originally each time.

- **Blurred motion:** Blurring in a photograph is often a nuisance. Other times it's a cool creative device that shows life in the picture. But each time you do it, the results will be different.

- **Painting with light:** Keeping the shutter open for an extended duration and using a penlight to outline the subject or as a brush to paint light in front of the camera makes the image a pen-and-ink drawing.

Subject Matters as Much as When You Shoot

It's no secret that keeping the shutter open for longer than a fraction of a second changes the way a scene is rendered. Many situations lend themselves perfectly to long exposure photography, making the mundane more interesting. Common subjects shot using long exposure times take on a new life.

But that doesn't mean anything you shoot for a long duration will always be a winner. Some subjects are perfect for extended duration, whereas others make very little impact. For example, static scenes can sometimes be difficult for the viewer to notice anything unique about the picture or how long it took to capture it; however, capturing a scene against a twilight sky or capturing a colorful light source can make a powerful impact.

Stationary subjects can make a significant impression when you use a strong perspective. Placing the camera on the ground to capture a simple backyard scene and using a 30-second exposure (**Figure 2.4**) reveals a new perspective normally unseen by the human eye.

Figure 2.4 Sometimes the blandest image during the day can be the most dazzling when captured in relative darkness using an incredibly long exposure. With the camera on the ground pointing upward at the umbrella and the timer on (to eliminate vibration during exposure), I was able to produce this rich color combination.

Canon 6D • ISO 800 • 30 sec. • ƒ/14 • Canon 24–70 ƒ/4L at 24mm

Practical Reasons for Long Exposure

Not all long exposures are shot for creative purposes, at least in the visual sense. Some are quite practical. For example, studio photographers who specialize in product photography require maximum sharpness and detail in their photography. That requires using a low ISO setting along with the smallest possible aperture to maximize depth of field (**Figure 2.5**). Despite the brightness of the lighting, excluding flash, of course, it's necessary to take a long exposure from a very sturdy tripod. Shooting the same scene with a wide aperture, as shown in **Figure 2.6**, yields very different results.

Architectural photographers often shoot exceptionally long exposures. By attaching a neutral density filter over the lens, they can use the smallest aperture setting. Because |the neutral density filter lets less light into the lens, the image requires more exposure. As a result, architectural photographers can photograph a building on a bustling street full of pedestrians, yet render the scene as if the pedestrians were never present. To produce this effect, it's not unusual to use a several minute exposure taken during the day. Instead of freezing the peoples' movement as a high shutter speed can do or blurring it from a slower speed, the filter affects density to such a degree that a moving subject will not register.

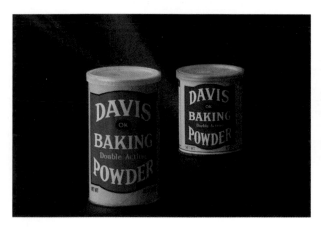

Figure 2.5 Although the cans are far apart, shooting this mock product shot shows the effectiveness of long exposure on a stationary object. The long exposure allows you to stop the lens all the way down to ensure maximum depth of field.

Canon 6D • ISO 100 • 30 sec. • ƒ/32 • Canon 200 ƒ/2.8L

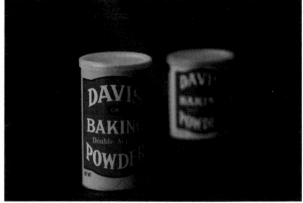

Figure 2.6 This version of the vintage baking powder cans was shot with the lens wide open, so only the can in the foreground is in focus.

Canon 6D • ISO 100 • 1/4 sec. • ƒ/2.8 • Canon 200 ƒ/2.8L

Neutral Density Is Your Friend

On a sunny day you would wear sunglasses to make your eyes more comfortable in the brightness. Well, the neutral density filter does the same for exposure. By reducing the amount of light that enters the lens, it forces you to increase exposure, providing the opportunity to choose the combination of exposure duration and depth of field. Neutral density filters are available in a variety of ranges and can reduce exposure up to ten stops.

Understanding the Reciprocal Nature of Exposure

Proper exposure depends on the balance between intensity and time. The aperture lets light into the lens, and the shutter determines its duration. Once proper exposure is determined, changing one without the other will affect exposure balance and either overexpose or underexpose the scene. If you increase shutter speed, you must decrease the aperture setting to maintain the same exposure value. This balance is known as *reciprocity*.

There are good reasons for altering the reciprocal balance between the shutter and aperture setting. You can control depth of field to maximize the level of focus in a scene (**Figure 2.7**) or minimize it (better known as *selective focus*), as shown in **Figure 2.8**, having everything but the main subject blurred in the image. As you can see in Figure 2.8, when it comes to portraits, it's an effective technique.

Figure 2.7 A higher aperture setting, like f/22, lets less light into the lens, causing a longer shutter duration. It also provides the widest depth of field, which works when you need the entire scene to be clear and in focus. But complete sharpness doesn't work for every situation, namely portraits.

Canon 6D · ISO 3200 · 1.6 sec. · ƒ/22 · Canon 85mm

Figure 2.8 A lower aperture setting (wider), like f/1.8 in this case, lets more light into the lens. But using a lower setting limits the depth of field, which is ideal for a portrait because you blur the background so the subject stands out.

Canon 6D · ISO 3200 · 1/80 sec. · ƒ/1.8 · Canon 85mm

But there are other reasons for altering reciprocity as well. For example, you might prefer to use a specific shutter speed high enough for action photography, such as 1/500 of a second. Or, you might need to produce maximum sharpness. Based on their physical design, optical lenses are sharpest in the middle apertures. Why? When stopped down, they use the smallest piece of lens real estate, and when opened up, they are subjected to vignetting or a difference in edge sharpness. That makes using an aperture setting of f11 or f8 optimal.

Fractional Exposures

Most snapshots are captured at a fractional duration, generally between 1/60 and 1/250 of a second. During that split-second exposure, the action of everything happening is frozen as part of the photograph. But what about exposures that are fractional in time, yet are still not acceptable for handholding the camera? Those count as a long exposure too, although the results are not usually as striking as the long exposures. **Figure 2.9** provides an exception to the rule.

Figure 2.9
Taken while hand-holding an iPhone at a concert, the camera decided most of the settings for this photo, other than my tapping the screen for focus and exposure. Consistency during exposure also helped produce the sharp silhouette, as did the video screens not showing motion at the time of exposure.

Apple iPhone · ISO 250 (set by camera) · 1/20 sec. · ƒ/2.4 · 4.1mm lens (equivalent to 33mm)

Factors That Make Great Photographs

Successful nighttime photography depends on more than mounting your camera on a tripod, crossing your fingers, and hoping for the best. Unlike fractional situations, additional variables will affect the final image. The outcome will depend on how those variables are mixed and matched, as well as the capture conditions. Keep in mind that a universe of activity is happening within the frame that comes together as a single image.

Time of night, artificial lighting, length of exposure, and weather conditions will influence the look of an image.

Let's examine these factors.

Time of Night

When it comes to mastering a night image, the time of night you capture the scene is sometimes as important as what you choose to capture. Consider the following example: If you photograph a scene after the sun goes down, your image will contain a pretty blue sky with some ambient light still present. If you shoot that same scene two hours later, the results will be remarkably different. So time of night is one of the most prominent factors that will affect your results.

Twilight

The "sweet spot" for night photography happens at twilight (**Figure 2.10**). That transitional period between day and night provides a short window for optimal photography because of its rich, blue sky and lingering bits of ambient light. Twilight is when the sun dips below the horizon but continues to skim light from below for a little while longer. During this period, the remaining ambient light helps to "open up" the shadow areas and helps show separation between the subject and background.

The twilight sky differs slightly each night, but often it changes from a purplish tone to a deep blue. This provides an intense background and is especially effective when a warmly lit subject is juxtaposed in front of it (**Figure 2.11**). But twilight doesn't last that long, and once it dissipates, the sky transforms to black, which creates a new set of circumstances and dilemmas.

Figure 2.10
Shot during the early period of twilight, plenty of ambient light provided detail and color to this scene, including the bicycles in front of this beach cantina.

Canon 20D • ISO 100 • 5 sec. • ƒ/8 • Canon 20–35mm (equivalent to 32mm)

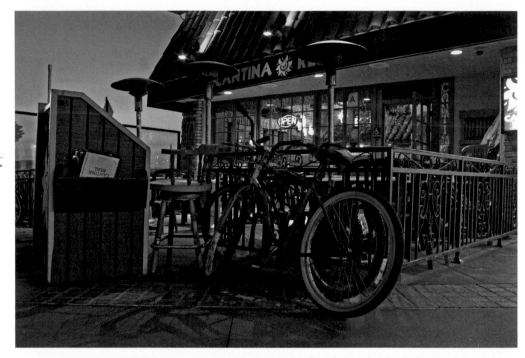

Figure 2.11
The statue of surfer Tim Kelly at Hermosa Beach was captured at twilight. The warm light of artificial illumination contrasts beautifully with the vivid blue sky.

Canon 20D • ISO 100 • 5 sec. • ƒ/9 • Canon 20–35mm (equivalent to 32mm)

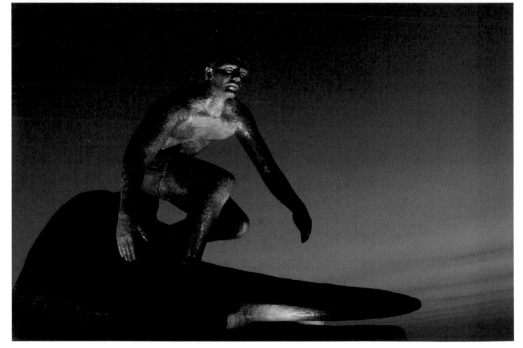

Dark Sky

You would think a black sky would make a great background, but unfortunately, looks are often deceiving. Any time illumination comes from an artificial light source, which is rarely meant for making photography look good, the results more often than not end up problematic. It's not that anything is wrong with these light sources, per se, but their contribution leans more toward helping you see in the dark rather than making your photographs look good. High contrast, dominant colorcasts, and lack of ambient light all work against you, producing less than impressive results. However, not every black sky situation is a total fail, as shown in **Figure 2.12**, but it's definitely a trickier time to shoot

The Effects of Artificial Lighting

It's a paradox that one of the great contributions seeing in the dark offers shares little regard for the outcome of your photograph. Don't get me wrong; it gets us through our fear of the dark, but high contrast, dominant color, and inconvenient placement of a light source can make it a photographer's nightmare.

But a dominant colorcast is not the main culprit. After all, the camera's white balance can adjust to the situation or you can correct color in postproduction, but that's only when the artificial light source produces a full spectrum of color. Unfortunately, many artificial lights found in public places are designed for efficiency and can only produce a single color. When you correct the colorcast, the result is a monochromatic image, but there are ways around that. Before we explore the remedies, let's look at two different types of lighting.

Figure 2.12 **Even though the sun was down for hours before capturing the Torso sculpture in Beverly Hills, the conditions provided an "even" exposure balance throughout the scene. The variety of artificial light types also helped create a colorful background.**

Canon T2i • ISO 800 • 1/10 sec. • ƒ/5.6 • Canon 24–105mm at 73mm (equivalent to 117mm)

Passive vs. Active Light

Many long exposure situations—particularly those shot after dark—offer limited control over the image, especially when it comes to lighting. You're at the mercy of conditions outside your influence. If the subject you choose to capture isn't properly lit, you can't move a streetlamp to provide the right angle of illumination, nor can you turn off a spotlight shining into your lens to avoid lens flare. Besides making adjustments on the

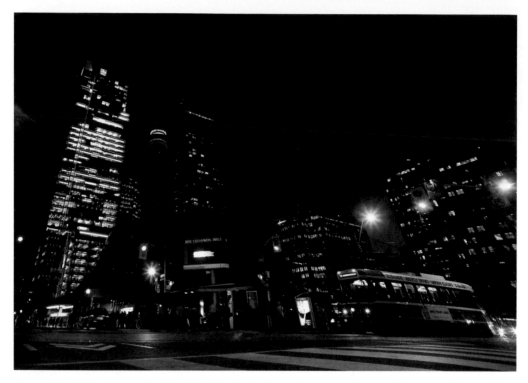

Figure 2.13 This busy scene shot at twilight illustrates the passive nature of some night scenes. Some ambient illumination is still present, so the scene isn't completely dominated by artificial light. But you can still see how these passive elements affect the image: spectral hotspots from streetlamps, motion blur from a pedestrian walking in front of the camera, and lens flare from direct lighting.

Canon 6D • ISO 400 • 1/2 sec. • f/11 • Sigma 14mm f/2.8

camera, you have passive control over capturing the scene. In addition, long exposures introduce other elements into the scene (**Figure 2.13**), increasing the passive nature of capturing the scene.

Conversely, active control allows you make lighting adjustments. When you're shooting a dimly lit situation—or to simply override the existing light sources—using electronic flash (**Figure 2.14**) is the most common way to bring light to the scene. But even more advanced techniques (discussed in Chapter 4), such as "painting" the scene with flash over a long exposure or placing colored gels over the flash unit or lens, can make the shot more impressive.

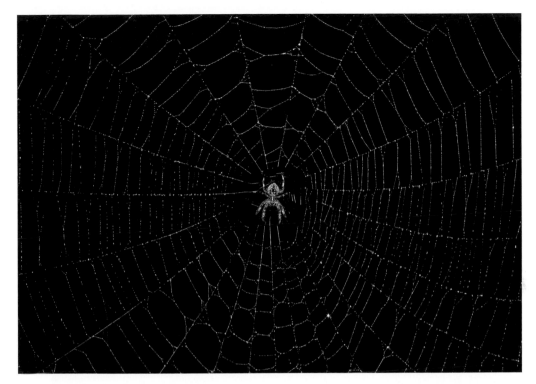

Figure 2.14 Not enough light was available to capture this perfectly made spiderweb, making it necessary to activate the on-camera flash. Not only did flash provide sufficient illumination, but it also helped to define details in the web. Because the camera-to-subject distance was relatively close, it was necessary to stop down the lens so the flash didn't overexpose the scene.

Canon T2i · ISO 200 · 1/10 sec. · ƒ/11 · Canon 50mm (equivalent to 80mm)

Length of Exposure

Because we've been examining long exposure in this chapter, you already know the possibilities of what happens when you keep the shutter open. Everything that happens during exposure collects as a single image (**Figure 2.15**), making a direct correlation between the length of exposure and the randomness of the image. For example, a 1-second exposure can expose a dark scene as a detailed photograph; a 10-second exposure can record an amusement park ride as a concentrated swirl of light. A 30-second (or less) exposure lets you saturate trails of beautiful light from passing traffic at a low ISO and small aperture setting. And if you want an even longer exposure, point the camera toward the sky for a few hours and render stars as streaks of light contouring to the earth's curve.

Going beyond the fractional exposure times also allows you to introduce additional elements into the scene, including both subject matter and illumination. You can regain active control of a scene by firing off a few flash pops during a long exposure time.

Figure 2.15
With some subjects, the length of exposure is not apparent; with others, it's obvious. This picture showing the three positions of a traffic light gives the viewer an idea how long the shutter was open.

Canon 20D • ISO 100 •
20 sec. • ƒ/22 •
Canon 80mm
(equivalent to 128mm)

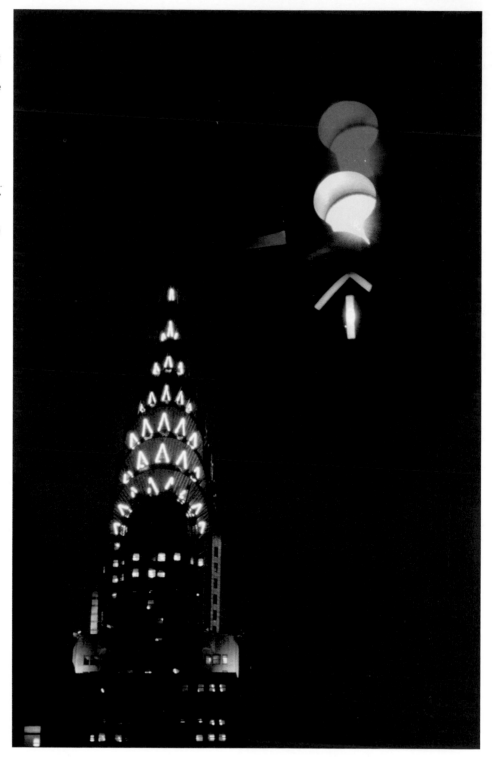

Or you can jazz up a scene by using colored gels. You can even keep the shutter open for minutes or hours and use a penlight or flashlight. Other creative ideas include positioning a person in the scene for part of the exposure to create a ghost image or using your hand to dodge exposure from a bright part of the scene (more about that later in the book). The possibilities are endless for the active control you have while the shutter remains open.

Weather Conditions

Sometimes when the weather is bad, it makes the potential for taking compelling photos ideal. Inclement weather conditions can offer some very creative possibilities, because changes in atmospheric conditions introduce a variety of elements that include cloud cover (**Figure 2.16**), fog, and reflections from wet pavement. Another benefit of inclement weather is that you won't be subjected to the limitation of dark sky conditions (and its issues), as mentioned earlier. As long as cloud cover is present in the sky, you won't have to deal with high-contrast lighting or unfavorable colorcasts.

However, poor weather conditions can also wreak havoc on your equipment. Rain, snow, or any kind of moisture is as deadly to electronics as Kryptonite is to Superman. Just a tiny bit of water can severely damage your digital camera. Make sure you keep it dry.

Let's examine some of the conditions you can expect in foul weather.

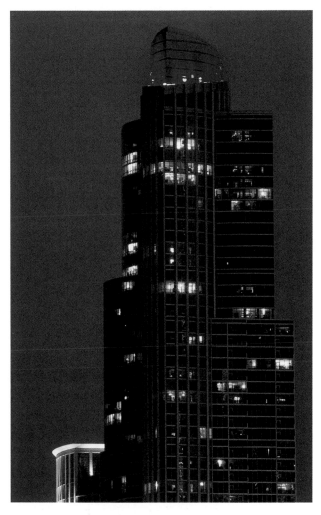

Figure 2.16 Although the sun had set hours before, the heavily overcast sky provided a lighter background that the camera's white balance recorded with a warm colorcast. The lighter sky also produced a natural reflector effect that "opened up" the dark parts of the building. Stopping down the lens to f/22 allowed for maximum focus throughout the scene.

Canon T2i • ISO 400 • 10 sec. • ƒ/22 • Canon 200mm (equivalent to 320mm)

Overcast

There's quite a difference between photographing a scene on an overcast day at the beach and under the clouds at night. Not many of us want to go to the beach on an overcast day, opting instead for direct sunshine. But taking photos at night under overcast skies provides a different thrill. The cumulus cover provides a lighter background than the night sky, which often produces a dramatic effect. As long as your equipment is safe and dry, it's a great opportunity to make some captivating photographs.

Fog

Throughout the history of cinema, scenes shot in the fog created a mood. Well, the same can happen when you're shooting photographs in the fog. Misty conditions provide the scene with a diffused, sometimes ominous, look, which can also add to the randomness discussed earlier. But fog imposes some limitations as well. One of the main restrictions is that it can render the subject a little soft. How much? That depends on the camera-to-subject distance to some degree. Some objects farther away from the camera are sometimes rendered as partially visible or completely obscured. Regardless, shooting in foggy conditions often creates a dreamlike appearance in the picture.

Rain

Shooting in the rain is not much different than shooting under overcast conditions except you get something extra: the actual rain. Of course, you have to be vigilant not to get your camera wet or water on the lens to avoid damaging your equipment. As long as you're careful, shooting in the rain presents a few more opportunities. Besides the subject standing out from the background—due to the overcast sky—the wet pavement lets you add a reflection to balance the scene. Often, these areas of saturated color can fill a void in the composition that would otherwise be unbalanced.

When you're shooting in the rain, it's best to use an umbrella to protect your camera and take many exposures to capture variations in the scene. Then there's the lightning that occurs during thunderstorms, but more on that in Chapter 3.

Snow

Maybe the first image that comes to mind when you think about a snow scene is that bucolic holiday card photo of a house covered in snow with smoke billowing from the chimney, perhaps shot in late afternoon light. Although shooting that same scene after dark creates its own special moment, other situations shot in the evening in snowy conditions can also be enchanting, and sometimes surreal. You can create some very intriguing images when shooting in the snow because the environment combines several other elements

that occur during inclement weather conditions (**Figure 2.17**). These elements include overcast skies, which make for a lighter background and provide natural diffusion, as well as the possibility of capturing reflections, especially on pavement as the snow melts. However, there is one caveat: It's nearly impossible to render the actual white stuff without a colorcast, but that shouldn't matter.

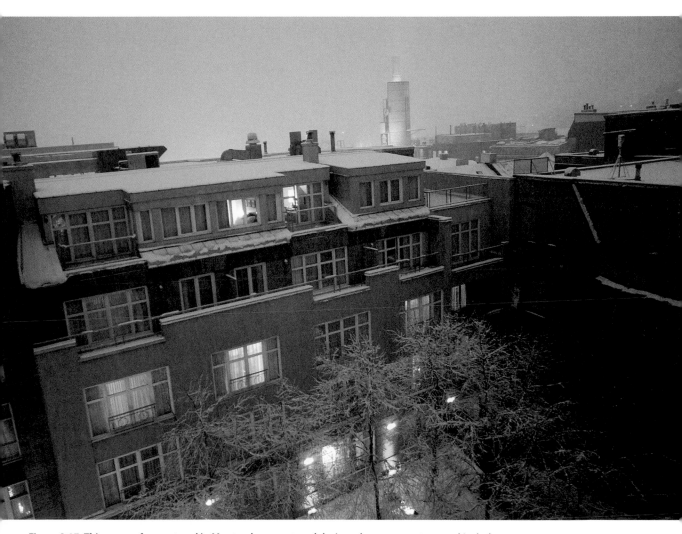

Figure 2.17 This scene of a courtyard in Montreal was captured during a heavy snowstorm and includes many of the benefits of shooting during inclement weather: a lighter background, natural diffusion (from falling snow), and a lower overall contrast.

Canon T2i · ISO 400 · 10 sec. · ƒ/22 · Canon 200mm (equivalent to 320mm)

The Risk and Reward of Blurring

Keeping the shutter open for longer than normal introduces blurring by moving subjects. It's a natural by-product of a long exposure because of the movement of objects in the frame. Sometimes blurring diminishes the quality of an image, making the viewer think the scene was improperly captured (**Figure 2.18**). But when done effectively, blurring can add a sense of motion and liveliness to an image (**Figure 2.19**).

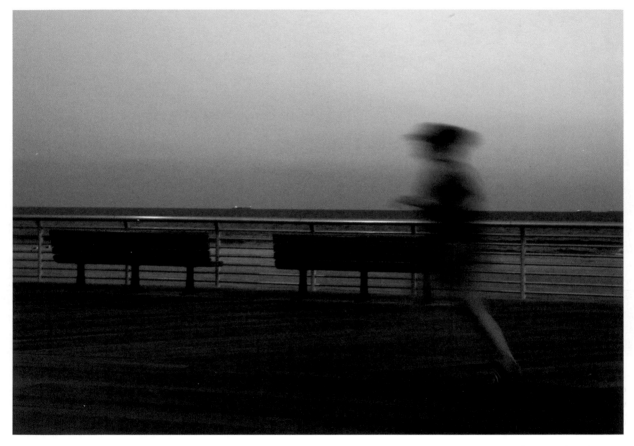

Figure 2.18 Although not a bad image, and perhaps even one that can illustrate a specific point, this photo might look like it was captured at the wrong shutter speed. With my camera placed on a tripod, this scene was captured using a slow enough shutter speed to blur the jogger, which is effectively juxtaposed with the stillness of the scene.

Canon 6D · ISO 2000 · 1/10 sec. · ƒ/16 · Canon 24–70mm at 55mm

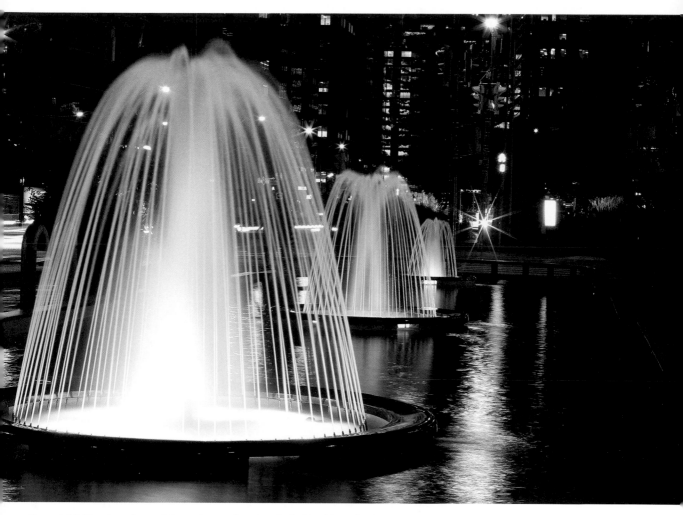

Figure 2.19 The street fountain's continuous flow is technically a blurred subject—albeit a very controlled one—so it makes for a great blurred motion subject. By keeping the shutter open for 13 seconds, the water was rendered as a fine stream.

Canon 6D · ISO 100 · 13 sec. · ƒ/22 · Canon 85mm ƒ/1.8

Seeing Ghosts

Although people moving through a scene during a long exposure can produce a blur that provides the photo with a sense of motion, the subject can also move more deliberately by staying still in one part of the photograph and then move to another part, rendering a transparent appearance—much like the illusion of a ghost. This effect is relatively easy to produce and can create very unique portraits. All it takes is the use of a tripod, your camera set for a long exposure, and a subject willing to transform into a photo ghost. This technique works well with static or boring scenes, adding some pizazz to the image or a bit of eeriness (**Figure 2.20**).

Figure 2.20
Captured in a New Orleans French Quarter hotel room, for this 30-second exposure the subject sat on the right side for part of the exposure before moving to the left side.

Canon EOS-1 • ISO 100 • 30 sec. • ƒ/11 • Canon 28–85mm ƒ/2 .8

Chapter 2 Assignments

Shoot in the Dark

Set up your tripod and shoot a subject in a lowly lit scene using a long exposure time. Often, the camera can catch what our eyes can't see. If you can't measure the light accurately, use the trial-and-error method by observing the picture on the camera's preview window. Don't be afraid to "open up" the lens, use a remote for a several minute exposure, or increase the ISO setting to increase the sensor's sensitivity. This is a great way to understand the potential of shooting in the dark.

Practice Reciprocity

Exposure value is based on the variation of shutter speed and aperture setting. There's a counter-balance to altering it, much like a scale. If you increase the shutter speed, you must decrease the aperture setting to maintain the same level of exposure. As previously mentioned, there are significant reasons for finding the right combination. It's best to measure exposure, and then practice shooting at different shutter/aperture combinations. It will help you understand how to control the look of the image by manipulating depth of field, use motion creatively, or strike the perfect balance for your intentions. For example, when capturing the light trails of passing traffic, a 1-second exposure will record a short burst in the frame, whereas at 10 seconds the trail might pass through the scene. Conversely, in a portrait, using the widest possible aperture is often the goal.

Experiment During Inclement Weather

Dreary weather conditions can often lead to impressive photographs, so get out there and see what happens when you shoot under an overcast sky, surface reflections in the rain, and fresh falling snow. Just make sure your camera stays dry and you stay safe.

Compare the Same Subject at Twilight and Under a Dark Sky

A twilight sky can make almost any subject look good, but wait a bit later and you lose its benefit. Still, it's important to understand the difference between shooting under a twilight sky and a night sky. And the only way to do that is to stick around and see what it's like to shoot under a dark sky. Sometimes you'll end up with a problematic picture; other times the outcome will be an image with a dramatic appearance.

Share your results with the book's Flickr group!
Join the group here: flickr.com/groups/timelapse_longexposure_fromsnapshotstogreatshots/

Canon 6D • ISO 100 •
30 sec. • ƒ/16 •
Sigma 14mm lens

3
A Universe in Every Frame

Trials and Tribulations of a Long Exposure

When you take a snapshot, the part of the world in front of the camera is frozen at a fraction of a second. It's a moment captured as a sliver of time, just like the blink of an eye. But when you keep the shutter open for a longer period—say a few seconds you capture all the activity happening in the frame from the time it begins and ends as a single exposure. Yet, what goes on in the frame and how you depict that world depends on many factors—some within your control, some not so much. Even when you have a balanced exposure, sometimes factors in the scene can make it less than perfect. Spectral lighting, lots of shadow areas, and others factors can make the situation worse.

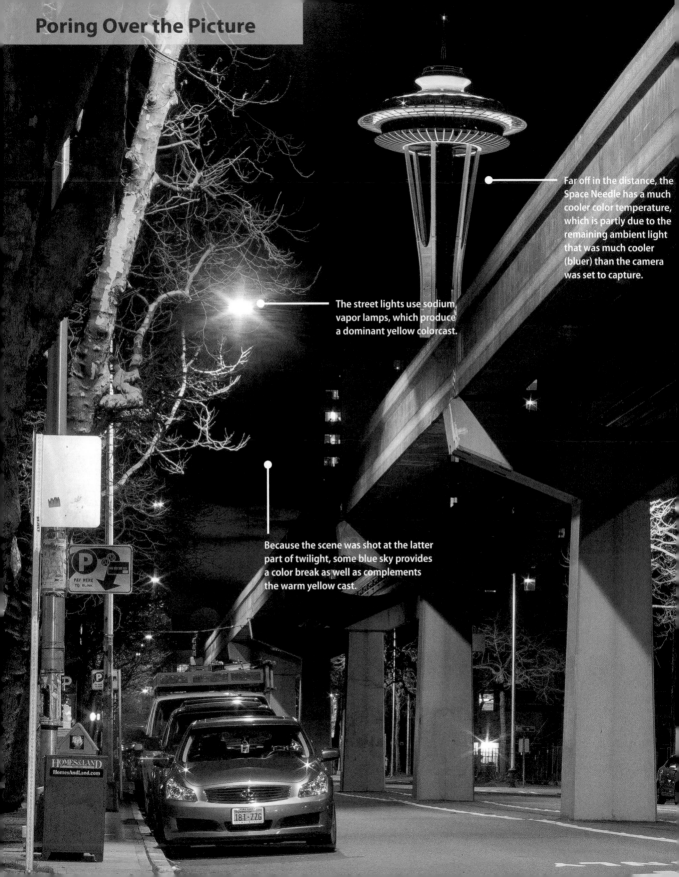

Poring Over the Picture

Far off in the distance, the Space Needle has a much cooler color temperature, which is partly due to the remaining ambient light that was much cooler (bluer) than the camera was set to capture.

The street lights use sodium vapor lamps, which produce a dominant yellow colorcast.

Because the scene was shot at the latter part of twilight, some blue sky provides a color break as well as complements the warm yellow cast.

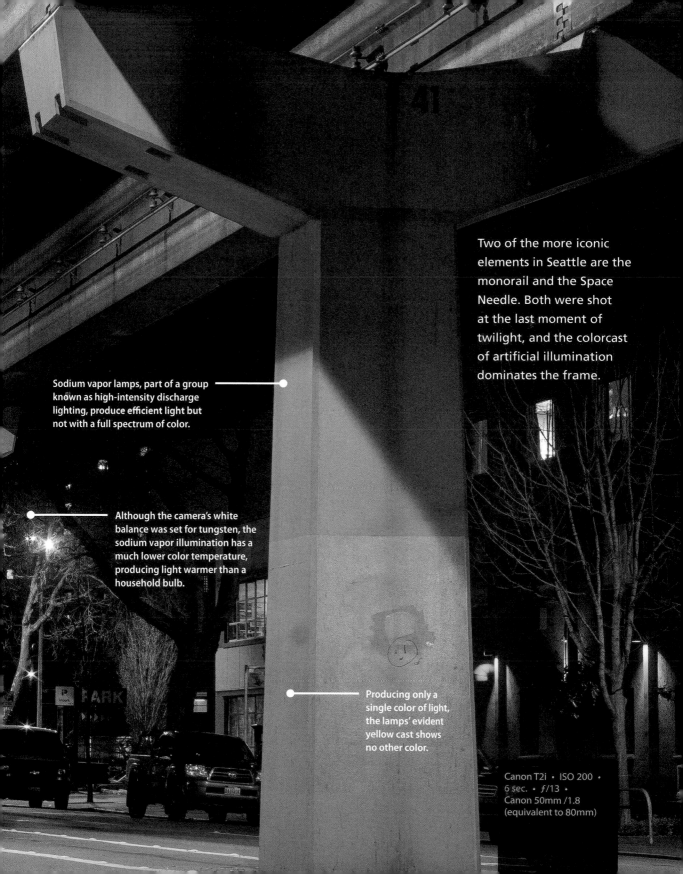

Sodium vapor lamps, part of a group known as high-intensity discharge lighting, produce efficient light but not with a full spectrum of color.

Two of the more iconic elements in Seattle are the monorail and the Space Needle. Both were shot at the last moment of twilight, and the colorcast of artificial illumination dominates the frame.

Although the camera's white balance was set for tungsten, the sodium vapor illumination has a much lower color temperature, producing light warmer than a household bulb.

Producing only a single color of light, the lamps' evident yellow cast shows no other color.

Canon T2i · ISO 200 · 6 sec. · ƒ/13 · Canon 50mm /1.8 (equivalent to 80mm)

Poring Over the Picture

The time of night and the randomness of passing traffic transform this Florida road captured at dusk from a simple situation to one more compelling.

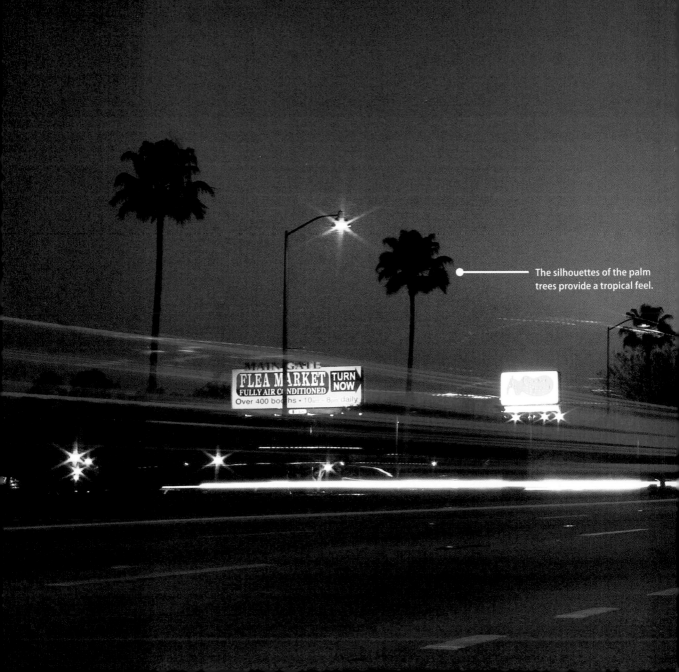

The silhouettes of the palm trees provide a tropical feel.

The cool tones of the twilight sky nicely complement the warm illumination on the surface.

The ambient light after sundown coupled with the illumination from street lamps provides a pleasant orange cast along with detail in the scene.

Because the sun had just set, you can see a warm glow at the horizon.

Exposure duration is long enough to allow the traffic to completely pass through the frame, creating a continuous flow.

Canon 20D • ISO 100 • 8 sec. • f/22 •
Canon 20–35mm f/2.8L at 29mm (equivalent to 46mm)

Understanding Artificial Lighting

Regardless of where a light source resides or how effectively it illuminates the area, artificial lighting adds another serious caveat: It influences the color of the image. The problem intensifies because there are so many types of artificial lighting; it's sometimes tricky to predict their behavior.

During the day, the sun has a monopoly over outdoor lighting, leaving you in a passive role. But it's still predictable enough for you to make proper adjustments. Once the sun sets, artificial illumination dominates the landscape, and that changes everything (**Figure 3.1**).

The colorcast is completely correctible when the light produces a full spectrum of color (more on that in a moment). Contrast issues are more likely because each light source is bright enough to expose the scene but has a limited range. So when you're shooting without the presence of ambient lighting, light quickly falls off, going from light to darkness pretty quickly. At that point, even a balanced exposure can show blown-out highlights and shadow areas without details.

Combine that contrast problem with color issues, and you can see the problem that it creates: uneven lighting and weird color. Many artificial light sources found in public places are designed for efficiency, not their ability to create a full spectrum of light. Rather, they produce a single color. As previously mentioned, when you correct the colorcast, all you're left with is a monochromatic image. But there are ways around it. But before we get into the solution, let's first look at the different types of lighting you'll come across at night.

Figure 3.1
Artificial lighting coming from a variety of sources transforms the darkness of a street scene into an area you can see your way around in.

Canon T2i • ISO 200 • 5 sec. • ƒ/22 • Canon 20–35mm ƒ/2.8L at 30mm (equivalent to 48mm)

Passive light refers to a light source you cannot control. And sometimes that can be a problem when shooting outdoors. Unlike a studio situation, or even a lamp in your living room, you can't just move it or tone it down. Case in point is the shoreline scene in **Figure 3.2** with a sodium vapor lamp flaring into the lens.

Figure 3.2 Sometimes the artificial light source gets in the way, and there's nothing you can do about it. Not only does this sodium vapor lighting create a dominant colorcast in the scene, but also one of the lights is flaring in the frame.

Canon 6D · ISO 100 · 20 sec. · ƒ/7.1 · Canon 24–70mm ƒ/4

Incandescent Light Sources

Light sources that produce illumination as a by-product of heat are categorized as incandescent and are pretty hot to the touch when illuminated. Many light forms make up this category, including fire (**Figure 3.3**), the sun, or heating a tungsten filament inside a bulb. Although the color temperature of each differs, all produce a full spectrum of color. That means even if you set the camera for the wrong white balance, you can correct it in Adobe Photoshop in postproduction to represent all colors in the scene.

Figure 3.3
The burning log was captured using a white balance setting of 3200 K, and it still renders pretty warm. Normally, the color temperature is significantly lower.

Canon 20D • ISO 200 • 2.5 sec. • ƒ/22 • Canon 100mm (equivalent to 160mm)

Tungsten

Tungsten, the most popular type of incandescent light, resembles that iconic image of a lightbulb that pops up over your head to represent a great idea. But tungsten lighting is used in many places besides household bulbs. Commercial applications include studio lighting, movie lights, and accent lamps. Although they come in different sizes and appearances, they all create illumination the same way, inside the bulb. They heat a thin filament inside the glass envelope until it glows. Because they get hot, they have a short life span as opposed to other lighting types, such as LED and CFL. Slowly being phased out for home use by the more energy-efficient CFL bulb and even more efficient LED lights, tungsten lighting is still fairly common, continuing to make its mark in many situations including outdoor gatherings, accent lights, or movie theater entrances (**Figure 3.4**).

Fluorescent

Thanks to their cost efficiency, long fluorescent tubes remain a popular choice for interior lighting in offices and commercial spaces. Although economical to buy and use, they also provide the widest range of color balance. Some produce a full spectrum of color, in various configurations, including daylight balance. Others are designed strictly for industrial use and produce a single dominant colorcast. Some are even designed specifically for photographic purposes, including light banks for product and television lighting. Unlike incandescent lighting, fluorescent lights are cool to the touch and are as efficient as their cousin, the high-intensity discharge lamp discussed later in the chapter.

The next time you walk past an office building or factory, observe the color of light emanating from the windows. Often, you'll see a greenish or cyan cast, as shown in **Figure 3.5**. Other fluorescent light types produce a wide range of colors from warm tones to neutral balances and daylight.

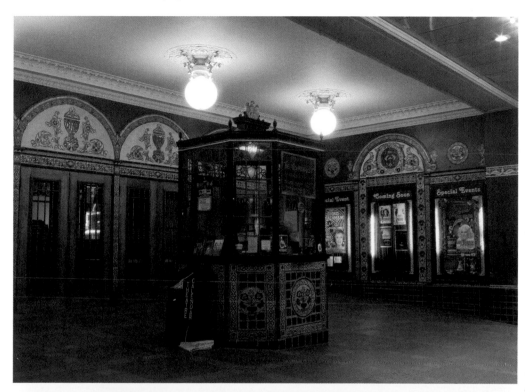

Figure 3.4
The movie theater box office area positioned under the marquee is illuminated by a variety of tungsten lighting and spotlights. In this photo, the camera's white balance was set to match it, so the image doesn't look warmer than normal.

Canon T2i • ISO 200 • 4 sec. • f/22 • Canon 20–35mm at 20mm (equivalent to 32mm)

Figure 3.5
Office buildings illuminated with interior fluorescent lighting often show a greenish cast. Here, the illumination complements the strong black tones and rich blue background.

Canon T2i • ISO 200 • 2.5 sec. • f/16 • Canon 20–35mm at 20mm (equivalent to 32mm)

Color Temperature

The success of photographing under available light conditions depends in part on understanding the color temperature of each light source and how it relates to the camera's White Balance setting (**Figure 3.6**). Without getting into a physics lesson, color temperature is measured using the Kelvin scale. In simple terms, the lower the temperature of illumination, the warmer the light it produces. For example, light from a single candle measures approximately 1200 K, and a household bulb measures approximately 2800 K. Daylight temperature measures about 5500 K, which is also the approximate output of electronic flash.

Figure 3.6
This image was originally captured on daylight-balanced film, which is compatible to a White Balance setting of 5500 K. The tungsten lighting on the deck rendered slightly warmer and the twilight sky slightly cooler.

Canon F1 · ISO 100 film · 8 sec. · ƒ/11 · Canon 24mm

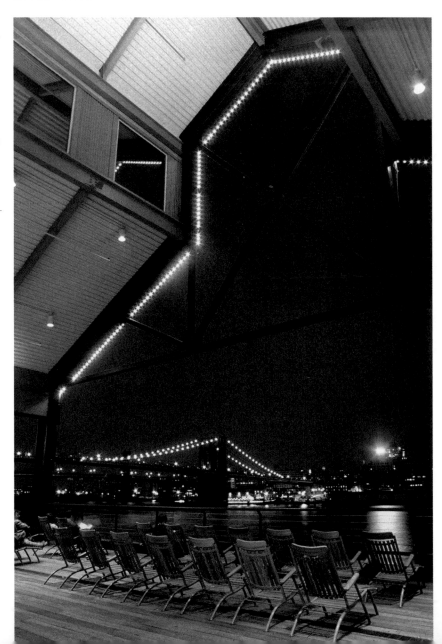

White Balance

The White Balance setting on your camera can automatically adjust to the color temperature of the scene. You can also manually adjust it for specific situations; just be mindful that if you set the white balance higher than the actual color temperature of the light source, it will render the subject warmer than normal, as shown in **Figure** 3.7. Of course, setting the white balance lower than the actual color temperature renders the subject with a cooler tone.

Figure 3.7 With the camera set to Auto White Balance, It measured the color on the Capitol Building at a much higher color temperature than the sodium vapor street lamps. As a result, the camera rendered an accurate color balance, which rendered the street with a warm red tone. The red traffic lights also added to the colorcast.

Canon 20D · ISO 200 · 0.6 sec. · *f*/5.6 · Canon 20–35mm at 35mm (equivalent to 56mm)

High-Intensity Discharge Lamps

Public and commercial spaces require efficient illumination to cover large areas, but the efficiency of high-intensity discharge lamps comes at a price to photographers because the most common lighting types don't produce a full spectrum of color. Most produce a single color that is nearly impossible to correct. Sure you can remove the color, but then you're left with a monochromatic image. However, that shouldn't sway you from shooting under this type of illumination because there are still lots of ways you can create effective imagery.

Three basic types of high-intensity discharge lamps are sodium vapor, mercury vapor, and multi vapor; each has its own distinct properties.

Sodium Vapor

Most commonly used for streetlamps, accent lighting, and building entrances, sodium vapor lamps emanate a yellowish illumination similar to tungsten. But don't be fooled into thinking they behave the same way. Unlike tungsten, these lamps don't create light by heating a filament; instead, they use electrodes to excite gas within a glass envelope. This method produces very efficient illumination that is not overwhelmingly ugly. But as mentioned earlier, they don't correspond to a full spectrum of color, so you can't color correct the image; however, that's not necessarily a bad thing. For example, shooting a subject at twilight solves the problem, especially when a twilight sky complements a warmly lit subject (**Figure 3.8**).

Mercury Vapor

More efficient for illuminating large spaces than sodium vapor and even less friendly for photography, mercury vapor lamps emit a greenish cast that dominates the scene with light that resembles an industrial landscape on Jupiter, and not the good kind. Its illumination helps motorists find their cars and pedestrians avoid tripping over curbs, making it perfect for parking lots, garages, and industrial spaces. It's just not flattering for capturing subjects and less so when it comes to capturing a person, because it renders a sickly appearance. But don't lose hope so quickly. Although it produces an unusual color-cast, sometimes you can use it creatively. For example, you can mix it with other light sources to show an array of color in the scene produced by the different lighting sources. Positioning the main subject against a twilight sky also adds a bit more color to the scene. Or try both techniques, as shown in **Figure 3.9**.

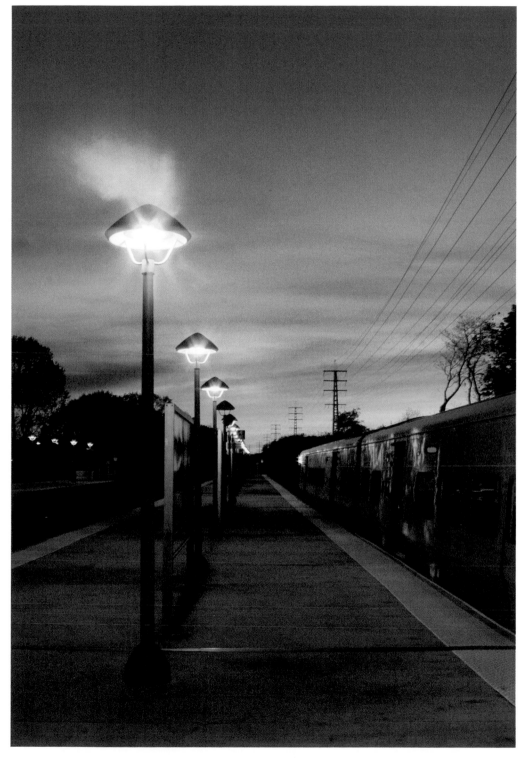

Figure 3.9
Mercury vapor
lighting illuminates
the Washington
Square Arch. But a
variety of other light
sources are also
in the scene—as
well as a twilight
sky—preventing the
mercury vapor light-
ing from dominating
the scene with its
green cast.

Canon EOS-1 •
ISO 100 • 30 sec. •
ƒ/11 • Canon
20–35mm at 24mm

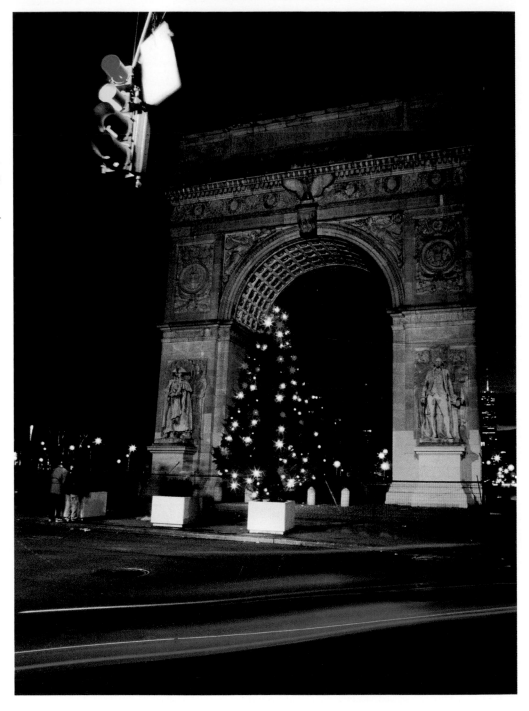

Multi Vapor

Imagine watching Monday night football on your 4K big-screen television with the stadium illuminated with sodium vapor or mercury vapor lighting. Besides defeating the purpose of watching the game on a high-quality screen, that color bias of yellow or green, respectively, would lack the realism of seeing the game live. Instead, it would resemble a night high school game shown on public access television. Sporting events need the efficient lighting that high-intensity discharge lamps deliver but also need to produce a full spectrum of color. Multi-vapor lighting provides the best of both worlds: They are efficient and have accurate color balance (**Figure 3.10**).

Some multi-vapor lights differ in color temperature, so be sure to do a test shot before shooting, because color balance varies with each type of lamp and venue.

Figure 3.10 Illuminated by multi-vapor lighting, this scene shot before the Super Bowl in Lucas Oil Stadium in Indianapolis shows a slightly warmer balance than twilight outside.

Canon T2i · ISO 800 · 1/80 sec. · ƒ/6.3 · Canon 24–105mm at 24mm (equivalent to 38mm)

Neon Lighting

The contorted tubes of colorful light in neon lighting make up one of the most iconic pieces of the nighttime landscape. Twisted into all sorts of names and designs they create light by passing neon gas through a glass tube using coated phosphors to produce color for the light source and the residual glow on nearby surfaces. But the name of the light source is somewhat deceiving because some don't use neon gas; instead, some lights favor argon, which produces more of a purplish illumination as opposed to the warmer-toned neon. But the manner in which each type produces light matters very little because the actual color of the light depends on the colored phosphors. Due to its intensity, the color of the neon is not adversely affected by the camera's White Balance setting, as shown in **Figure 3.11**. There's also wide latitude for exposure due to the level of saturation you desire in the tubes and the reflection the neon lighting creates on the surface.

Figure 3.11
With a little help, neon often takes on practical forms, such as this rendition of a chef. Captured before the sky went completely dark, ambient light exposure provides a little bit of detail to the wall. The White Balance was set at Daylight, or 5500 K, so the building has a cooler colorcast, but the tubes are still quite colorful.

Canon T2i · ISO 200 · 1/6 sec. · ƒ/11 · Canon 200mm (equivalent to 320mm)

Taking Pictures in the Dark

Sometimes low-light photography can resemble no-light photography because it lacks any tangible amount of illumination. That means you can capture situations with very little, if any, direct light as long as you have the time and perseverance for each exposure. Although low-light photography is not one of the more practiced disciplines of long exposure photography, it can certainly yield impressive results (**Figure 3.12**). But shooting in the dark does have its own set of problems. Prominent issues regarding exposure, sharpness, and color are sometimes tricky to handle, yet most can be solved with some common sense techniques.

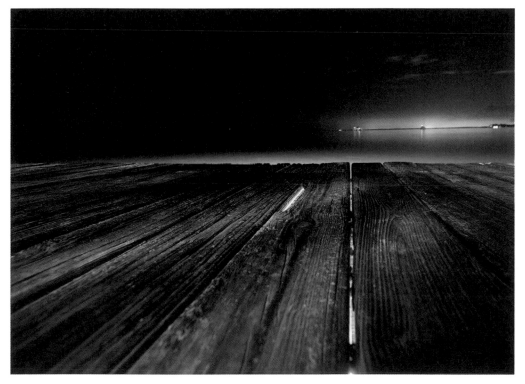

Figure 3.12
Although this scene appears well-lit, it was nearly pitch black. Scant illumination coming from a light under the dock and ambient light from a nearby restaurant was collected over a 30-second exposure at a high ISO setting.
Canon 6D • ISO 800 • 30 sec. • f/8 • Canon 14mm

If you want to master photography in the darkness, consider the following:

- **High ISO setting:** A high ISO setting increases the sensitivity of the sensor, requiring less light to properly expose the image. On many of the newer cameras you can gain at least eight stops of exposure (based on an original setting of ISO 100) and even more on others. Although image noise increases substantially at the higher settings, it's sometimes an acceptable trade-off.

- **Very long exposures:** Depending on just how dark the situation is, you'll need to keep the shutter open for a longer time, which is usually from 30 seconds to minutes, and

sometimes longer. The latter does entail special circumstances, such as capturing star trails, using a very high aperture setting in darkness to maximize depth of field, or setting a low ISO setting to capture as much detail as possible.

- **Wide aperture setting:** Letting the maximum amount of light into the lens reduces the length of exposure. But you can also limit focus to the main portion of the scene. Some situations are totally acceptable for using a wide aperture setting because it will not affect depth of field; for example, if you were capturing a starry sky through the trees. As long as the closest part of the scene is in focus, you don't have to worry about stopping down the lens. So using an aperture setting of *f*2.8 lets you use manageable shutter duration.

Focusing in the Dark

Autofocus is ideal for many situations, but working effectively in the dark is certainly not one of them. That is, unless you enjoy listening to the lens trying to find focus by whirring in and out indefinitely. It can be quite annoying. You can manually focus the scene, but you might have just as hard of a time finding a proper focus because of the lack of light in the scene.

Here are some solutions for focusing in the dark:

- **Manually focus the scene:** Sometimes there's no substitute for using the "old-school" method of manual focus by turning off AF on the lens and turning the barrel into sharpness. The best part is that you can immediately click the shutter without the camera focusing.

- **Use a flashlight:** It's a good idea to carry a small flashlight in your bag. Not only does it help you see in the dark and avoid tripping over objects, but it can also illuminate the subject so the camera can focus accurately, whether you do so manually or automatically.

- **Set distance manually:** If you have an idea of the subject's distance from the camera, manually set it on the lens. For example, if you think your subject is approximately ten feet away, set the lens distance marker to ten feet and press the shutter. Keep in mind that if you use a medium aperture, depth of field will add a little focus to the foreground and background areas.

Long Exposures During the Day

Don't be fooled into thinking long exposures are used exclusively for working in low-light situations. Quite the contrary; you can also use extended exposure times under bright conditions. You might want to shoot a long exposure during the day for lots of reasons: Some are practical; others are creative. Whatever the reason, it's another tool in your arsenal for capturing interesting photographs (**Figure 3.13**).

Figure 3.13
This overcast autumn afternoon was relatively bright, but in order to produce maximum depth of field, along with the blur of a passing car, it was necessary to shoot a long exposure.

Canon 6D • ISO 100 • .5 sec. • *f*/22 • Canon 85mm

Let's examine some of the reasons for using this technique in the daylight:

- **Maximum depth of field:** Even if you could handhold the camera to get maximum depth of field in the daylight, more often than not you wouldn't get as much of the scene in focus as you desired, even when it's relatively bright. Instead, you can place the camera on a tripod, use a long exposure, and stop down the lens as much as you need.

- **Eliminate passing people:** By using a long exposure, people, pets, and anything else that passes through the scene will not register because there's simply not enough time to capture their fleeting ways. To succeed in removing passersby, exposure times must be more than a few seconds and preferably close to a minute to eradicate their existence from the picture.

- **Use a neutral density filter:** Some situations are too bright for a long exposure, and therefore the exposure is not long enough to prevent the ghosts of people and moving objects that were in the frame for part of the time. Although sometimes these ghosts produce a cool effect, other times they're a nuisance. The remedy to get rid of the ghosts is to place a neutral density filter over the lens to force you to increase exposure time. Just find one with the right density for the situation to make at least a 30-second exposure, and you're in business.

Zooming as a Creative Device

The main purpose of a zoom lens is to be able to shoot a range of focal lengths without having to carry several lenses: You can adjust the lens precisely to frame each exposure. But you can also use the entire zoom range creatively in a single exposure. Simply press the shutter and slowly zoom in or out of the scene during exposure. It's another perk of using a long exposure to create a sense of motion. However, because this technique uses another random type of photography, it's far from an exact science, making the recipe for success a trial-and-error endeavor. When done correctly, it can transform an otherwise simple subject into a far more compelling image, as shown in **Figure 3.14**.

Figure 3.14
Changing the focal
length of a short
zoom lens captured
this mundane
store window filled
with taxi souvenirs.
Exposure began
at 35mm, and the
zoom barrel was
quickly pulled
wider to create the
motion effect.

Nikon 90s • ISO 100 •
2 sec. • ƒ/8 •
Nikon 35–70mm

Photographing Trails of Light

Although you use light primarily for illumination purposes, at times the subject is light. During a long exposure, just about anything bright that moves across the frame can make a great subject. Popular choices include capturing automotive light trails, shooting amusement park rides, photographing a fireworks display, and drawing in front of the camera with a penlight (**Figure 3.15**). Situations for capturing light often differ drastically from capturing the subject it usually illuminates; but the approach for effectively capturing each is very much the same. So if you enjoy adding saturated streaks of color to your picture, you'll need a tripod, a relatively long exposure time, and the tolerance to accept that every shot is random.

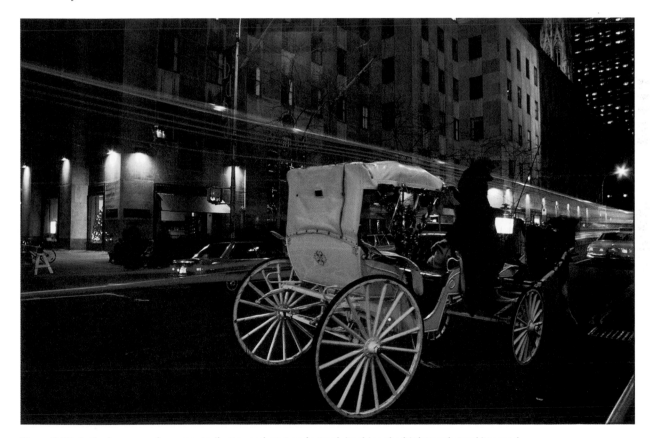

Figure 3.15 As the hansom cab momentarily stopped, cars and a truck (making the higher red streak) passed through the scene.

Canon EOS-1 · ISO 100 · 8 sec. · ƒ/11 · Canon 24mm

Photographing Automotive Light Trails

If the scene you're trying to capture involves shooting a cityscape or a road after dark, chances are you'll encounter trails of light passing from traffic in your photograph. Of course, to what degree depends on the number of cars that drive through the scene. Although automotive light trails are random, they're still somewhat predictable because cars remain on the road, or at least they're supposed to. Fortunately, that's the case most of the time.

Adding light trails to your composition integrates effectively and provides the scene with a sense of time. And it can do more by transforming a boring or stagnant scene into one with more visual appeal. Or you can just shoot the light, which at times can be as dominant as the subject.

But not all light trails are created equal in color, position, and intensity. Regardless of your intent, consider the following:

- **Stay safe:** To make great photographs of passing light, you need to stay out of danger. Don't stand in the street or near dangerous curves. Instead, position yourself on the sidewalk or above the traffic.

- **Create an even flow:** Every situation is different, but you can achieve the best photos when traffic flows smoothly through the frame. How do you do that? One effective technique is to make sure exposure duration is long enough, meaning adequate time for vehicles to pass through the frame.

- **Direction matters:** Deciding to capture traffic coming toward the camera or traffic moving away from it depends entirely on your preference. The latter renders taillights as red saturated lines of color, whereas the former produces white light from headlamps. Buses and trucks create additional colors because they have yellow and green safety lights.

- **Angle of view:** The angle of the camera plays a big part in the way light trails are depicted in the scene. If the camera is a few feet off the ground, it's on the same plane as the traffic pattern, which means it either registers thin bands of light or worse, light flare into the lens. Sometimes this is acceptable; other times it's not. Often, it's best to position the camera above traffic, as shown in **Figure 3.16**, to register a wide range of color and light in the scene.

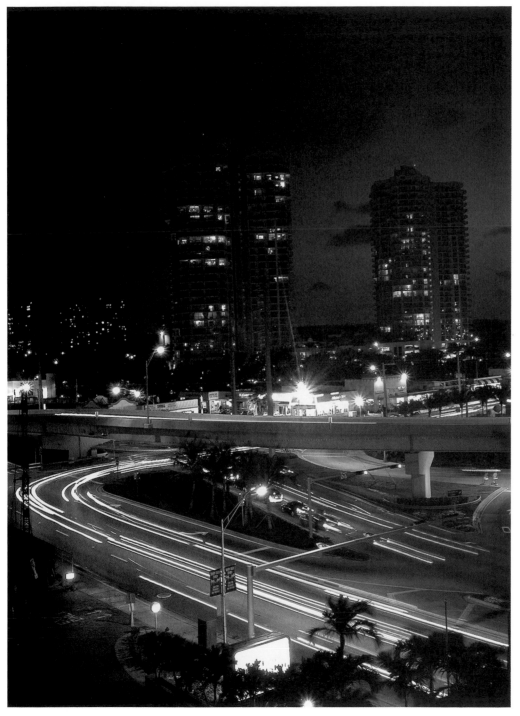

Figure 3.16
Shot several stories
above the highway,
the traffic patterns
enhance the build-
ings set against the
twilight sky.

Nikon 5000 · ISO 100 ·
4 sec. · ƒ/7.1 ·
Nikon 28–85mm at
38mm

Having Fun with Amusement Park Rides

Unlike automotive trails, which are more random, amusement park rides are a more controlled capture. Random subjects don't move through the frame because the motion is on a track. Illumination comes from various light panels and hundreds (or more) of tungsten lightbulbs. These attractions are transformed into saturated swirls of light representing light and motion (**Figure 3.17**).

Here are some tips for shooting theme park rides:

- **Shoot multiple frames:** Bracket exposures (shoot slightly different variations) to make sure you capture the light as perfectly as possible.

- **Use a low ISO setting:** Capture the most detail and eliminate image noise by using a low ISO setting.

- **Shoot at night:** Take advantage of shooting at twilight, because it will provide a strong complement to the warmly lit ride.

- **Find creative angles:** Avoid the cliché shot and look for an exciting perspective.

Figure 3.17
The warm radiance of hundreds of spinning lightbulbs on the stands is enhanced by the cool twilight sky. Notice the motion blur created by the swings.
Canon EOS-1 • ISO 100 • 8 sec. • ƒ/11 • Canon 24mm lens

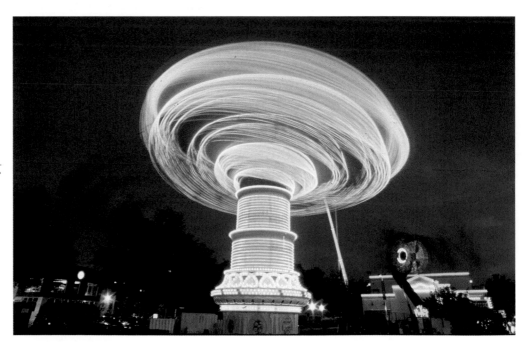

Shooting Fireworks

We all love to watch a good fireworks display, but shooting one is not always an easy task, especially when you're striving for originality. Fireworks have an unpredictable nature when it comes to location, color, and type of burst. Sometimes you think you know where the burst will appear, so you set up for it, only to see it happen in another part of the sky. That makes it difficult to compose the scene, which makes photographing fireworks the most random of the random collections of light.

Consider the following when you're trying to get great fireworks shots:

- **Don't move:** If you keep changing position, you'll be one step behind the display. Instead, find the most common place where the fireworks appear and be patient.

- **Use the B setting:** By using the B setting, you can open and close the shutter manually by using a remote cable to start and stop exposure as soon as the burst is done.

- **Shoot test exposures:** Measuring exposure under a black sky is not an accurate place to read exposure. The black sky will fool exposure, and because you can't take a reading of the burst, it will be too late to capture it. So do a few test shots to find the proper aperture setting. Thereafter, you'll just need to change settings due to some variations in color and density of the burst.

- **Change perspective:** You don't always need to shoot a fireworks display in the over-head sky. Sometimes you can find other creative ways to capture them behind objects at ground level (**Figure 3.18**).

Painting with Light

You don't have wait for cars to pass you on the street to capture light trails, nor do you need to count the days for a holiday celebration to capture bursts from fireworks. Instead, you can create your own magic using a penlight and the determination to draw with it around a subject. All it takes is mounting the camera on a tripod and manually keeping the shutter open with a remote control. The shutter should stay open long enough for you to finish "painting" the scene. Of course, it may take a few tries to make sure the exposure is just right. One suggestion is to take a long exposure of the scene to find the right duration. And how long is that? Long enough to expose the scene, actually slightly underexposing, to allow the light painting to stand out (**Figure 3.19**).

Figure 3.18 For this shot, the camera was positioned so the bursts from a neighborhood fireworks show look like they're coming from behind the pole.

Canon EOS-1 · ISO 100 · Approx. 15 sec. (Shutter on B) · ƒ/11 · Canon 28–85mm lens at 85mm

Figure 3.19
With the camera mounted on a tripod and the shutter kept open for nearly ten minutes, I used a penlight to outline this park bench. Without any light pollution coming from nearby lamps, the conditions were very dark.

Canon EOS-1 · ISO 100 · Approx. 10 min. (Shutter on B) · ƒ/5.6 · Canon 50mm

Shooting the Night Sky

Sometimes nature provides great illumination for your night images. Whether it comes from moonlight, a brilliant moon, or a starry sky, you can create some compelling imagery. With the exception of the moon as a subject—where illumination comes from varying angles of the sun—exposure durations need to be very long due to relatively low light. That means exposure times can range from seconds to minutes, even when you're using a high ISO and shooting with a wide-open aperture.

Shooting lightning in a night sky is bright enough for a "quicker" exposure time, but because it appears so briefly, you need to keep the shutter open long enough to capture it from when it starts to when it stops.

Capturing Star Trails

Capturing the motion of the celestial bodies above your head requires you to keep the shutter open for a very long duration, anywhere from minutes to hours. So if you have patience, you can easily capture trails of light from a starry sky, as shown in **Figure 3.20**.

Here are a few tips to capture star trails:

- **Use a sturdy tripod:** Extremely long exposure times can potentially increase the possibility of movement; so don't use flimsy support when you're capturing an exposure that requires a time investment of a few hours.

- **Have a remote cable:** The only way to maintain an exposure duration longer than 30 seconds, besides holding the camera for hours without letting out a breath, is to use a cable remote. Make sure you have fresh batteries in your cable remote so it doesn't stop working midway through the exposure.

- **Make sure it's a clear night with stars in the sky:** Although it sounds obvious, there's no sense in wasting a few hours, only to find out you've come up empty. So what's a good night? One with a lot of bright stars in the sky.

- **Look for the North Star:** The North Star, or Polaris, is the bright one, and because the earth's axis points directly toward it, the North Star moves less than the other stars around it. Over a few hours, you'll see circular trails around the North Star as the stars revolve.

- **Avoid light pollution:** Because some areas have so much artificial lighting that creates a reflective glow in the sky, that lighting affects the clarity of the night sky. It's the reason rural areas tend to have clearer skies with more stars than city skies. It's not that you can't capture star trails within city limits, but light pollution is still something to be mindful of.

Figure 3.20
By positioning the camera near the North Star (bright dot on the left) for two hours, I was able to capture the circular motion of the stars during the earth's rotation.

Canon EOS-1 •
ISO 100 • 2 hours •
ƒ/5.6 • Canon
20–35mm at 20mm

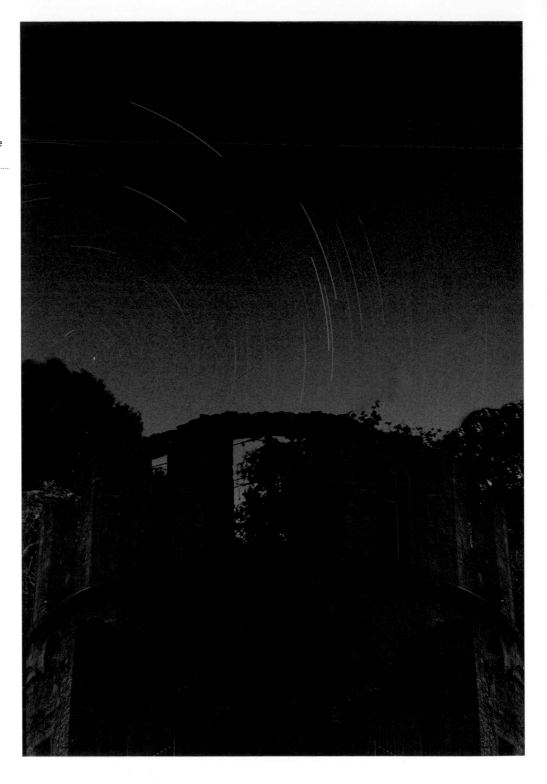

Shooting the Moon

Even in the dark of night, the moon is not traditionally a long exposure subject. If you treat it like a low-light subject (attempting a long exposure that measures the sky), the picture will end up looking like a white disk surrounded by a sea of black in the sky. Instead, base your exposure reading on just the moon to capture as much detail as possible (**Figure 3.21**).

Figure 3.21
The brightness of the moon makes it like shooting a daylight scene at night. The APS-C sensor increased the 200mm lens to 320mm bringing the lunar subject a little closer.

Canon T2i • ISO 100 • 1/160sec. • *f*/11 • Canon 200mm lens (equivalent to 320mm)

Here are few tips to help you successfully shoot the moon:

- **Use a long telephoto lens:** Depending on its position and your perspective, the moon can appear large or small. Regardless, it's a good idea to use a long lens, preferably with a lens extender, to bring the moon in as close as possible. How long depends on the position of the moon. Just make sure you can fill the viewfinder as much as possible with the moon.

- **Use a low ISO setting:** A low ISO setting provides the most detail and also lets you crop the scene (within reason) to allow the moon to fill the frame of the picture without losing much detail.

- **Mount the camera on a tripod:** Sometimes moon exposure falls into the handholding range (meaning it's a fractional exposure time), but it's still best to use a tripod to keep the camera steady and the image sharp.

Other Night Sky Situations

Shooting the moon and collecting star trails are pretty common subjects in the night sky, but that's not all the heavens have to offer. Here are a few other potential subjects:

- **Lightning:** You can read an entire book on tips and techniques for capturing bolts of lightning, but the most obvious advice is to keep the shutter open the same way you would capture fireworks, and do it in a safe place.

- **Airplane trails:** From time to time you'll capture airplane trails unintentionally during long exposures pointed at the sky. But these trails aren't always as pleasing as those that come from cars or amusement park rides. Why? Mostly because they're just straight lines in the sky.

- **Starry night:** Shooting a starry night differs from shooting star trails because the exposure is long enough to properly capture the celestial night sky but not so long that you notice movement in the sky. See "Poring Over the Picture" in Chapter 1.

- **Other celestial occurrences:** Northern lights, eclipses, meteor showers, and other incidents in the sky are all possible to photograph. But the success of each depends on understanding how, where, and when they occur. Thereafter, you use a similar approach to shooting any other long exposure situation.

Chapter 3 Assignments

Shoot Under Available Light

Photograph subjects illuminated by artificial light. Venture out and find as many different types of light as you can and observe the results. It's a good idea to try shooting under twilight and dark conditions to understand the possibilities with both. Also, consider making color corrections in Photoshop, especially with lighting types that produce a dominant colorcast and see how far you can go before depleting the picture of all color. Some situations may surprise you with a better range of color than others. Of course, that depends on the other light sources in the scene.

Try Very Long Exposures

Don't be afraid to make very long exposures. Most cameras already have a setting for 30-second duration so try it out and see what happens. Sometimes you can create a world normally unseen in the darkness, and other times shoot with a maximum depth of field. Just make sure you have a steady tripod and a remote cable. For those times when you don't have a cable, using the camera's timer can help alleviate the vibration of touching the camera.

Capture Light Trails

Have some fun capturing different types of light trails. You can stand near the street or over traffic and capture the taillights of passing cars to create red streaks of lights. Take a chance and shoot the headlights too when traffic is moving in the direction of the camera (but not near you). Amusement parks and local carnivals provide a rich selection of subjects waiting for you to make your masterpiece. If a special occasion presents a fireworks show, bring your camera and tripod and capture the colorful bursts in the sky. And if you're feeling creative, break out your flashlight and outline a common or unique object during a long exposure.

Share your results with the book's Flickr group!
Join the group here: flickr.com/groups/timelapse_longexposure_fromsnapshotstogreatshots/

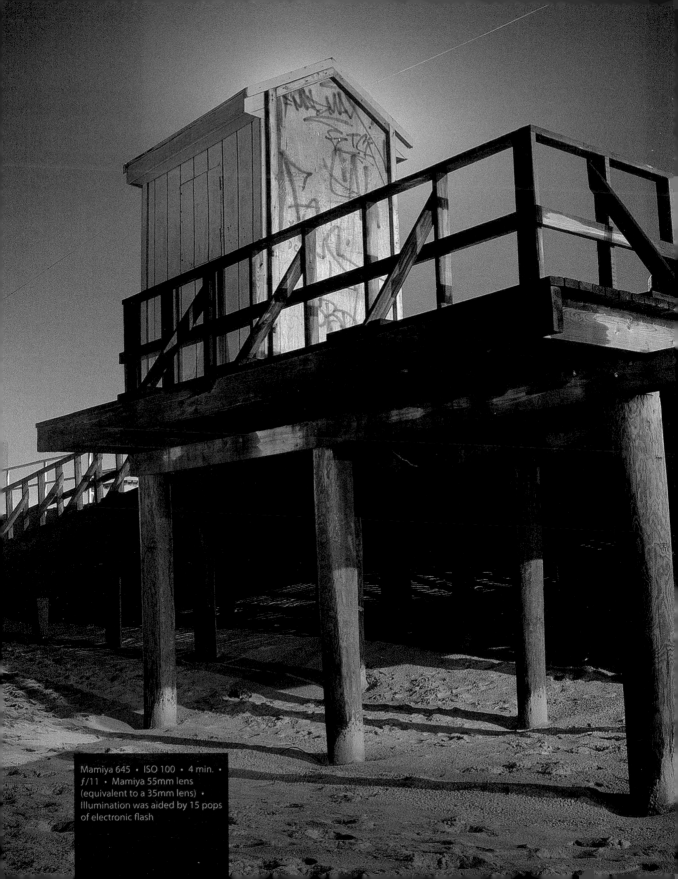

Mamiya 645 • ISO 100 • 4 min. •
f/11 • Mamiya 55mm lens
(equivalent to a 35mm lens) •
Illumination was aided by 15 pops
of electronic flash

4

Mixing Time and Flash

Playing with Time in the Same Frame

Flash provides another way to control time in your photographs, but instead of collecting all that happens in front of the camera over a long duration, it produces a quick burst of light. Regardless of the level of brightness, flash can adequately expose a scene, as long as the subject is within range, and freeze the action too. But it does more than simply provide light: It can also override ambient illumination with a predictable color balance.

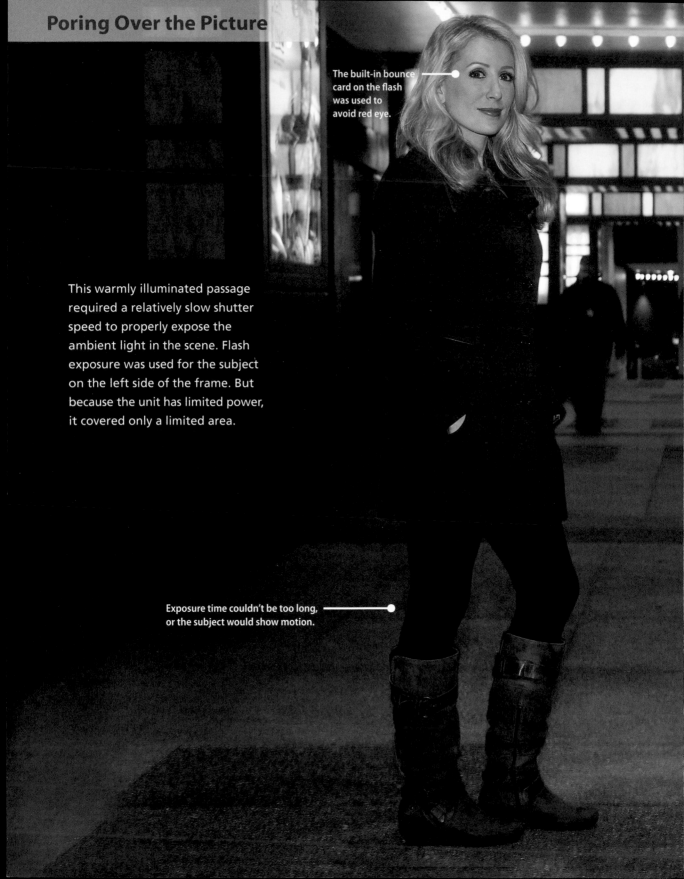

The built-in bounce card on the flash was used to avoid red eye.

This warmly illuminated passage required a relatively slow shutter speed to properly expose the ambient light in the scene. Flash exposure was used for the subject on the left side of the frame. But because the unit has limited power, it covered only a limited area.

Exposure time couldn't be too long, or the subject would show motion.

The overall scene lacks sharpness, mostly because of the slight blur from handholding the camera, but that doesn't matter because the subject is in focus.

This scene required a slightly long exposure time to expose the ambient light, but the camera was handheld because the flash would freeze the action of the main subject.

The image has a warm and a cool tone. White Balance was set to daylight at (5500 K) so the ambient light renders warmer, and the flash exposure has a slightly cool tone. Portraits tend to need a warmer tone than normal.

Canon 6D • ISO 100 • .3 sec. • f/6.3 • Canon 50mm lens • Canon Speedlite 580EX Flash

A Halloween prank done in the dark was transformed into a compelling image by using a long exposure and manually painting the scene with flash.

Walking around the scene with a powerful flash unit and firing off pops to cover the foreground provided illumination to an area that was otherwise dark.

Because the streams of toilet paper were white, it did not take much light to expose the trimmings.

Nine pops of flash were fired throughout the scene.

Stopping down the lens on an ultrawide-angle lens allowed for an expansive view and depth of field.

The 30-second base exposure provided sufficient illumination for the background traffic light and light trails from passing cars.

Canon 6D · ISO 100 · 30 sec. ·
ƒ/22 · Sigma 18mm lens ·
Canon Speedlite 580EX Flash
popped nine times

On the creative front, you can combine flash with long exposure, both stopping and collecting time, respectively, in the same picture, which can lead to some compelling imagery. If you're feeling blue, or perhaps green or red, you can place a colored gel over the flash to change the hues in the scene. If you're thinking a bit more on the scientific side, why not set the flash to fire multiple bursts (using a unit that supports this feature) to capture the subject in several stages of motion. Or perhaps set the camera on a very long exposure and "paint" the scene with colored light.

Unfortunately, flash is not some easy-to-use magical device. Although it provides a great deal of flexibility, it's not always the most cooperative tool in your camera bag.

To help communicate more effectively with flash, this chapter gives you some information, advice, and tips on using it to your advantage in a variety of situations.

Electronic Flash Basics

In its most basic form, electronic flash provides a portable burst of light at a very quick rate. The average flash unit goes off anywhere from 1/500 of a second to a 1/35,000 of a second or faster (depending on the model and mode.) That's enough to expose a dimly lit subject and freeze the action of a moving one. The actual intensity of the burst and its subsequent range of coverage depend on the model and its strength, yet even the most basic flash units (including those built in to the camera) provide enough power to light a subject. The actual power of a flash unit in terms of coverage and range uses a unit of measurement known as the *Guide Number* (see the "Guide Number" sidebar).

Obviously, a separate unit, the kind mounted on a camera, offers more features and power, and of course, a higher Guide Number. Clearly, it's more effective than the camera's built-in flash unit. And yet, that doesn't necessarily make one easier to use than the other.

Guide Number

The power of a flash unit is determined by its Guide Number (GN). The higher this value, the more power the flash can emit. Although the GN was at one time part of a crucial formula for setting your camera to properly expose the scene, these days it's been relegated to simply differentiating each particular flash model. But back in the days of film when cameras were less electronic—and there was no way to preview the scene—flash photography required much more finesse. Sometimes you used a Polaroid to get an idea of the result, but for the most part you waited for the film to come back from the lab and hoped for the best.

Flash photography has become easier over the years because you no longer need to manually calculate its output. Currently, most flash units work in conjunction with the camera's metering system to automatically adjust the output of light (**Figure 4.1**). But even the integration of the two doesn't always ensure a perfect result for a variety of reasons, which include: the direction of light coming straight toward the subject and the flash unit sharing the same axis as the lens, which occasionally leads to red eye, either because you were too close to the subject or the unit was too strong. Sometimes the best flash photography shows the least evidence that flash was used.

Figure 4.1
WIndee Airedale was captured using the camera's pop-up flash before attending a formal kibble dinner.

Canon T2i • ISO 800 • 1/60 sec. • *f*/4 • Canon 50mm Macro lens • Pop-up flash

Advanced Flash Unit Features

The newest models of the electronic flash unit have evolved to provide the perfect complement to today's sophisticated Digital SLR cameras. These tools have come a long way since the old days when flash exposure was independent of the camera's automated or Through-The-Lens (TTL) functions. Back then you set the power output on your flash—perhaps after doing some math with subject distance, ISO, and Guide Number—and crossed your fingers.

But flash units have greatly improved since those very technical, yet trial-and-error based days.

Here are some of the features you'll find on flash units now:

- **TTL flash metering:** Whether the manufacturer calls it iTTL, eTTL, or whatever letter precedes TTL, Through-The-Lens (TTL) flash metering produces more accurate output because it measures the light in the scene directly through the lens. Early models used a sensor on the flash, which could be fooled by elements outside the frame, as shown in **Figure 4.2**.

- **Exposure compensation:** Even with TTL, you can fine-tune flash output by increasing or decreasing output by 2–3 stops (depending on the unit). This allows you to tweak exposure more effectively, especially when combining flash with long exposure.

- **AF assist beam:** When you're shooting in low-light conditions, sometimes not enough light is available to focus the scene. But now this is not a problem. Some models provide a built-in assist beam to help determine focus in dark or low-lit areas.

- **Slave ability:** This flash unit mode lets you trigger one or more flash units positioned in the scene based on the burst of your main flash. You can even hold the camera-mounted flash with one hand and the unit set on Slave in the other to provide fill light.

- **Movable flash head:** Although a movable flash head is not a new feature, it has seen some improvements. With it, you can tilt the head upward to bounce light from a surface above the scene, and some let you swivel the head to either side to reflect light from a wall. Many also include a slide-out bounce card.

- **Filter holder:** Regardless of the lighting conditions, flash output matches the color balance of daylight, which is 5500 K. But you can match the color temperature of ambient light by using the proper filter.

- **Wireless capability:** With wireless capability, you can remotely trigger one or more flash units positioned away from the camera when you press the shutter.

Figure 4.2
The subject was in shadow under a scaffold for this portrait set against the colorful light trails of passing traffic. By setting the flash to -2 stops, I was able to make the setting appear more natural. The only giveaway is the light reflecting in the woman's sunglasses.

Nikon N90s • ISO 100 • 4 sec. • ƒ/8 • Nikon 35–70mm lens • Nikon SB-26 Flash

Reasons for Using Flash

Bringing light to situations that have none or very little of it is the most apparent reason for using flash. But it's not the only one. Numerous reasons exist that range from the necessary and the practical to the scientific and the creative. Some are serious for creating the most compelling imagery, whereas others are handy for the silly snapshots, as shown in **Figure 4.3**.

Figure 4.3
If the question of what to do with a watermelon after scooping it out arises, taking a whimsical approach and carving it into a mask is one option. This melon head was captured with the pop-up flash on a DSLR.

Canon 20D • ISO 200 • 1/60 sec. • ƒ/2.5 • Canon 50mm Macro lens • Pop-up flash

Flash Sync Speed

Flash sync speed is the maximum shutter speed at which the camera can capture a flash exposure without one of the curtains closing fully, leading to the darkening of an area of the photograph. Many flash units sync at 1/250 of a second; others are as slow as 1/60 of a second. So if your camera is set on a high shutter speed, you'll see a dark area somewhere on the image. Many newer camera models simply override the high shutter speed to eliminate this image defect.

Consider the following as to when to use flash:

- **Bring light to dark areas:** As previously mentioned, adding light to unlit areas is the most common reason for using flash. No matter how dark the scene, as long as the flash burst reaches the distance to the subject, it can even illuminate a piece of coal in a pitch-black cave. Of course, more practical uses include exposing people in indoor situations or a stationary subject in low-light conditions.

- **Stop action of a moving subject:** If you want to freeze action and illuminate it at the same time with a bright burst of concentrated light, flash can do that for you too. Of course, the subject must be in range to reap the full stopping power. Also, make sure the shutter duration doesn't exceed the flash sync speed (see the sidebar "Flash Sync Speed").

- **Correct color balance:** More realistically, flash provides a predictable color temperature by over-powering the existing ambient illumination. Flash produces a color temperature similar to daylight, which comes in handy when you're shooting a subject in unflattering illumination (**Figure 4.4**).

- **Create special effects:** Even though you don't always need a flash unit with sophisticated features to be creative, it does provide more options. Depending on the model you use, you can produce a variety of effects, including multi-flash, which allows you to capture the subject in various stages of motion; rear curtain synchronization, which fires the flash at the end of a long exposure as opposed to the beginning (see the section "Rear Curtain Sync"); and color filtering in which you use a holder for colored gels for correction and creative purposes.

- **Mix flash with long exposure:** Use flash with a long exposure to balance a portrait with the background, mix color from flash and artificial light, and paint with flash.

Figure 4.4 This New York Giants fan celebrates his team spirit on a cool night. The artificial lighting is relatively bright, but it has a dominant reddish colorcast. Flash provides the subject with a normal color balance.

Canon T2i · ISO 1600 · 1/60 sec. · ƒ/4 · Canon 24–105mm lens at 45mm (equivalent to 72mm) · Pop-up flash

On-Camera Flash

It doesn't matter if you have a pop-up flash on your DSLR, a built-in flash on a point-and-shoot camera, or whatever that burst of light coming from your smartphone is called, the direction of illumination will basically be the same. Each flash will get the job done, but it's not always perfect. Even when you're using a feature-rich unit mounted atop the camera, it still exposes the scene with direct illumination, and that's not always the most flattering light. Why?

Because the flash hits the subject head on, it creates a number of issues, including harsh light, washed-out illumination, and a disparity between the areas it doesn't reach. When the scene is rife with blown-out highlights and detail-less shadows, they create a high-contrast ratio that makes the photo lack dimension, and it's not very appealing.

Another issue occurs when the flash is too close to the axis of the lens, which increases the possibility of red eye. Still, it's hard to beat camera-mounted flash because it's easy to take advantage of, especially when you want to grab a quick snapshot (**Figure 4.5**).

Figure 4.5
On-camera flash is great for snapshots, because the moment of capture can sometimes carry as much weight as the aesthetic.
Canon T2i · ISO 800 · 1/60 sec. · ƒ/4 · Canon 24–105mm lens at 47mm (equivalent to 75mm) · Pop-up flash

Dealing with Red Eye

That possessed look of people in some pictures has plagued photographers ever since the flash unit was introduced. Red eye is not solely a problem of on-camera flash; rather, it occurs when the flash, lens, and subject's face converge on the same axis. When that happens, light reflects from the retina in the subject's eyes, producing those darting red pupils (**Figure 4.6**). Some cameras and flash units have red-eye reduction modes. You can also correct the problem in Photoshop or another image editing application.

But you can prevent red eye from occurring by trying the following techniques:

- If you're shooting close to the subject, avoid having the subject look directly in the lens.

- Bounce the flash. (See the next section for an explanation of how to do this.)

- Use an off-camera flash.

Figure 4.6 The built-in flash on many cameras sits very close to the lens and will cause red eye when in line with the subject.

Nikon 5000 • ISO 100 • 1/60 sec. • ƒ/2.8 • 28mm lens

The Effectiveness of Bounce Flash

Some camera-mounted flash units allow you to change the direction of the light source. By positioning the head away from the subject and onto an area where it can reflect and hit the subject with softer, more directional light, you're able to use the flash mounted on your camera more effectively (**Figure 4.7**).

Figure 4.7
This classic portrait was simply illuminated by bouncing the on-camera flash off the white ceiling at a slight angle.

Canon 20D • ISO 100 • 1/60 sec. • f/8 • Canon 50mm lens (equivalent to 80mm) • Canon Speedlite 580EX Flash

Bouncing the flash greatly increases the quality of illumination from your on-camera flash by softening the light and spreading it out. Of course, this technique does have its limitations: one of which is not having a place to bounce that light. Bouncing prevents the flash from spewing the light as much as it redirects it for a more flattering rendering of the subject.

Bouncing flash off a ceiling or wall does require extra flash power, but the results are well worth it.

Consider the following bounce flash tips to bounce flash effectively:

- Tilt the flash at an angle that will effectively illuminate the subject.

- Make sure the color of the bounce surface is neutral (white is always best) because it will affect the color of the flash.

- Ensure that the bounce surface is not too far from the flash so you have enough power to bounce the light onto the subject.

- If a bounce surface is unavailable, you can choose optional flash attachments that redirect and spread the light. These include a bounce-dome diffuser that fits over the flash head; a mini softbox that attaches to the flash; and a light bouncer that redirects and softens output.

Where Do I Bounce Now?

You just have to face the fact that you won't always have a surface to bounce the light, especially when you're shooting outdoors. You certainly won't be able to bounce the light from a ceiling. But you can still bounce the light using a bounce card to redirect the light from the subject. Some advanced camera models include a built-in bounce card that slides out, such as the one I used in **Figure 4.8**. But don't worry if you don't have one. You can just attach a white card to the flash using a rubber band to hold the card in place.

Off-Camera Flash Works Really Well

Using flash away from the camera provides a more effective means of lighting a scene. It allows you to change the direction of light to come in from the side, which is always more flattering to the subject (**Figure 4.9**). You can use the flash in several ways, but the most basic way involves using an accessory cable that plugs into the camera's hot shoe and onto the flash. You can either use a bracket (a device for holding the flash off-camera) or simply handhold the flash to create beautiful lighting that may not resemble flash at all.

Figure 4.8
When you're shooting outdoors, it's hard to find a place to bounce the light. Fortunately, this flash unit had a slide-out card.

Canon 6D • ISO 100 • 1/13 sec. • ƒ/1.8 • Canon 85mm lens • Canon Speedlite 580EX Flash

Figure 4.9
Holding the flash away from the camera allows you to produce a more flattering, dramatic illumination.

Canon F1 • ISO 200 • 1/30 sec. • ƒ/11 • Canon 24mm lens • Vivitar 285 flash held off camera

Balancing Flash and Ambient Light

Previous chapters covered the effect of long exposure to capture a dimly lit scene, and this chapter shifted gears to cover the importance of using flash for illuminating darker subjects with a quick burst of light. Now it's time to put this dynamic duo together. When done correctly, magical things can happen because the image is captured over two different time planes within the same scene: one very quick and the other slower. The trick is to get the long exposure and flash burst of light to work together in harmony. How you do it is in information you'll find in the proverbial section on "easier said than done."

Making these two techniques come together begins with understanding the factors that control each one. Flash exposure is dictated by the aperture setting with little effect from shutter speed. Conversely, ambient exposure (the natural light in the scene) is controlled by shutter speed duration. It has little impact because the flash already produces a quick burst of light, so duration doesn't play much of a part in affecting exposure.

For example, if you were shooting a portrait that was properly exposed at an aperture setting of f5.6, changing the shutter would just affect the areas not covered by the flash. One exception is if the shutter speed creates "more" exposure than the flash.

Adjusting shutter speed provides a great means for balancing exposure, as shown in **Figure 4.10**. So, find an aperture setting that works with the flash exposure, and then adjust the shutter duration to expose the ambient (natural light) part of the scene.

Figure 4.10
Although this image looks natural, this uniquely composed portrait depended on balancing the flash and ambient exposure. Once I established the aperture setting for the flash exposure, I chose a matching shutter speed for the illuminated sign in the background.

Canon 6D · ISO 100 · 1/15 sec. · f/1.8 · Canon 85mm lens · Canon Speedlite 580EX Flash

Get a Good Reading of the Scene

Understanding how to control flash and adjust for ambient light in the scene provides a good start to a successful photograph but still requires a little trial and error. Unfortunately, some situations leave little time to plan. The next time you need to balance flash and long exposure, consider the following suggestions:

- **Shoot on Manual:** You don't want any surprises affecting exposure or fluctuations from passing light, or something else that might affect exposure.

- **Test flash exposure:** Use a middle aperture setting, anywhere from f5.6 to f11, to see if that properly exposes the subject. You don't want to overexpose with flash. It's best to have a little less exposure than a little more.

- **Adjust ambient exposure:** Use the camera as a light meter to measure a middle tone in the scene. Because the aperture is already set for flash, adjust exposure by changing the duration.

- **Take a test image:** Once you have an idea of the exposure in the scene, take a test exposure and then make adjustments.

Use a Tripod or Not?

Normally, you mount your camera on a tripod to capture a long exposure; doing so and using a flash provides more flexibility. But there's nothing unusual about handholding the camera when you're using flash. It's also possible to handhold a long exposure with flash to create a sense of motion. Usually, anything but a fractional exposure time requires that you mount the camera on a tripod, unless you want to blur motion, either accidentally or intentionally. However, when you want to shoot action scenes, you can use a high shutter speed to freeze the action (along with flash), as shown in **Figure 4.11**.

Figure 4.11
When you want to freeze action, using a high shutter speed along with flash produces the scene without any motion blur. Because it was relatively dark and I handheld the camera, I also used a higher ISO setting to capture the diver in midair.

Canon 6D • ISO 1250 • 1/125 sec. • ƒ/11 • Canon 24–70mm lens at 50mm • Canon Speedlite 580EX Flash

Mixing flash and long exposure provides a creative alternative when the camera is hand-held, allowing you to create a more exaggerated sense of motion. Of course, if you want the background to be crisp and sharp or maybe rendered as a subtle blur through selective focus, then by all means use a tripod (**Figure 4.12**).

Figure 4.12 **This family photo mixed flash and long exposure by mounting the camera on a tripod and using the self-timer. Because the ambient portion of the scene needed a longer exposure time, you can see a slight motion blur around the subjects.**

Canon 20D • ISO 100 • 2 sec. • ƒ/7.1 • Canon 20–35mm lens at 27mm (equivalent to 43mm) • Pop-up flash

Not All Flash Exposures Are Created Equal

Even the most remedial knowledge of flash photography is rooted in understanding that the operation consists of turning on the flash unit, pressing the camera shutter, and having a burst of light illuminate the subject. It's a safe assumption that the flash will go off immediately—at least that's how it works by default. Some advanced model flash units include a mode that will fire the flash at the end of the exposure. Although when the flash goes off doesn't sound like that big of a deal, the two are noticeably different, especially during a long exposure. That's not to say one is better than the other, yet each has a special purpose. It's important to understand how each one captures the subject.

Dragged Shutter Flash

The dragged shutter flash effect blends the ambient and flash exposure in the same frame, with the burst coming at the beginning of exposure and the shutter continuing to collect light into the scene after the flash goes off. It's not the kind of thing you would normally think about, because we tend to think of the flash going off during a fractional exposure; so within a blink the entire process is complete. But when exposure duration goes on for a bit longer, the flash fires and freezes the action, but exposure continues to collect in the picture along with any motion in the scene. This is the reason the dragged shutter flash technique works best with nonmoving subjects (illuminated by flash), such as portraits or stationary objects in the scene. Even when a partially moving object is frozen with flash, the object will show a motion (as an outward motion). By no means should this dissuade you from using this technique with moving subjects—either to exaggerate the effect of motion blur (**Figure 4.13**) or create a "softer" sense of motion (**Figure 4.14**) with a slower moving subject and faster shutter speed.

Rear Curtain Sync

In rear curtain synchronization mode (also known as *second curtain synchronization*), the flash fires at the end of a long exposure just before the second curtain closes. That makes it ideal for capturing moving subjects with flash during a long exposure. By setting the flash to rear curtain sync, you can capture the ambient parts of a scene and subject movement before the flash fires, producing a more fluid rendering of motion. Flash going off at the end of exposure can eliminate the awkward blur by freezing the subject at the end of exposure after it has moved through the scene. The effect can also convey a sense of speed, as shown in **Figure 4.15**.

Figure 4.13
This rendering of the early morning commuter rush consists of both motion and frozen action. I handheld the camera while trailing behind the pack.

Olympus D-40 • ISO 100 • .5 sec. • ƒ/3.8 • Olympus 35mm lens • Built-in flash

Figure 4.14
Although the exposure was too long to handhold the camera, the exposure was still relatively short, so the flash captured the color and motion of this party scene without creating an extreme motion blur.

Nikon 5000 • ISO 200 • 1/4 sec. • ƒ/4 • Nikon 28mm lens

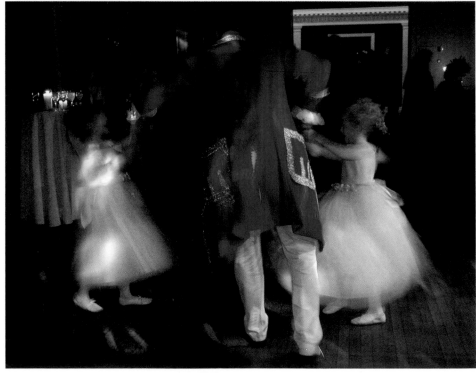

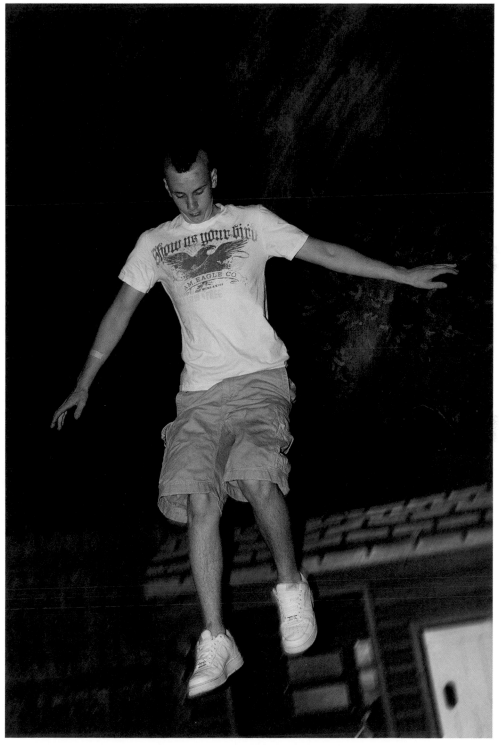

Figure 4.15
In this situation, the rear curtain synchronization works effectively by conveying a fluid sense of motion during the long exposure of Anthony jumping off a play-house roof.

Canon 20D • ISO 1250 • 1 sec. • ƒ/6.3 • Canon 20–35mm lens at 56mm • Canon Speedlite 580EX Flash

The Long Exposure Portrait

In many ways, taking a portrait at night can feel like a hybrid version of studio photography. Both offer active control when it comes to illuminating the subject. Whether portrait photography occurs in the studio or out in the field, flash illuminates the subject exactly the way you want. But unlike studio photography, photographing people over a long exposure time can also add a passive element to the image.

Although capturing the ambient portion of a scene makes the photograph more interesting, it also consists of variables out of your control. These include objects you can't move, light sources you can't control, and elements moving through the scene. But maybe the latter is not a bad thing, especially when it comes to the colorful rendering of taillights from passing traffic (**Figure 4.16**).

Figure 4.16
Taken on a busy street, the subject remained stationary as the shutter stayed open long enough to capture passing traffic.

Canon 20D • ISO 400 • 2 sec. • f/9 • Canon 20–35mm lens at 35mm (equivalent to 32mm) • Canon Speedlite 580EX Flash

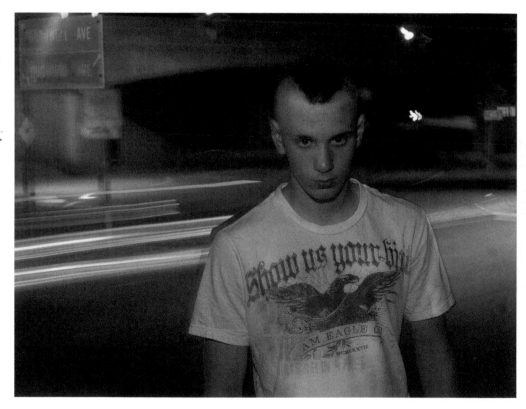

Filtering Flash

The many reasons for putting a colored filter over your flash head range from corrective to creative. Understanding why you would do this begins with understanding the basic output of flash, which produces a color temperature similar to daylight, or 5500 K.

As mentioned in the previous chapter, artificial light situations vary in color temperature, and at times you might want to override the colorcast on the subject illuminated by flash. Unfortunately, it doesn't mean the ambient part of the scene will match the color balance. For example, you can balance a tungsten scene by setting the camera's White Balance in the 3200 K range (tungsten, or indoor lighting) and using an orange gel over the flash. Not only do the setting and the gel correct the colorcast, but they also provide a uniform balance throughout the image.

You can also have some fun with colors that are not normal to the scene by placing filters over the lens. Place a green or red filter over the lens to make the subject that color. In addition, you could paint the scene with flash by using a long exposure and coloring the scene with pops of flash using different filters (**Figure 4.17**), as mentioned earlier in "Poring Over the Picture."

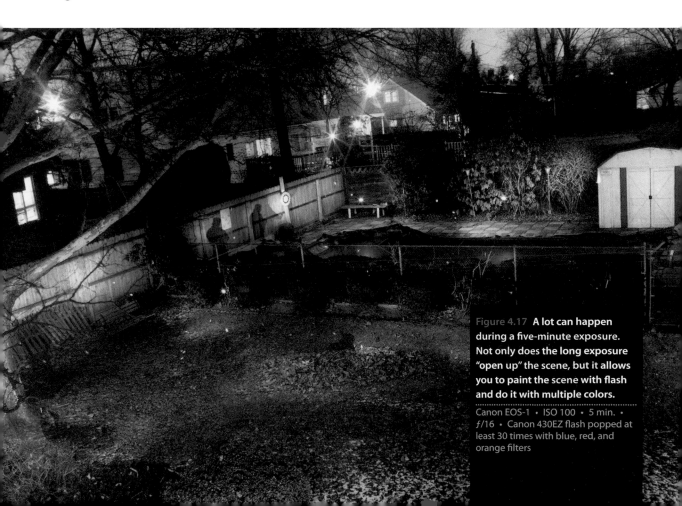

Figure 4.17 **A lot can happen during a five-minute exposure. Not only does the long exposure "open up" the scene, but it allows you to paint the scene with flash and do it with multiple colors.**

Canon EOS-1 • ISO 100 • 5 min. • f/16 • Canon 430EZ flash popped at least 30 times with blue, red, and orange filters

Fun with Multiple Flash Exposure

Flash units have limited power and range. We've all seen those special moments at sporting events when hundreds of flashes are going off. None of them will reach the player on the field, and few will go beyond ten feet, but when they do, the area of coverage will be fairly narrow. That works well in most situations but not when you need to cover a wide area. Sometimes you can remedy the problem by using multiple flash units; other times you can use long exposure and manually pop the flash in different parts of the scene. And if you use multiple flash pops, some flash units will fire several in succession to freeze the subject in multiple phases of motion in the same scene.

Repeating Flash in the Same Exposure

Some of the more advanced flash units enable you to create a stroboscopic effect by firing off the flash multiple times within a single exposure, allowing you to capture the subject in various stages of motion (**Figure 4.18**). Here's how it works: You determine the number of flashes and the duration between each burst (which range from 1 Hz to 50 Hz or more), as well as the strength of illumination.

Figure 4.18
This diving scene was captured in three stages by setting the flash at ¼ power at 3 Hz, producing three flash bursts that went off in succession during a one-second exposure.

Canon EOS-1 •
ISO 200 • 1 sec. •
ƒ/5.6 • Canon
20–35mm lens at
20mm • Canon
Speedlite 430EZ Flash

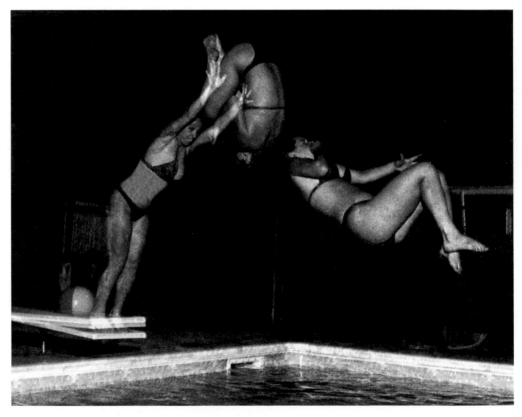

The following tips can help you repeat the flash in the same exposure:

- **Determine when the subject will begin and end the action:** This technique generally fails because multiple flash pops occur when the subject is passing through its own motion. So try to figure out where the subject's motion begins and ends, and how long it will take to get there. Doing so will lead to an effective multiple flash image.

- **Compose the subject so flash doesn't overlap:** Exposure level increases each time the flash is exposed on the same subject, so if not done evenly, part of the scene will receive more exposure.

- **Use a long exposure:** Make the exposure long enough to capture the subject's action from start to finish. For example, if the routine takes two seconds, make sure the exposure is that long.

- **Limit power:** You don't always need a lot of power to expose a scene, especially when you use flash units that have lots of power and fast recycling times. Turning the flash unit down to ½ or ¼ power allows you to recycle fast enough for situations that require multiple bursts.

- **Be conservative:** Use the minimum number of flash pops to avoid some of the problems that would occur due to overlapping. A good measure is to use three flash pops. Sometimes, too many pops of flash create distractions in the image.

The Father of Electronic Flash

The man who invented the electronic flash, Dr. Harold Edgerton, based the foundation of his invention on stroboscopic photography. The MIT professor experimented with multiple strobe effects on a single frame of film. Current flash technology has put this multi-flash feature on many high-end units, allowing the novice to capture some very compelling effects.

Manually Popping Flash

When you take the flash off the camera, place the camera on a tripod, and set the camera on a long exposure, you can then walk though the scene and manually fire off bursts of light in all the desired places. This technique works great in wide, dimly lit areas, as well as for a few creative applications (**Figure 4.19**).

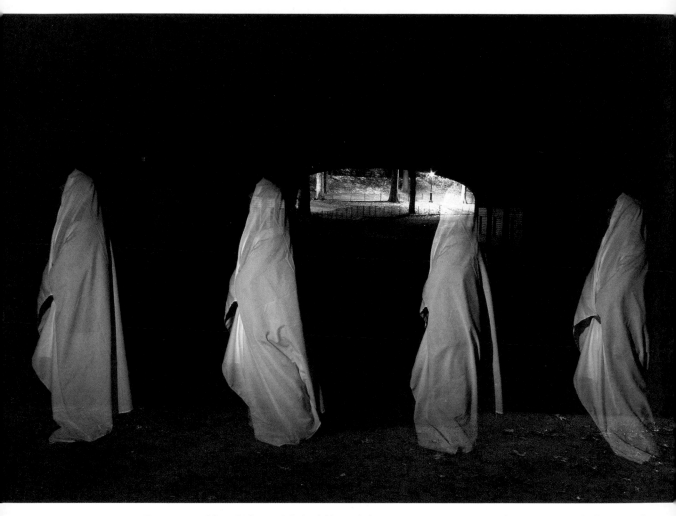

Figure 4.19 Although these might look like real ghosts, one person wearing a sheet was manually illuminated by a burst of flash every couple of steps. Because the image was shot as a long exposure in a relatively dark area, the ambient portion of the scene did not affect the burst.

Canon 20D • ISO 100 • 30 sec. • *f*/8 • Canon 20–35mm lens at 20mm (equivalent to 32mm) • Canon Speedlite 580EX Flash

Chapter 4 Assignments

Try Bouncing Flash

One reason flash photography can look boring is that it dominates exposure by blasting the subject head on. But it doesn't have to be that way. Instead, you can bounce the flash (using an external model with that capability) to get a unique rendering of a scene. You can bounce the flash off an overhead ceiling or pivot the head to the side and bounce the flash off a wall. If no ceiling or wall is in sight, just use a bounce card to produce a similar effect as well as add dimension to the image.

Create Random Images with Long Exposure and Flash

Combining flash with long exposure allows you to produce one-of-a-kind situations in every photograph. The reason is that you're dealing with various random elements in the scene that can work to your advantage. Take a portrait against the backdrop of moving traffic; photograph a subject on a moving vehicle to capture a blurred background; or illuminate a stationary object in front of a fireworks display. Regardless of how many frames you expose, each one will be unique due to the variables of moving objects. And when you consider facial expressions, the possibilities for originality in each frame become endless.

Capture Motion with Flash

Experiment with capturing motion with your flash unit during a long exposure. Even a one-second exposure time will freeze the subject illuminated by the flash and show some motion during the ambient part of the exposure. If you're using a more sophisticated flash, try capturing the subject with the flash set on the default setting (first curtain sync) and then switch to rear curtain sync (second curtain sync) to compare and contrast the difference.

Set the Camera on B and Pop Flash Manually

Another fun way to play with long exposure involves setting the camera on the B setting and manually "painting" the scene with flash. You can capture a subject moving through the frame in various positions. Or perhaps get creative and put different colored gels over the flash head to make a colorful rendering of the scene.

Share your results with the book's Flickr group!
Join the group here: flickr.com/groups/timelapse_longexposure_fromsnapshotstogreatshots/

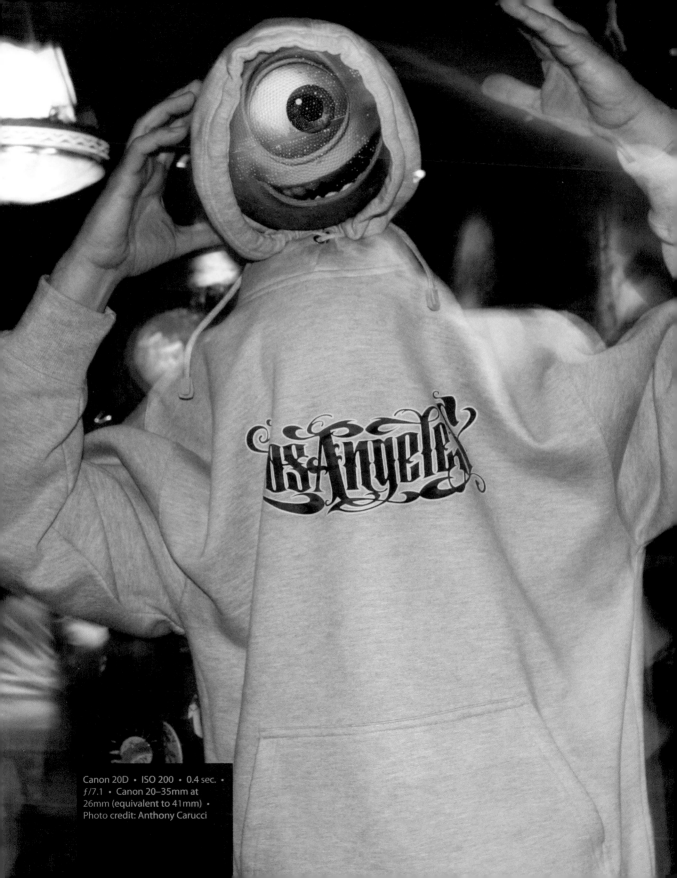

Canon 20D • ISO 200 • 0.4 sec. •
f/7.1 • Canon 20–35mm at
26mm (equivalent to 41mm) •
Photo credit: Anthony Carucci

5

Having Fun with Time Lapse

The Basics Behind Making a Time Lapse Sequence

Somewhere between still photography and a moving image lies the time lapse sequence. This sped-up version of a movie allows you to control a cinematic universe by capturing action in a fraction of the frames and then playing it back at normal speed, making it appear as though life is zipping by. Although these unique segments can take on various appearances, at their most basic they're presented as the opposite of a slow-motion sequence. In a time lapse sequence, what the viewer sees in a matter of seconds or minutes are actions that possibly took hours or days to occur.

Poring Over the Picture

Captured at one frame every .5 seconds: Slow moving traffic doesn't show much change.

 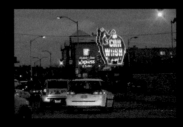 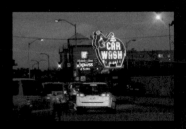

One frame every second: The action moves a little faster but is still a bit slow for the speed of the action.

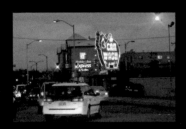 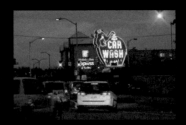 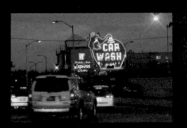

One frame every two seconds: At this rate, it's possible to capture a different car in each frame.

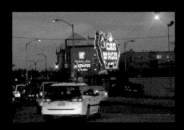 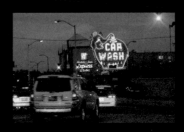 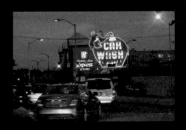

One frame every four seconds: Although the cars move a little faster through the frame, this rate allows the viewer to see the sign rotate.

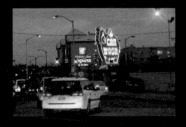 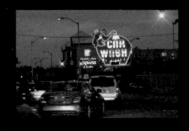

Sometimes a time lapse captures a few frames over a short period of time; other times those frames are captured at much greater intervals. These four image sequences show the effect of capturing the same scene at different intervals.

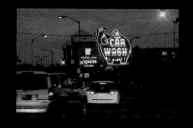 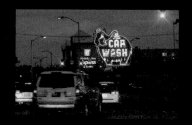 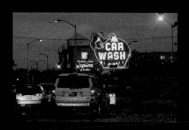

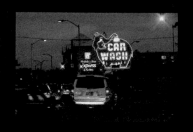 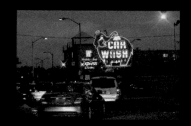 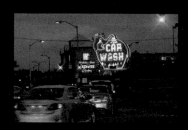

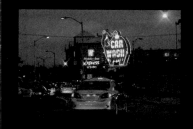

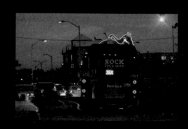 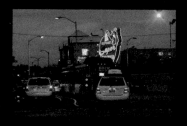

Canon T2i · ISO 800 · 1/30 sec. · f/5.6 · Canon 50mm lens (equivalent to 80mm lens)

Because time lapse photography can take hours or longer, it's important to control the situation as much as possible. That means properly calculating the duration, having the appropriate equipment, and keeping the camera and tripod free from vibration.

Turn off image stabilization.

Enable mirror lockup to reduce vibration between each frame.

Remove the camera strap to prevent any unnecessary motion.

Tape cables to prevent them from dangling and possibly causing vibration.

Do not raise the center column; it limits stability over a longer period of time.

Tighten the tripod legs so they don't move during a long exposure.

Properly set the tripod feet. Many models allow you to use spikes for soft ground and rubber for harder surfaces.

Canon 6D · ISO 500 · 5 sec. · f/22 · Canon 20–35mm lens

The Time Lapse Sequence

We've all seen that time lapse film of a sprout that transforms into a budding flower or that building demolition segment that unfolds in seconds yet takes place over an extended period of real time. Those are classic examples, but time lapse photography goes beyond the clichéd examples of time passage movies and can cover a much shorter passage of time.

Not every situation needs to be exotic; you can make time lapse movies of just about anything—from a visit to a supermarket to a walk in the park. You can even shoot stars in the night sky, as shown in **Figure 5.1**.

Figure 5.1
Scenes like this clear sky shot through the forest make an ideal setting to capture a time lapse of star trails.

Canon T2i · ISO 1600 · 30 sec. · ƒ/2.8 · Canon 20–35 mm lens at 20mm (equivalent to 32mm)

Regardless of whether you prefer to shoot a series of still images put together as an animated film using a built-in mode or manual experience, you need to know several details about the time lapse technique. Thereafter, you can upload your time lapse movie to your website, post it on your preferred brand of social media (**Figure 5.2**), create a stand-alone movie, or make the movie part of some bigger project.

Figure 5.2
This screen shot of a time lapse sequence was posted on Instagram using a hashtag to let anyone looking for time lapse find it easily.

Understand the Movie to Master the Time Lapse

Whether shown on a big screen, a small screen, or the wall next to the screen door, it's apparent that we love watching movies. Ever since the dawn of cinema more than a century ago, audiences have been drawn to motion pictures (**Figure 5.3**).

By definition, a movie consists of a collection of single images played in succession. Sound familiar? It should, because that's also the description of a time lapse sequence.

Figure 5.3
This image is a composite of a movie projected on the screen at a packed drive-in theater.

For nearly 100 years, movies have been shown at a frequency of 24 frames per second (fps) to project the film, whereas video uses a rate of 29.97 fps, but more on that shortly. Due to a condition known as *persistence of vision*, our eyes retain the last image they see after it passes the screen, which creates the illusion of motion and allows us to enjoy the cinematic experience.

Playback Speed Makes the Difference

Understanding the basics of cinema helps put the time lapse sequence in perspective. Because a movie is shot at 24 fps and plays back at the same rate it was shot (video plays back at 29.97 fps, or 30 fps to simplify), it will render the time passage of the scene in normal speed.

But what if you shot a movie with the camera set at 240 fps? In fact, some cameras allow you to capture movies at this rate, including some GoPro models. Because the camera would record ten times as many frames (at 24 fps, and eight times at 30 fps) as normal and play at the rate the frames were shot, the movie would play in slow motion (between eight and ten times slower, depending on the camera setting). That means a scene that took six seconds to capture—say a Ferris wheel turning (**Figure 5.4**)—would take up to 60 seconds to play back.

Figure 5.4
The Seattle Great Wheel was captured at night using a long exposure to show the motion of it stopping and starting.
Canon T2i • ISO 100 • 6 sec. • *f*/22 • Canon 24–70mm lens at 40mm (equivalent to 64mm lens)

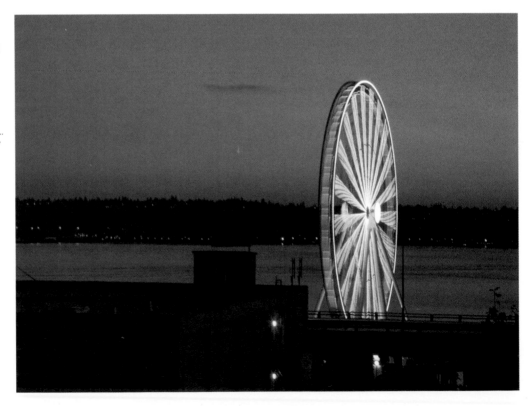

Conversely, if you captured only six frames per second and played it back at 24 fps, the sequence would spin four times faster onscreen. When you consider that time lapse can capture anywhere from a few frames per second to one per hour, you can understand how time lapse affects the passage of time and speeds through the captured frames.

Video Frame Rate

Video cameras capture at 30 fps, or more precisely, at 29.97 fps. Some HD camcorders have a setting for 60 fps, but that's for progressive scan. Others use a cinema setting of 24 fps, and PAL has a frame rate of 50 fps. So when you're editing in your Adobe Premiere Timeline, make sure it's set for the proper frame rate.

Making a Time Lapse Movie

Time is the operative word in time lapse because the movie requires a healthy investment in the continuum to capture the unfolding action in a long exposure image (**Figure 5.5**). But unlike a single frame made up as a collection of time, the time lapse sequence covers the same or greater amount of time as a series of frames captured at preset intervals.

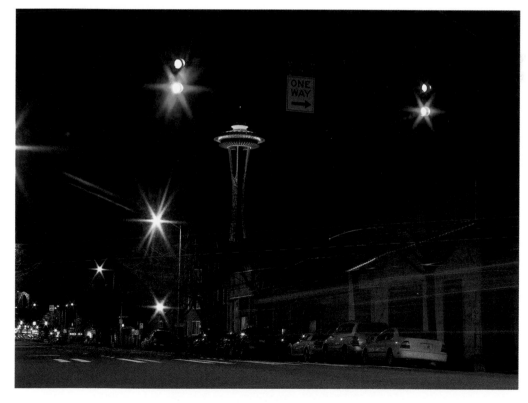

**Figure 5.5
This Seattle street scene was captured as a long exposure time lapse.**
Canon T2i · ISO 200 · 5 sec. · ƒ/16 · Canon 20–35mm lens at 30mm (equivalent to 48mm lens)

Regardless of the intended duration of the movie, you need to shoot the entire action to completion. That means you must wait for the action to finish. In many situations, you don't always have to physically wait, especially if you're waiting for a flower to bloom. That is, unless you have a lot of time on your hands. But when you're shooting scenes such as traffic moving in a busy intersection or fans filling a stadium, you'll want to wait until the action ends. You can even bring a lawn chair and something to help pass the time. Waiting around to capture a time lapse is a small price to pay for a very cool movie. But to maximize your time and effort, you must consider adequate preparation and the proper equipment.

What You Need for Time Lapse

If you're already keen on long exposure photography, then more than likely you have everything you need to produce your time lapse project. The only possible exception is that you might need a more sophisticated remote control cable that lets you select intervals and capture them in succession (see the sidebar "Using an Intervalometer"). Here's a checklist to ensure you have the proper equipment for time lapse:

- **A camera:** Whether you use a smartphone, DSLR, point and shoot, or GoPro camera, you can make compelling time lapse sequences.

- **Digital timer:** Some cameras have built-in timers that allow you to make adjustments; other timers are completely automated, leaving it up to the camera to decide the intervals (you press the button to start, and then press it to stop). Then there are cameras that use a separate timer.

- **Sturdy tripod:** For the most part, sturdy is a relative term. Mounting your GoPro doesn't require the same prerequisites as mounting a full-frame DSLR. Regardless, it's important to avoid any camera vibration.

- **Fresh batteries:** Whether you're using a smartphone or advanced model camera, they all run on battery power. Nothing is worse than losing power on your camera or remote while in the middle of capturing the action. So keep the batteries charged.

- **Entertain yourself while passing the time:** Some time lapse situations take only a few minutes; others last hours, days, or longer. So if you have to babysit the camera, it's not a bad idea to bring something to help pass the time. Read a book, play a video game, or text family or friends to occupy your time.

Using an Intervalometer

Some camera remote controls allow you to capture a set amount of frames in succession by programming them to trip the shutter at preselected intervals. More commonly known as an *intervalometer* (**Figure 5.6**), the remote lets you set the duration you want to capture. But not all come in the form of an optional remote. For example, this feature is built into GoPro cameras and lets you control intervals between half a second and a minute.

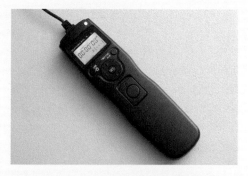

Figure 5.6 An intervalometer for a Canon 6D.

Time Lapse Length

Regardless of how much time it takes for the action to unfold, the playback time of a time lapse movie can range from several seconds to a few minutes and even longer. Entire feature films have also been dominated by time lapse. For example, the 1982 documentary *Koyaanisqatsi: Life Out of Balance* consists exclusively of slow motion and time lapse sequences. Those sequences you create using your smartphone or built-in camera mode tend to be on the shorter side. They capture a few minutes of action and play back for a few seconds. Sometimes they're longer but still relatively brief.

Choosing Your Camera

With advancements in camera and smartphone features, time lapse movies are easier to make nowadays. Although smartphone time lapse is simple and fun to produce, the phones are also limited in control. Conversely, a DSLR provides the most control but is also the most complicated to use when you're making a movie. Somewhere in the middle lies the GoPro. The diminutive, go anywhere camera provides significantly more power in your hands, and you can use it in places where you would never go with your phone, namely in wet places. It also gives you a cool perspective, but it's limited to a very wide view of the scene. If your tastes are more serious, using your DSLR and some old-school methods offer the most control, especially when paired with a sophisticated intervalometer, which lets you capture the scene in precise intervals.

Can your camera handle time lapse? Overwhelmingly, the response is yes. But although all cameras offer the ability to create a time lapse, not all of them do it easily. Theoretically, all you need to capture a time lapse sequence is a few frames shot in succession (**Figure 5.7**) and software that automatically or manually allows you to assemble and play them back. Some cameras offer the simplicity of a specialized mode that lets you select the time lapse feature and start recording. For example, many new smartphones—as well as GoPro cameras—offer a specific setting for capturing time lapse sequences that are point-and-shoot oriented. GoPro provides a bit more control. But to fully manage your intentions for capturing a sequence, the DSLR offers the most camera functions, intervals, and focal length but does require an optional remote to set frame intervals.

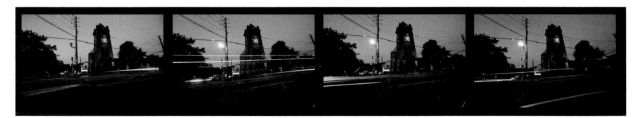

Figure 5.7 This sample of successive frames was captured at ten-second intervals using a GoPro HERO4 Silver.

Time Lapse with Your DSLR

When it comes to serious photography, it's hard to beat the quality and versatility of a DSLR. But although it's not the easiest camera to use to make a time lapse, it does allow you to choose a wide range of accessories that let you carry out every intention of your imagination to create a time lapse.

Here are the benefits of using a DSLR:

- **Much larger sensor:** Whether the camera has a full-frame or a crop sensor, you can capture more detail than with other cameras.

- **Focal length choices:** You can choose a lens that works best for the situation, such as a wide-angle, normal, telephoto, or ultrawide-angle lens, as shown in **Figure 5.8**.

- **Maximum exposure control:** Not only can you fine-tune exposure, you can also change shutter speed, aperture, or a combination of both, all of which allows you to control depth of field, blur, and selective focus.

- **Sophisticated timer options:** Timer options include smartphone apps and remote control cables (as mentioned earlier).

Figure 5.8
This frame was
captured at sunset
using an ultrawide-
angle lens that was
less than 12 inches
away from the cor-
ner of the building.
Canon 6D · ISO 100 ·
1/50 sec. · *f*/3.2 ·
Sigma 14mm lens

Transferring Your Images

After capturing the scene with a DSLR, all the image files reside on a media card, so you need to transfer them to your computer. Due to the overwhelming number of image files, it's necessary to stay organized; otherwise, you'll end up with a mess of files.

Here are some pointers for transferring and organizing your image files:

- **Establish a place to save:** Although it sounds academic, you need to save your files in an organized manner. At the very least, create a folder for time lapse and subfolders for each project. It's best to use an external hard drive specifically for your time lapse projects.

- **Do not rename files:** Numbered by the camera, the images are in sequential order, which makes them easy to arrange by simply clicking the filename or time function in your folders. But if you alter the filenames, all bets are off.

- **Shoot on different cards:** At times you might want to capture the same scene several times, either to change the interval between frames or simply to have a choice of which one to use. That's when it's best to shoot each sequence on a fresh card. Media cards

are cheap enough these days and using several will help you maintain order when transferring images to your hard drive.

- **Reformat your card:** You don't have to reformat a card every time you use it, but it's not a bad idea to do it before shooting an important sequence.

Making a DSLR Time Lapse

Although it's not as simple as using your smartphone or as self-contained as using a GoPro to make a time lapse, with a DSLR you can change lenses, fine-tune exposure, and use a wide range of accessories. When you're looking for quality and control (and not going to get it wet), a DSLR is the best choice.

Follow these steps when making your time lapse movie:

1. **Choose your subject:** Deciding on a subject is the fun part, but you'll need to figure out what you want to capture and how long it will take to show the proper activity. Just about anything that moves can work as a time lapse. It's just a matter of time. For example, the construction of a building could take several months to capture and requires some serious planning. Alternatively, a steady stream of pedestrian traffic can take less than a few minutes (**Figure 5.9**) and can be equally compelling. Once you decide on the subject and calculate a time (see "Calculating Your Time" later in the chapter), you're ready to roll.

Figure 5.9
Because a lot of activity is happening in the scene, you would need only a minute or so to capture a time lapse in this situation.

Canon 6D • ISO 100 • 5 sec. • ƒ/22 • Canon 85mm lens

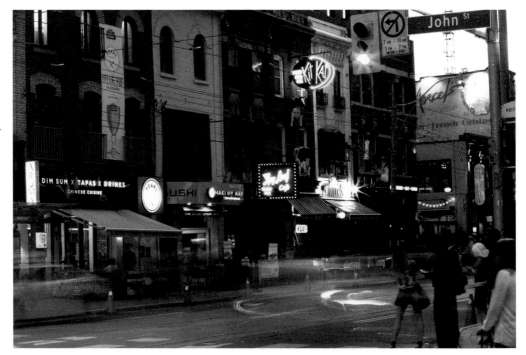

2. **Stabilize the camera:** Most of the time stabilizing means making sure the tripod is steady and free from vibration. But it can also refer to securely mounting the camera on a moving object or even keeping it steady when holding it (although the latter is not recommended for capturing time lapse).

3. **Set the camera for exposure:** Decide on a shutter speed and aperture combination that works for the situation and set the camera on manual. If you're concerned light values will shift too much, try using the Aperture Priority setting, which maintains a consistent aperture by adjusting shutter speed when light values change. It's not perfect, but it's the lesser of the other evil, which is when light values change and the exposure settings stay the same. Or use an exposure setting conducive to capturing maximum depth of field, or selective focus, providing that works for the situation.

4. **Perform a white balance:** There's no sense investing a lot of time in a lengthy time lapse with your DSLR to wind up with an unflattering colorcast. Set the White Balance on a manual setting and check it with a test exposure. Although it's not always perfect, it prevents the camera from analyzing the color of each frame.

5. **Decide on an effective interval:** Set your digital timer (intervalometer) or interval timer. The proper interval between each frame varies with each situation and depends on factors that include the time it takes to complete the action you're capturing, how quickly the action moves through the scene, and your intention. If you're not sure of the interval, see the section "Calculating Your Time" later in the chapter.

6. **Wait for the right moment:** There's no reason to shoot aspects of the scene that are not critical to the movie. Waiting for the right moment requires some degree of anticipation and makes perfect sense. For example, when you're shooting a time lapse of traffic, don't start shooting an empty street with no car in sight. Conversely, don't wait too long and start shooting after the action starts.

7. **Capture the scene as JPEG:** JPEG images process quicker than RAW files and take up less space. Although you can shoot in the RAW format, each file size will be considerably larger than a JPEG and it will take time to process each image after enhancement. As for the image size, you don't need to shoot at maximum resolution, but it's not a bad idea, especially if you want to crop the scene for more effective framing or do any sort of manipulation.

8. **Press the shutter button:** When you start recording, remain close to the camera to make sure it's safe. After the action is complete, you can let the fun begin as you edit your time lapse.

9. **Import your files:** With an abundance of software choices to import your images into, there's a lot you can do with your image files and the movie you'll make.

Dealing with Flicker

Due to the changing nature of light, exposure values can vary at times; the playback produces a flicker-like effect, not much different than what you see in an old movie. The problem with flicker exacerbates when you shoot in an automated mode (like Aperture or Shutter Priority) because it adjusts exposure to match light values in the scene. Instead, it's best to shoot on manual.

Calculating Your Time

After you figure out how long it will take to capture a scene, the next step is to determine the length of the movie. For the most part, when time lapse movies extend past 30 seconds, they lose their zest. You can randomly guesstimate the duration between each frame, or you can determine it ahead of time by using a formula. The latter is far more effective for obvious reasons. Let's say you're trying to create a 30-second time lapse movie of cars filling a parking lot before a big game. You're planning to capture the three hours it takes the lot to fill, but you're just not sure about the duration. If you use the "guesstimate" rate of one frame per second, that would make your sequence approximately six minutes long. And that's more than five minutes longer than anyone wants to watch.

Instead of guessing, use the following formula to calculate the number of frames you'll need:

1. Determine the desired length of the sequence, and then use this formula: (desired duration in seconds) x (frames per second for playback) = amount of frames for playback. So a 30-second sequence that plays back at 30 fps would require 900 frames. That's 30 x 30 = 900.

2. Translate the total time into seconds using this formula: (hours) x (60) x (60) = seconds. A three-hour interval would be (3 hours) x (60 minutes) x (60 seconds) = 10,800 seconds.

3. Divide the time in seconds in step 2 by the amount of required frames you calculated in step 1 to obtain the frame duration: (10,800) / (900) = 12 seconds. To make a 30-second movie, set the digital timer at one frame every 12 seconds and find something to do for the next three hours.

Time Lapse with Your Smartphone

Whether included with the smartphone's set of apps or as a download, time lapse is possible with your phone and is pretty easy too. Just compose the scene, make adjustments to focus and exposure, and tap the Record button (**Figure 5.10**). Record as long as you want, whether it's a minute or an hour.

Figure 5.10
The Time Lapse mode on the iPhone 6.

Both Apple and Android offer apps for recording time lapse. Apple has made it standard on iOS 8 and later, and you can record the scene as long as you want. iOS will alter the intervals based on the length of the recording, so playback is always in the 20–45 second range. The same applies when you're using an iPad to capture a time lapse sequence.

After you've finished recording, iOS saves the image sequence as a self-playing movie, so you can just export it to your computer. Then you can import it into a project, save it, or post it immediately on social media.

Here are some tips for using your smartphone for time lapse:

- **Mount it on a selfie-stick:** Hold the stick and phone steady as you capture the world happening behind you.

- **Place it on a ledge:** Sometimes you won't have a means of stabilizing the camera. In those cases, just prop up the phone on a flat surface and tap Record. Just be careful you don't end up in the shot unless that's what you want.

- **Hold it:** Although it's not always recommended, you can hold your smartphone while capturing the scene. Just make sure you hold it steady and try not to move its view from the main subject.

- **Press it against a window:** Whether you're on a plane or train (**Figure 5.11**), or in an automobile, you can steadily capture the action as you move through the scene or it passes you by.

Figure 5.11
Pressing an iPhone 6
against the window
of a moving train
captured this scene.

November 29 5:03 PM

Using the GoPro for Time Lapse

The GoPro provides considerable versatility with its elaborate set of controls built in to the camera, letting you capture frame intervals that range from half a second to one minute. It can mount almost anywhere on almost anything, and you don't have to worry about the weather conditions. You can even control it from a distance using a remote (**Figure 5.12**) or a smartphone.

Figure 5.12 The GoPro remote control lets you operate the camera from a distance.

The upside of using this mighty little camera is that it lets you get up close and personal with an ultrawide angle of view. But its wide view also has a downside, especially when the subject is not close enough to the camera. But the pros outweigh the cons because the GoPro allows you to capture some very cool imagery. Once you decide on a subject, have a rough idea of the length you want to capture, and have the camera properly mounted, you're ready to make the move, so just do the following:

1. **Put your GoPro in Time Lapse mode.** By default, when you turn on the camera, it's in Video mode. To change it to Time Lapse mode, press the Power button (**Figure 5.13**), which also acts as the Mode button. Cycle through the modes until you reach Time Lapse mode (it's the one with a clock next to the camera). Then press the Shutter—which doubles as the Select button—to activate it.

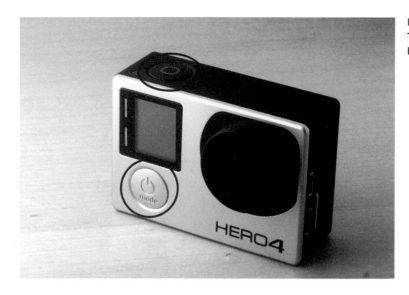

Figure 5.13
The Mode and Select
buttons on the GoPro.

2. **Decide on the proper interval.** If you're using the HERO4 Silver edition, you can make changes on the touch screen panel. For other models, when you press the Mode button, you'll see the default interval setting of .5 seconds. To change it, press the Settings button (**Figure 5.14**); Time Lapse should be highlighted. Click Mode. It will show the last interval setting. Click the Select button to cycle through the choices. When you find the one you want, click the Settings button again.

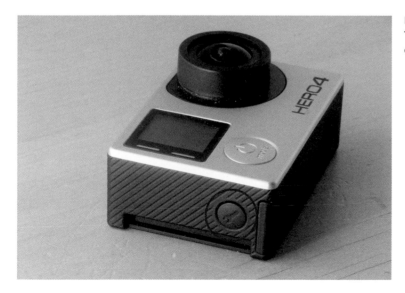

Figure 5.14
The Settings button
on the GoPro.

3. **Press Record.** When you're recording, the display will indicate the number of frames captured, and the red status light will blink each time a frame is captured. You don't even have to touch the camera to record; instead, you can use the optional remote or GoPro App loaded on your smartphone (**Figure 5.15**).

4. **Stop Record.** Press the Shutter button again to stop recording. Once again, you can use the remote or camera app.

5. **Check your sequence.** Although the GoPro captures a series of single frames, it doesn't capture them individually; instead, it saves them as a movie file. This eliminates the need for saving an image sequence that can sometimes consist of thousands of individual frames.

Using the GoPro App

The GoPro App downloads to your smartphone and allows you to control camera modes and settings as well as monitor the scene. This app comes in handy because the camera's diminutive size makes it cumbersome to make adjustments. The app works with the camera's built-in WiFi; you just need to make sure it's activated. A blue light will flash when it's on. You can download the app from the App Store for iPhone or Google Play for Android.

Figure 5.15 The GoPro App on an iPhone

Editing Time Lapse with GoPro Studio

Another great aspect of using a GoPro camera to capture a time lapse is easily converting those image files into a self-playing movie using GoPro Studio software. It's just a free download away at http://shop.gopro.com/softwareandapp.

After transferring the files from your media card to your computer, you're ready to start. Follow these steps:

1. Import the image files. On the left side of the GoPro Studio interface, click the IMPORT NEW FILES blue bar (**Figure 5.16**).

Figure 5.16 GoPro Studio interface.

2. Navigate to the folder that contains the image sequence. Highlight the folder, and click OPEN. The folder will populate the Import Bin (**Figure 5.17**).

3. Highlight the thumbnail, and preview the file in the PLAYER WINDOW. The files must be converted. The process begins by adding the folder to the conversion list. To do so, click the ADD CLIP TO CONVERSION LIST button on the bottom right (**Figure 5.18**).

Figure 5.17 The Import Bin.

Figure 5.18
ADD CLIP TO
CONVERSION LIST
button on the GoPro
Studio interface.

4. The file will reside in the Conversion List (**Figure 5.19**). Click CONVERT on the bottom of the panel. The CONVERT button will change to PROCEED TO STEP 2 (**Figure 5.20**).

5. The work area changes to EDIT. Here, you can export your time lapse, edit it, add effects, or combine it with other converted movies in the timeline. You can click the file in the MEDIA BIN or drag it to the timeline, as shown highlighted in yellow in **Figure 5.21**.

Figure 5.19
The file populates
the Conversion List
on the GoPro Studio
interface.

Figure 5.20 The Conversion List.

Figure 5.21 The video timeline in the EDIT workspace on the GoPro Studio interface.

6. When you've completed your edit, click EXPORT on the top right of the player (**Figure 5.22**), navigate to the folder you want to save the time lapse in, and name the file. The file will save as a self-playing QuickTime movie.

Figure 5.22
The third tab shows the EXPORT button on the GoPro Studio interface.

Using Photoshop to Build a Time Lapse

Dozens of editing programs are currently on the market: some are free; some are not. But you don't need to go much further than Photoshop to construct your time lapse. Here are the basics for setting up a time lapse in Photoshop:

1. **Create a new document:** Don't create just any document but one specific to making a video from a bunch of sequential still images. Select File > New. When the dialog pops up, name your file, unless you think Untitled-2 is cool. With the dialog open, click Presets, and choose Film & Video (**Figure 5.23**).

Figure 5.23 The File New dialog.

2. **Decide on the proper format:** Click Size, and choose the codec that best suits your needs. Choosing DVCPRO HD 1080p/29.97 from the drop-down menu is a common choice (**Figure 5.24**). Click OK and a blank canvas will fill the screen.

3. **Make the timeline visible:** Select Windows > Timeline to view the timeline. Click the Create Video Timeline button (**Figure 5.25**).

Figure 5.24 Film & Choices in the dialog.

Figure 5.25
A blank Timeline.

4. **Add photos:** Select Layers > Video Layers > New Video Layer From File. Navigate to the folder where you saved your images. Highlight the folder to open it. Click the first file, and as long as the files are in sequential order, Photoshop will build a video file that resides as a single layer in the Layers panel (**Figure 5.26**).

5. **Create a Smart Object:** Unless the image files are the same as the frame size you chose earlier, you'll need to resize them by creating a Smart Object. Right-click on the layer (**Figure 5.27**), and choose Convert to Smart Object (**Figure 5.28**).

Figure 5.26 The Layers panel.

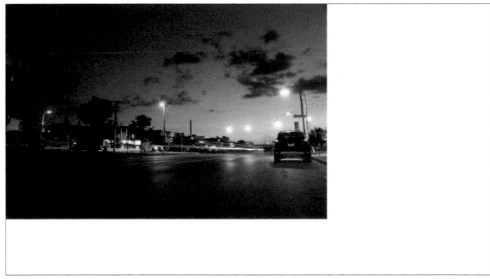

Figure 5.27
Context menu after
right-clicking the layer.

Figure 5.28 Sometimes the image size is smaller than the canvas.

6. **Resize to fit canvas:** Select Edit > Free Transform. Hold down the Shift key and move the anchors until the image fits. You may have to crop the image, as shown in **Figure 5.29**. Press Return to confirm the crop.

Figure 5.29
Changing the size
of the image as a
Smart Object.

7. **Export the file:** Select File > Export > Render Video. The dialog, as shown in **Figure 5.30**, lets you name the movie, select the appropriate folder to save it in, and create a movie file. Click Render: When the render is complete, you'll have a self-playing time lapse movie.

Figure 5.30 Export dialog

Choosing a Video Size

When you create a new document, you'll see many choices for video size. These are consistent with the project in which you want to include the time lapse or ones to import it. Although a lot of options are available, the NTSC and PAL choices cover standard resolution. The set of choices also includes the various HD settings, and the last group consists of the other video sizes including 4K, 2K, and Cineon.

Chapter 5 Assignments

Make a Smartphone Time Lapse

If you're using an iPhone with the latest iOS, the time lapse feature is already built in. If your phone doesn't have it, many free apps (or very cheap ones) are available that let you make a time lapse movie with relative ease. Once your smartphone is set, try shooting the following:

- Capture passing traffic for one minute.

- Record pedestrians in a public space for two minutes.

- Press your smartphone against the passenger side window of a car (drivers please don't try this) and capture the scene for three minutes.

Although control is limited when you're making a time lapse with a smartphone, it provides a great place to start.

Experiment with a GoPro

If you own a GoPro—or have the chance to borrow one—try shooting a time lapse. Its ultrawide angle of view provides a perspective that differs significantly from shooting with a smartphone or a DSLR. Try attaching the GoPro to a bicycle, headband, suction cup, or whatever mount you have for it, and position it in different places. Mount it on a car, place it in a fountain (it's waterproof in its case), or wear it while walking through a crowd. In addition, try downloading the GoPro app and controlling the camera from your smartphone. It's better than using a remote, because the app allows you to monitor the scene and makes all the adjustments you need.

Shoot a DSLR Time Lapse and Edit in Photoshop

Shoot a series of time lapse sequences that range in length and in intervals; then make a movie of your images using Photoshop. Begin by shooting short scenes at relatively short intervals, approximately one frame per second. Then shoot the same scene several more times by doubling the interval between frames. It's best to shoot on separate cards so you won't need to separate the sequences. When you're done, practice making a time lapse in Photoshop.

Share your results with the book's Flickr group!
Join the group here: flickr.com/groups/timelapse_longexposure_fromsnapshotstogreatshots/

Canon T2i • ISO 400 •
1/1000 sec. • f/4.5 •
Sigma 14mm lens
(equivalent to 22mm)

6
Crisp High-Speed Photography

Exposing for the Moment

Magic can happen when you venture higher on the shutter dial. Unlike collecting time in a single image or creating a sense of motion in successive frames, a high shutter speed controls duration in a different way than long exposure and time lapse photography by freezing the moment. Just because a high shutter speed captures the subject quicker than·a blink of an eye, it's not always about stopping action. In this chapter you'll learn some practical techniques to use when you're shooting with consumer or prosumer cameras at 1/500 of a second or higher.

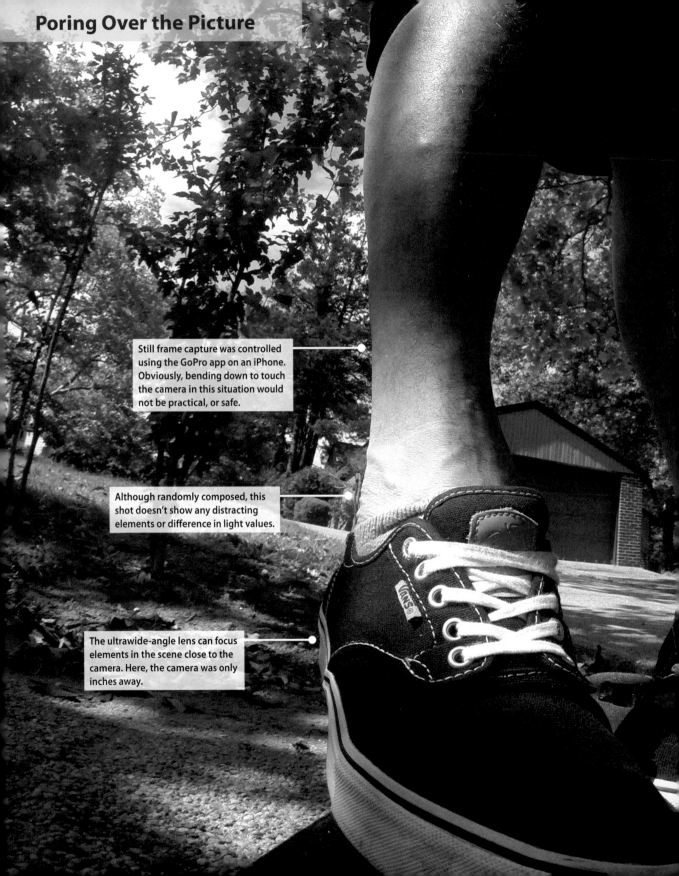

Poring Over the Picture

Still frame capture was controlled using the GoPro app on an iPhone. Obviously, bending down to touch the camera in this situation would not be practical, or safe.

Although randomly composed, this shot doesn't show any distracting elements or difference in light values.

The ultrawide-angle lens can focus elements in the scene close to the camera. Here, the camera was only inches away.

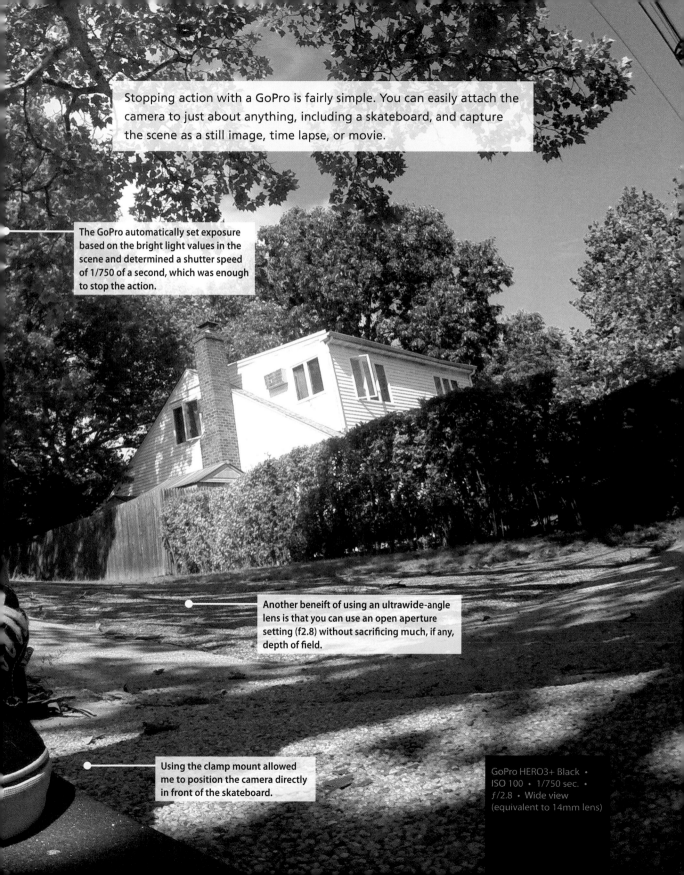

Stopping action with a GoPro is fairly simple. You can easily attach the camera to just about anything, including a skateboard, and capture the scene as a still image, time lapse, or movie.

The GoPro automatically set exposure based on the bright light values in the scene and determined a shutter speed of 1/750 of a second, which was enough to stop the action.

Another beneift of using an ultrawide-angle lens is that you can use an open aperture setting (f2.8) without sacrificing much, if any, depth of field.

Using the clamp mount allowed me to position the camera directly in front of the skateboard.

GoPro HERO3+ Black •
ISO 100 • 1/750 sec. •
ƒ/2.8 • Wide view
(equivalent to 14mm lens)

Poring Over the Picture

A high shutter speed does more than stop action: it also enables you to effectively shoot the scene in bright situations while handholding the camera, allowing you to control sharpness and depth of field.

This brightly lit beach scene in Bermuda required a shutter speed of 1/500 of a second to properly expose the scene.

The high shutter speed also froze the people in the frame.

Enough light was present to also use a high aperture setting to control depth of field.

Using an ultrawide-angle lens allowed me to focus on the driftwood less than 12 inches away from the camera while maintaining focus all the way to the background.

Canon T2i · ISO 100 · 1/500 · f/11 · Sigma14mm lens (equivalent to 22mm lens)

A Fast Shutter Speed

Some situations merit the use of a long exposure, whereas others thrive on very brief ones. Circumstances benefitting from fast exposure times include freezing action, dealing with brightly lit situations, and minimizing shake while handholding the camera. Then there's the ongoing need to control depth of field, or more specifically, lack thereof, by selecting a shutter speed high enough to balance exposure to use a wide aperture. Every situation worthy of a high shutter speed depends on one or another of these factors; often, more than one reason is evident in the same picture (**Figure 6.1**).

Figure 6.1 **This pilot boat off the coast of Bermuda was captured from a high position using a high shutter speed.**

Canon T2i • ISO 100 • 1/500 • ƒ/11 • Canon 24–105mm lens at 92mm (equivalent to 147mm lens)

Using a High Shutter Speed for Bright Situations

Let's take a refresher course in exposure for a moment. The relationship between aperture setting, ISO, and shutter speed determines the foundation for correctly exposing a scene. Every photographic situation can use a different balance of the three because they are reciprocal, meaning if you change one, you must change the other to maintain equal exposure. Using this logic, a high shutter speed lets less light into the lens. That's not to say it always affects exposure, but it certainly comes in handy when you want to avoid overexposure while photographing subjects in brightly lit situations.

Capturing scenes in the snow or shooting at a beach, as shown in **Figure 6.2**, share similarities beyond their climatic differences because they're both very bright due to their highly reflective nature. It's not uncommon in either situation to require a high aperture and shutter speed to avoid overexposure.

Figure 6.2
Jillian burying her brother in the sand—or a visual rendition of *I Ain't Got Nobody*—was captured using a high shutter speed on a sunny day at the beach.

Sony Cybershot 750 • ISO 100 • 1/500 sec. • *f*/8 • 35mm lens

When you're shooting in either condition, in snow or at the beach, consider the following advice:

- **Don't get fooled:** The brightness in either situation can possibly fool the matrix metering on your camera and underexpose the scene. If the preview looks too dark, increase exposure compensation by two stops (it's simple to do, but operation differs from camera to camera so check your manual) or just shoot on manual exposure.

- **Expose for the highlights:** When the highlights are exposed normally, the rest of the scene renders darker, which can add a dramatic effect.

- **Keep the camera safe:** Regardless of the element, sand or water, both wreak havoc on electronics, so keep the camera covered when you're not using it.

- **Use the light to your advantage:** Try shooting with the light at your back unless you want lens flare to enter the lens.

High-Speed Control Differs with Each Camera

Not all cameras provide the same level of control. Some allow you to manage every aspect of a shoot, whereas others offer limited functions. Some cameras can handle high exposure but leave you few, if any, options to do anything else but hope for the best.

The Digital SLR

Besides the ability to select the focal length, use a variety of accessories, and benefit from a basic design that's existed for decades, using a DSLR provides the most control over exposure, allowing you to set the shutter speed fairly high (**Figure 6.3**), completely control the aperture, and set ISO into the stratosphere. The downside is that a DSLR is more expansive than other types of cameras; it requires some understanding to use effectively and is prone to mishaps from the elements.

Figure 6.3
The hansom cab was frozen at a high shutter speed as it slowly moved down a street in Old Montreal.

Canon T2i · ISO 100 · 1/800 · f/13 · Canon 24–70mm lens at 40mm (equivalent to 62mm lens)

Point-and-Shoot Cameras

Current point-and-shoot cameras are not your father's point-and-shoot models; many now offer features comparable to a DSLR although not as robust. Basic models can still capture a subject at speeds up to 1/2000 of a second. But the downside is that you cannot change the lens so the angle of view is not always very wide.

GoPro Cameras

The GoPro is capable of recording an image at a very high shutter speed, and thanks to a diverse and relatively inexpensive set of mounts, you can use the camera in places you would never go and use an app to control it from a safe distance. But the downside is that you have limited control over exposure. The camera offers several ISO and exposure value settings but uses a fixed aperture and automatically chooses the shutter speed **(Figure 6.4)**.

Figure 6.4
The GoPro was placed in a fountain and captured the bursts of water at a very high shutter speed.

GoPro HERO3+ Black • ISO 100 • 1/2400 sec. • *f*/2.8 • Wide view (equivalent to 14mm lens)

Smartphone Cameras

Although most smartphone cameras have the capability to stop action at fairly high shutter speeds, they offer very few functions to fine-tune your exposure. But their functionality is based on how you look at it. If you consider a smartphone a camera, it's not a very good one. Yet, when you think of it as your phone taking pictures, the results are a bit more awesome (**Figure 6.5**).

Figure 6.5 This panoramic on a Bora Bora motu was captured with an iPhone 6.
iPhone 6 • ISO 50 • 1/3200 sec. • *f*/2.4

Determining the Correct Shutter Speed

Many cameras capture action at speeds well into the thousandths of a second, but you don't necessarily have to go that high. Each situation has its own effective shutter speed for properly capturing a subject; it depends on several factors, including the brightness of the scene and how quickly the action moves through the frame. For example, freezing a person jumping in the air requires a slightly higher shutter speed than capturing a performer on stage. Other factors include the direction of motion, focal length of the lens, and your intention for the picture.

Table 6.1 contains some minimum shutter speeds for stopping action in various situations.

Subject	Minimum Shutter Speed
People walking	1/250
People running	1/500
Person jumping	1/500
Sporting events	1/550
Concerts	1/250
Birds in flight	1/1000
Airplane in sky	1/1000
Moving vehicle	1/1000

Table 6.1 Minimum Shutter Speeds for Capturing Action

Use an Effective ISO Setting

Prepare to set ISO high enough to support the shutter speed and aperture combination that works best for the scene. The ISO setting determines sensor sensitivity and can vary from 100 to 50,000 or more. Low ISO settings yield more detail and minimal image noise (see the sidebar "What Is Digital Noise?"), whereas higher settings increase digital noise. During the day, it's possible to shoot at a low ISO setting, but nighttime and indoor events require a lot more sensitivity, so it's not unusual to use a setting of 1600 or higher. The good news is that today's sensors are able to capture maximum quality with minimal noise (**Figure 6.6**).

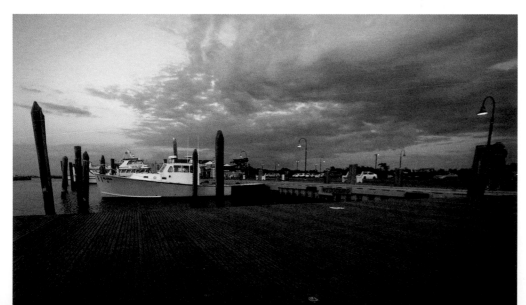

Figure 6.6
With the ISO set on automatic, this twilight scene was shot with a fast shutter speed and medium aperture.

Canon 6D • ISO 3200 • 1/320 • f/5.6 • 14mm lens

What Is Digital Noise?

You can think of digital noise as the digital equivalent of film grain; it increases as ISO settings get higher. Depending on the sensor in your camera, the differences will vary, but most new cameras handle higher ISO settings smoothly, provided that you don't underexpose the scene.

Shooting Continuous Frames

Capturing action is not always a one-shot deal. Often, it's a matter of selecting the best of a number of successive frames you captured of the action. DSLR models allow you to shoot at a fast rate per second (even faster with an optional motor drive). GoPro lets you shoot a burst of frames, offering the possibility that one frame will show the decisive moment of action (**Figure 6.7**) or expression on the subject's face.

**Figure 6.7
A quick burst of frames captured these children diving in the harbor on the French Polynesian island of Ta'a Oha.**

Canon T2i · ISO 100 · 1/800 · ƒ/5.0 · 24–105 at 88mm (equivalent to 140mm lens)

When you're shooting continuous frames, consider the following:

- **Be conservative with your finger on the button:** The latest sensors provide high quality, but each file can take up a lot of space on a media card and your hard drive. Unless you have unlimited virtual real estate, use the bursts sparingly.

- **Use a fast media card:** Besides having a card with substantial capacity, a faster one can records files without lag. If you're not sure which card is right for you, check out "Having the Right Media Card" in Chapter 1.

- **Shoot in RAW:** Files are bigger in the RAW format and take longer to process. But the ability to process an image after it's captured—and do it on your computer—ensures the best quality image, especially when you're "gunning" through the scene.

Handholding During a Long Exposure

Sure, you can handhold your camera to capture action, but it takes more than a steady hand to reduce camera shake. With gravity working against you, a little bit of movement while pressing the shutter can rob the picture of sharpness, which is why sports photographers use monopods. But they're not always practical, and you may not have one when you need it, so you have no choice other than holding the camera. In a handheld situation, it's important to understand the minimum shutter speed you can use and how it relates to focal length.

Since the dawn of the SLR, the rule has been that the shutter speed can never be lower than the focal length of the lens. That means if you're shooting with a 200mm lens, you must shoot at 1/200 of a second or higher. That rule has changed somewhat during the digital era because the different sized sensors have impacted the effective focal length of a lens. So although 1/200 of a second is fine to use with a full-frame DSLR (**Figure 6.8**), it's not enough when you're using a DSLR with a crop sensor, or more specifically, one in the APS-C format.

Figure 6.8
While handholding the camera and using a fast shutter speed, I was able to freeze the action of this cliff diver off the Kona coast of Hawaii.

Canon T2i · ISO 200 · 1/640 · ƒ/8 · 24–105 at 95mm (equivalent to 152mm lens)

Minimum Shutter Speed

Table 6.2 breaks down the minimum shutter speeds for each focal length in both full-frame and APS-C cameras. But remember that these are the lowest shutter speeds you should use to eliminate shake and may not be high enough to freeze the action, so take that into consideration as well.

Focal Length	Full Frame	APS-C
14mm	1/15	1/25
20mm	1/20	1/30
24mm	1/25	1/40
28mm	1/30	1/50
35mm	1/40	1/60
50mm	1/50	1/80
70mm	1/80	1/125
85mm	1/100	1/125
100mm	1/100	1/160
135mm	1/160	1/250
200mm	1/200	1/320
300mm	1/320	1/500
400mm	1/400	1/640
500mm	1/500	1/800

Table 6.2
Minimum Shutter Speed for Full- and Crop-Framed Cameras

Image Stabilization

Found on many lenses, as well as some cameras, image stabilization allows you to reduce blurring and camera shake. Using this function, you gain 2–4 stops of shutter speed and more flexibility handholding the camera. Although image stabilization reduces camera shake, it has no effect on the subject's motion.

Shooting at the Decisive Moment

Great photography often comes down to precisely pressing the shutter at a pinnacle moment in the scene. In the blink of an eye, you either get the shot or you don't, making it imperative to capture the decisive moment.

Attributed to the renowned street photographer Henri Cartier-Bresson, the term "decisive moment" refers to his belief that every situation has a special moment of activity that defines it. Whether it is a man and his reflection captured in mid-air jumping over a puddle, the expression on a young boy's face as he turns a corner, or a kissing couple who catch their dog's attention, all situations have a defining moment.

That same intention can make your photographs stronger. Whether it's action, an expression (**Figure 6.9**), or just the right alignment of objects in the frame, the right moment plays a huge role in the success of your photo.

Figure 6.9
An ice-cold beach shower led to this magical expression captured at the decisive moment.
Canon EOS-1 •
ISO 200 • 1/500 •
ƒ/5.6 • 20–35mm
at 24mm

Mastering Motion Blur

Somewhere between stopping the action with a high shutter speed and showing it in the picture with a slower shutter duration lies the motion blur. This cool technique provides viewers with a strong sense of activity happening in the photograph. Whether it's those classic examples of a race car set against streaks of blur in the background or a BMX bicyclist doing a 360-degree turn (**Figure 6.10**), the subject is relatively frozen, yet the background shows motion.

A motion blur is fairly easy to do and often leads to a dramatic effect. The streaking or motion occurs as you move the camera with the subject. Depending on the speed of the action, you can even use a slightly slower shutter speed because you're following the subject as you pan. The movement keeps the subject in focus but blurs the background into a kinetic image.

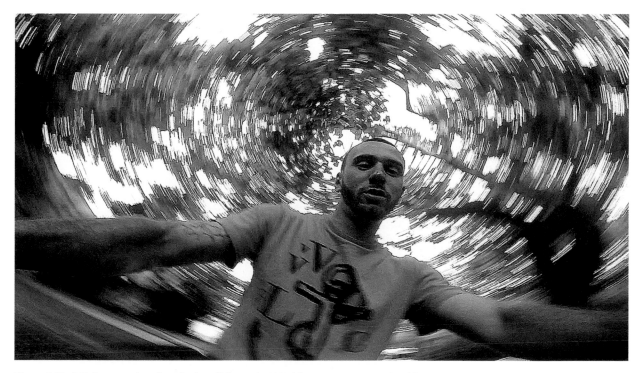

Figure 6.10 A GoPro was placed on the handlebars of a BMX bike to capture a motion blur.

GoPro HERO3+ Black · ISO 100 · 1/60 sec. · ƒ/2.8 · Wide view (equivalent to 14mm lens)

Freezing Action with Flash

Electronic flash can stop action without using a high shutter speed, which comes in handy in dimly lit scenes or those without any light at all, as shown in **Figure 6.11**. As mentioned in Chapter 5, a flash unit uses a very fast burst of light that freezes action, provides illumination, and keeps the color balance predictable. But flash doesn't work in every situation. For example, you can't use it at sporting events because it's distracting to the players. Flash units cover a limited distance, which makes it necessary to be closer to the subject, and that's not always possible. And in some situations, flash units can produce harsh illumination. But the pros outweigh the cons most of the time, making electronic flash a viable option for stopping action.

Figure 6.11 In near darkness, this diver was frozen using a slow shutter speed with a flash unit. Because the flash was the only illumination in the scene (besides the pool's interior light), no motion blur is seen on the subject.

Canon 6D · ISO 1250 · .4 sec. · ƒ/11 · 24–105mm at 28mm

Fun with People

Stopping action can also have a whimsical side as you capture enjoyable moments with your friends and family. Whether it's a kid wakeboarding at the edge of the shoreline (**Figure 6.12**) or a young woman caught in a mid-air pose, you can have a lot of fun creating action moments with those closest to you (**Figure 6.13**).

Figure 6.12 Playing on the shoreline led to a fun picture.

Canon 6D · ISO 800 · 1/800 sec. · f/5.0 · 200mm lens

Figure 6.13
Sometimes you can have fun capturing everyday action at unusual angles, like this diver doing a flip caught before hitting the water. Thanks to a wide-angle lens and small aperture setting, the entire scene is in focus.

Canon 20D • ISO 800 • 1/250 sec. • *f*/14 • Canon 20–35mm lens at 29mm (equivalent to 46mm)

But stopping action or capturing that perfect expression is often easier said than done, so consider the following:

- **Shoot a lot of frames:** The perfect image rarely comes on the first try, so keep shooting and make adjustments to get the image just right.

- **Use a high enough shutter speed:** There's nothing worse than *almost* stopping the action, especially when it's compelling.

- **Take a few test shots:** Make sure exposure and composition work for the scene by shooting a few frames and making adjustments before the action begins.

Chapter 6 Assignments

Experiment with Shutter Speed

Look for a situation that consists of continuous activity (pedestrians walking, a busy intersection, or an amusement park ride) and shoot the same scene multiple times using different shutter speeds. Start at 1/30 of a second and increase by one full stop until you get to 1/1000 of a second. You can make this experiment easier by setting the camera on Shutter Priority and letting the camera select aperture. Then, check out the images and look for the shutter speed that stops the action as well as those that blur it.

Try Different ISO Settings

Shoot the same scene using different ISO settings to observe the effect each setting has on your images. Depending on the camera model and generation of sensor, the results will vary. Nonetheless, it's important to learn how much noise (or lack thereof) you will get at each setting to understand the limitations of how far you can go to capture a perfectly exposed image in limited light. Keep in mind that a higher ISO allows you to use a relatively high shutter speed in dark conditions.

Capture Action with a GoPro

Because you can easily mount a GoPro on anything and control it from afar, you can experiment with capturing action scenes up close. The camera uses a wide-open aperture setting, so the reciprocal exposure balance produces a very high shutter speed. Also, try setting the camera in Burst mode (you can access it directly from the GoPro app): The camera will shoot a bunch of frames in succession so you don't miss the perfect frame. Finally, change the ISO setting to gain higher shutter speeds.

Create a Moment with a Friend

Set up a situation with a friend who is involved in an activity. Ask the subject to jump in the air as you take photographs from different angles. Spice things up by suggesting different facial expressions as your friend moves. Also, experiment by freezing the action with flash. When you're done, check out the images and see which situations worked and which ones didn't.

Share your results with the book's Flickr group!
Join the group here: flickr.com/groups/timelapse_longexposure_fromsnapshotstogreatshots/

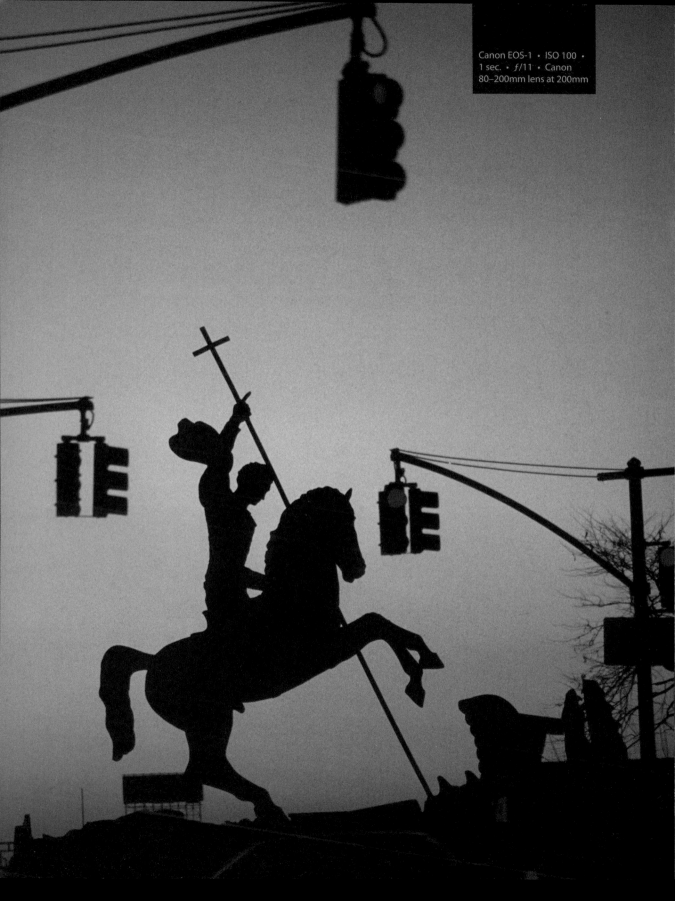

Canon EOS-1 • ISO 100 •
1 sec. • ƒ/11 • Canon
80–200mm lens at 200mm

7

Compositional Aesthetics

Creating a Visually Literate Image

A well-designed photograph forms a coherent conclusion for the viewer. The subject matter and the creative way you capture it affects how the image is received. But finding your personal vision goes beyond what you choose to photograph. Instead, it's rooted in how you arrange objects in the scene, use color, and control perspective to your advantage. In this chapter, you'll learn techniques that will enrich your visual literacy to effectively depict long and brief exposure times. Beginning with the rules of pictorial composition, you can translate your intention into an effective image, much like using the alphabet to read and write.

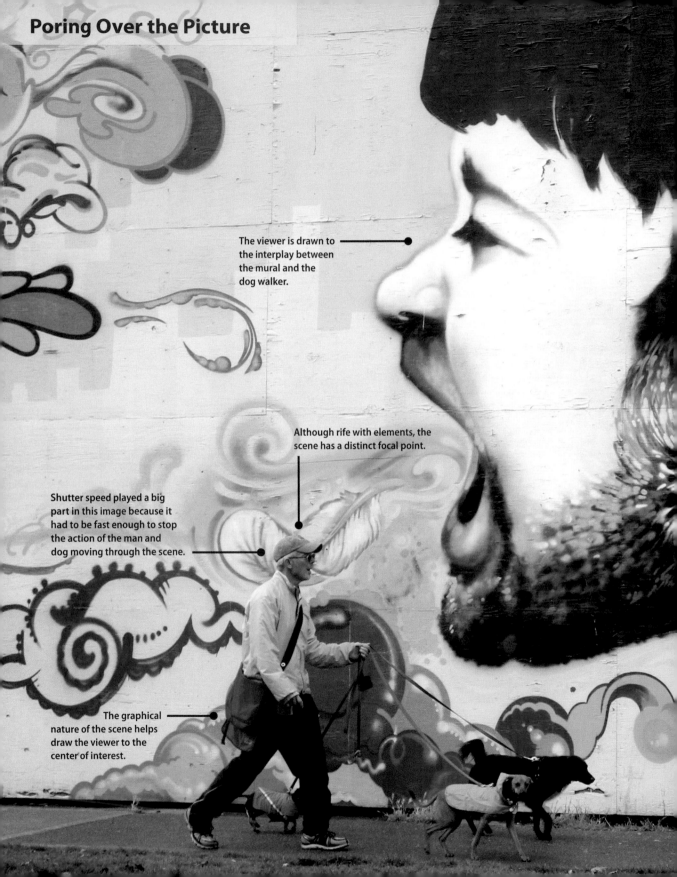

Poring Over the Picture

The viewer is drawn to the interplay between the mural and the dog walker.

Although rife with elements, the scene has a distinct focal point.

Shutter speed played a big part in this image because it had to be fast enough to stop the action of the man and dog moving through the scene.

The graphical nature of the scene helps draw the viewer to the center of interest.

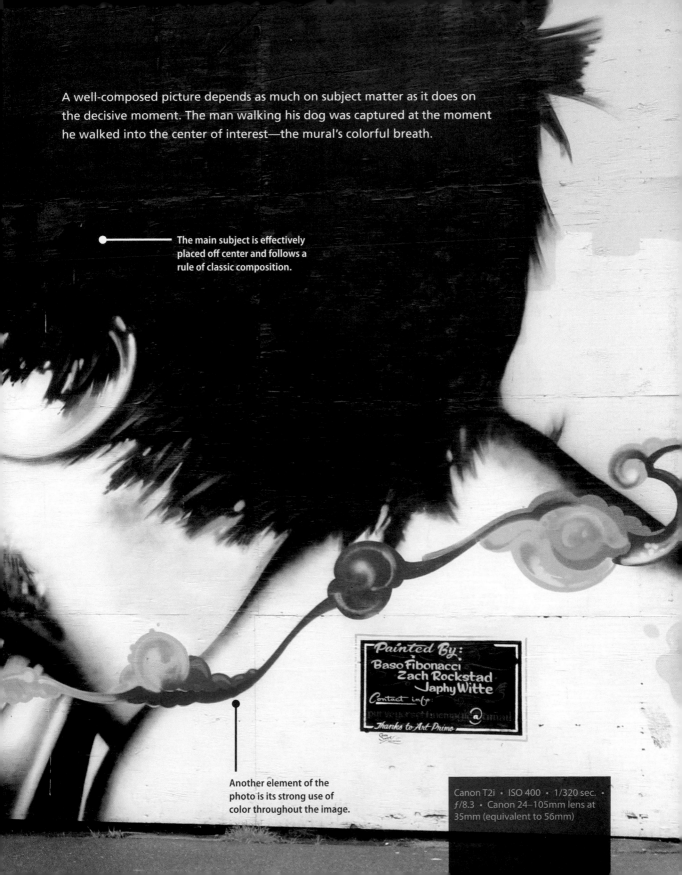

A well-composed picture depends as much on subject matter as it does on the decisive moment. The man walking his dog was captured at the moment he walked into the center of interest—the mural's colorful breath.

The main subject is effectively placed off center and follows a rule of classic composition.

Another element of the photo is its strong use of color throughout the image.

Canon T2i · ISO 400 · 1/320 sec. · ƒ/8.3 · Canon 24–105mm lens at 35mm (equivalent to 56mm)

Poring Over the Picture

The dimly lit lava tube appears much brighter due to a long exposure and high ISO setting.

The narrow opening in the background leads the viewer's eyes to the center of interest.

Slow-walking sightseers register with a slight blur because of the long exposure time.

Placing the camera close to the ground created a unique perspective.

Shot inside the Thurston Lava Tube at Volcano National Park, this scene has an expansive view. Because it was shot with an ultrawide-angle lens, the foreground areas appear much wider than the background, even though the widths are similar.

Even with a medium aperture, the entire image from foreground to background is in focus.

Illumination from tungsten bulbs in conjunction with the long exposure created a dominant yellow colorcast.

Canon T2i · ISO 1600 · 1.3 sec. · f/10 · Sigma 14mm lens (equivalent to 22mm lens)

Utilizing the Tools of Composition

Allegedly, a picture is worth a thousand words, but that doesn't mean every word is clearly understood. Just as it happens in conversation, some pictures easily communicate to the viewer, whereas others make it more challenging to be understood. Becoming fluent in visual literacy begins with understanding the components that make up an image, such as arrangement of elements in the scene, focal length, angle of view, and color (**Figure 7.1**). All play a big part in explaining the scene to the viewer.

Figure 7.1
This New York City scene captured at twilight uses numerous compositional techniques, including the rule of thirds, shape, form, and leading the viewer.

Canon EOS-1 ·
ISO 100 ·
8 sec. · *f*/16 ·
Canon 24mm lens

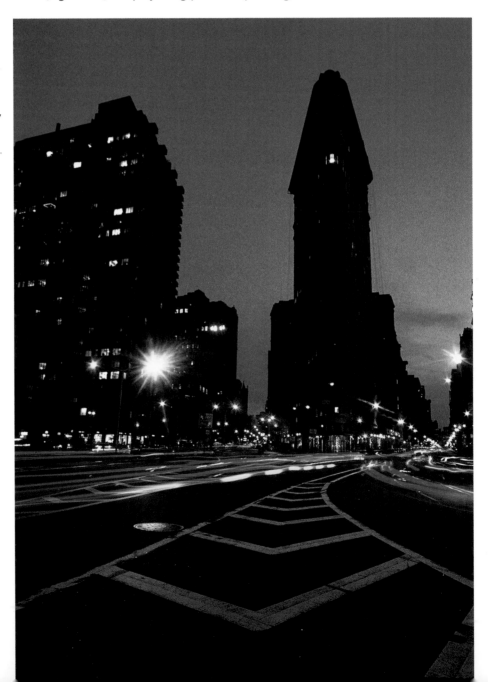

It All Happens in the Frame

An image resides within the confines of the frame, which is all the viewer has to make sense of it, so the visual arrangement of elements helps tell the story. Beginning with the rules of composition, you can translate whatever your intention is for the image into a visually cohesive one. Clearly, viewers are drawn to a technically perfect image; otherwise, they wouldn't continue looking at it. But once you've established the technical aspects of an image, it's important to understand the different elements that make up a visually appealing image.

Automated Camera Functions

Automatic exposure and focus allow you to pick up your camera and quickly capture a scene without much thought. Unfortunately, the camera cannot think for you, so be aware of the "autopilot" mentality when you're composing a scene. The next time you pick up your camera and shoot automatically, use the extra time you saved from not having to figure out the technical details to effectively arrange the elements in the scene.

Creative Composition Techniques

The art of taking a three-dimensional scene and depicting it as a two-dimensional picture heavily depends on how you compose the scene. Deciding how to control elements in a scene is an art form that allows you to create an image that appeals to the viewer (**Figure 7.2**). Effective composition accentuates your objective, whereas a weak composition impedes it.

Let's examine some of the compositional elements that effectively depict an image.

The Rule of Thirds Rules!

Dating back to the ancient Greeks, the rule of thirds is perhaps the oldest and most revered rule of composition. The rule of thirds suggests that you keep the main subject outside the center of the frame. Basically, it divides the image into nine equal parts: three parts from top to bottom and three from side to side. By placing the subject in one of those areas but not in the center, you can create a more pleasing arrangement in the scene.

Devised by the Greek mathematician Euclid, who felt that the ratio between the minor and major division of a whole part was more pleasing than when equally divided, the Greeks used the rule of thirds primarily for architecture and sculpture. It eventually found its way into photography and pictorial art as an effective device. Just think of an image divided into a tic-tac-toe board with the optimal placement for the main subject outside the center square, as shown in **Figure 7.3**.

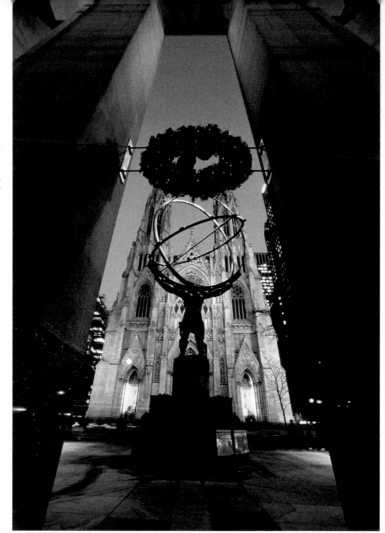

Figure 7.2
This rendering of the Atlas statue and St. Patrick's Cathedral uses various compositional techniques, including a wide focal length, perspective control, and framing.

Canon EOS-1 •
ISO 100 •
8 sec. • ƒ/11 •
Sigma 14mm lens

Figure 7.3
This lazy beach scene on a Bora Bora motu uses the rule of thirds.

Canon T2i • ISO 200 •
1/800 sec. • ƒ/5 •
Canon 200mm lens

When a scene has a distinct horizon, as shown in **Figure 7.4**, arrange it on the upper or lower line.

Although the rule of thirds technique dates back thousands of years, it's still as important today as it was for Ictinus and Callicrates, the architects of the Parthenon, which follows this principle.

Figure 7.4 This image of sunset on Hapuna Beach on Hawaii's Big Island creates a series of warm tones and uses the rule of thirds, placing the horizon above the center of the frame.

Canon EOS-1 • ISO 400 • 1/640 sec. • ƒ/8 • Canon 24–105mm lens at 105mm (equivalent to 160mm)

Keep It Simple

More often than not the axiom less is more applies to photographic composition, especially when defining the center of interest. The reason is that the effectiveness of an image greatly depends on creating a focal point in the image, and often that means separating it from the extraneous clutter in the scene. Distracting elements, such as a telephone pole in the background or a light flaring into the lens, can interfere with the intention of the image.

A simple arrangement (**Figure 7.5**) prevents confusion. But arranging a minimal composition is not as easy as it sounds, especially when you're dealing with the passive situations that occur outside a controlled situation, such as a photo studio.

Figure 7.5
The Seattle Space Needle was photographed from below using a telephoto lens to isolate the subject.

Canon T2i • ISO 400 • 5 sec. • ƒ/25 • Canon 200mm lens (equivalent to 320mm)

Here are some helpful hints for composing a clean image:

- **Watch out for complicated backgrounds:** Extraneous elements in an image can distract the viewer and make the picture less effective.

- **Use focal length to your advantage:** Bring the subject closer by using a telephoto lens to emphasize the center of attention. You can also use a wide-angle lens inches away to isolate the main subject and create a unique perspective.

- **Try selective focus:** Another way to isolate the subject is to limit focus to the main subject, thereby deemphasizing extraneous elements.

- **Move closer to the subject:** Call it the poor man's telephoto or just getting personal with the subject, but either way, moving closer to your subject allows you to capture just the subject and nothing more.

Fix It in Post

Photoshop cannot make a bad image better, but it can certainly improve a good one that's simply stricken with minor issues. Perhaps the horizon is tilted, the subject is plastered in the center of the frame, or a light post is growing out of the subject's head. No problem; just fix it in postproduction.

Framing the Subject

Objects in the foreground help create a sense of depth in your composition. Shooting through a window, archway, or overhanging tree branches (**Figure 7.6**) helps to define the main subject because each element occupies the otherwise empty areas of the frame, making it simpler to distinguish the center of interest. It's a useful technique that often makes the difference between a snapshot and a great shot.

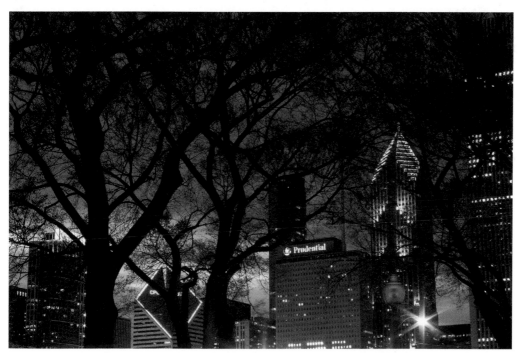

Figure 7.6
The Chicago skyline was photographed through a row of trees, making a mundane scene more appealing. A small aperture setting was used to control depth of field.

Canon T2i • ISO 400 • 13 sec. • ƒ/22 • Canon 50mm lens (equivalent to 80mm)

Working the Dutch Angle

You don't always have to keep the horizon straight to make a great picture. Sometimes, you can intentionally tilt the frame to add some pizzazz to a boring composition or simply to create a cool effect (**Figure 7.7**). It doesn't work in every situation, but for those times when you come across a situation that's cliché or one that leaves too much negative space in the frame, give the camera a tilt and check out the results. Just make sure the effect is evident. A slight tilt may lead the viewer to believe you weren't holding the camera steady. Also, be aware of any background elements, and try to ensure they are symmetrically composed.

Figure 7.7
A variety of elements make this scene intriguing, including tilting the camera.

Canon T2i • ISO 200 • 1/400 sec. • ƒ/5.6 • Canon 20–35mm lens at 21mm (equivalent to 34mm lens)

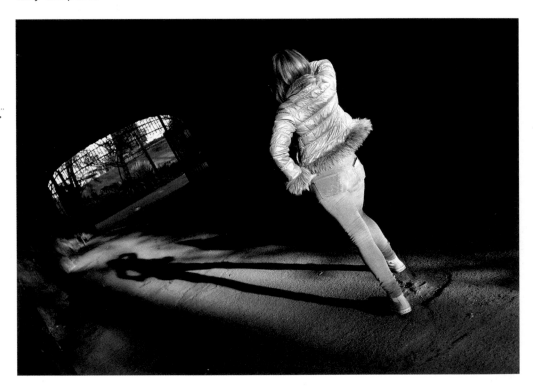

Shadows and Reflections

Although distinctly different, shadows and reflections share similarities when they are being used as creative devices. Balancing the subject with a shadow or reflection can help unify a one-sided arrangement or add some zing to an image because both can effectively act as an extension of the main subject.

Shadows produce a rich texture that can balance the frame, lead the viewer into the picture, or show depth (**Figure 7.8**). Reflections also capture viewers' attention by drawing them into the scene. But you can also use reflections effectively as the main subject (**Figure 7.9**).

Figure 7.8
Floating on the shoreline, this newspaper casts a shadow on the beach floor, adding depth to the subject.

Canon 6D · ISO 400 · 1/1250 sec. · *f*/8 · Canon 200mm lens

Figure 7.9
The wet pavement made the perfect surface for a reflection of these colorful neon signs.

Canon EOS-1 · ISO 100 · 8 sec. · *f*/8 · Canon 100mm lens

Using Shape and Form as Creative Devices

Depicting the shape or form of a subject provides another strong compositional device. Geometric and free-form objects are found just about anywhere, so all you have to do is look around you (**Figure 7.10**). To create a great image, sometimes it's a matter of picking the right angle; other times it's more about selecting the proper focal length to isolate the form.

Figure 7.10
The Pacific Portal sculpture was captured using an ultrawide-angle lens to depict it in a free form.

GoPro HERO3+ Black • ISO 400 • .3 sec. • ƒ/2.8 • Ultrawide-angle view (equivalent to 14mm lens)

Dealing with Symmetry

Another strong dialect for visual language is symmetry because it provides balance by strengthening elements in the scene, such as form, color, and light. It can also "even out" the arrangement of objects in the frame, as shown in **Figure 7.11**.

In contrast, asymmetrical balance, which is sometimes trickier to achieve, also proves to be an effective device. In some ways it's an extension of the rule of thirds: The subject occupies half of the frame, and the other half consists of scenery (**Figure 7.12**), negative space, or a contrary object. Just keep in mind that viewers read the frame from left to right and top to bottom—the same way you read a newspaper. The problem is that sometimes the frame can look like it's divided in half, making it appear as though the image consists of two separate pictures.

Figure 7.11
Sometimes the picture shows balance on both sides.

Canon T2i • ISO 200 • 1/100 sec. • ƒ/3.5 • Canon 50mm lens (equivalent to 80mm lens)

Figure 7.12
With the main subject positioned on the right side of the frame, the viewer's eyes are led across the landscape to the pink statue.

Canon EOS-1DS • ISO 320 • 1/1000 sec. • ƒ/16 • Canon 14mm lens (equivalent to 80mm lens)

Consider the following when capturing a symmetrical image:

- When you place the subject on the bottom right of the frame, it leads the viewer through the frame to the subject.

- When you place the subject at the top left of the frame, the viewer's eyes are drawn to the subject first and then the rest of the scene. The eye movement across the image allows viewers to draw a conclusion about the picture.

- Sometimes the viewer is looking into the center of the frame; other times the viewer is looking outside of it. The direction in which the subject is looking can help the viewer understand your intentions.

Using Color Effectively

You can use color to help establish a strong visual statement in your photos, creating dynamic imagery that can wow viewers and draw them into the picture (**Figure 7.13**). Exploiting color not only acts as another compositional tool, but can also help convey a mood, depending on how you feel about the subject, or the response you want to elicit from the viewer. And because color is often used in association with certain feelings, such as green with envy, got the blues, and red with anger, using color in your images can show a strong connection between emotions and the hues that represent them.

Figure 7.13
Captured just before twilight, this street scene makes an impact with its display of primary colors. Because the final image required a slightly long exposure, the passing gentleman was illuminated by a burst of flash.

Canon EOS-1 •
ISO 100 •
1 sec. • ƒ/2.8 •
Canon 24mm lens

For the Sake of Color

There's a distinct difference between photographing an afternoon sky and returning hours later to shoot it again. Instead of exhibiting the pale blue background captured earlier in the day, the sky is alive with the warm colorful hues of sunset. The setting sun provides one example of the many subjects you can shoot merely for the sake of color. Some colors are indicative of the subject, whereas others are the result of color temperature (see Chapter 3) and the way the camera renders it (**Figure 7.14**). Regardless, the intensity of color can make the difference between a good photograph and a great photograph.

Figure 7.14
The burning coals show both the warmest and coolest tones, making for a visually interesting image.
Sony Cybershot •
ISO 320 • .3 sec. •
ƒ/2.0 • Sony
30mm lens

Here are a few ways to look for color in a scene:

- **Monochromatic color:** Some pictures tell a story with the use of a single color, whether it's a warmly lit subject captured in the late afternoon or one dominated by a single-colored accent light.

- **Subdued color:** Some scenes are best depicted using subdued lighting, and others are best depicted in natural light, as shown in **Figure 7.15**. You can also desaturate the color in Photoshop to make a visual statement.

Figure 7.15
Sulfur Banks at Volcano National Park reveals a harsh, yet interesting beauty, mostly because the sulfuric gas emanating from fissures on the surface have killed or stunted the plant life.

Canon T2i • ISO 800 • 1/320 sec. • ƒ/5.6 • Canon 24–105mm lens at 105mm (equivalent to a 168mm lens)

- **Complementary color:** Some situations thrive on the interplay between colors opposite one another because complementary colors help create a more dramatic image. Each color makes the other livelier—for example, a yellow object juxtaposed against a rich, blue sky. Cyan and red as well as magenta and green are also opposites that are considered complementary.

Controlling the Scene with Focal Length

Perspective also plays a big part in how a picture communicates with the viewer, so it's important to understand the effect focal length can have on a subject. Wide-angle and telephoto lenses have distinct qualities. A wide-angle lens provides an expanded angle of view as wide as 180 degrees, allowing you to fit a confined area into the context of the photo frame. Telephoto lenses cover a narrow field of view and can bring the subject much closer to you.

In addition to allowing you to change the magnification of the subject as it appears in the frame, focal length can affect the size relationship of objects in the foreground or background, as shown in **Figure 7.16**.

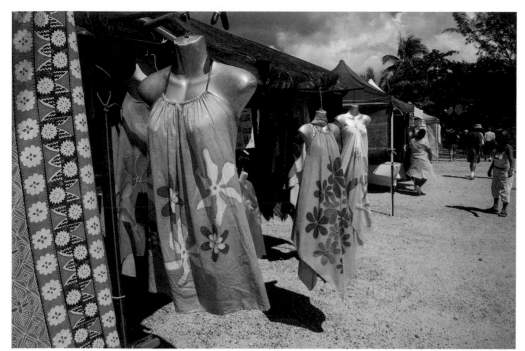

Figure 7.16
The shopping
bazaar on Mo'orea
was captured with
a wide-angle lens
to emphasize the
garment closest to
the lens while still
showing the other
tents down the line.
Canon EOS-1DS •
ISO 320 • 1/500 sec. •
f/16 • Canon 24–
105mm lens at 24mm

Our Eyes Are Like Lenses

Our eyes share many similarities with a camera lens. Both adjust the iris to dilate or constrict based on light levels. The camera renders the image through its sensor, whereas our eyes use the retina. The camera lens can have a limited depth of field in low-light conditions, just like our eyes. Have you ever noticed the limited area of focus you have in dim lighting or when lighting conditions are brighter, how that level of focus increases? Squinting in bright sun is essentially the same as stopping down the lens.

Understanding Ultrawide-Angle Lenses

The foremost misconception regarding ultrawide-angle lenses is that they include more of a scene by covering an expansive view. That's like saying your laptop computer can only search the Internet. Just as your computer can run different software, the ultrawide-angle lens does more than capture a wide view. In fact, quite the contrary; these lenses are most effective when you get extremely close to your subject for an intimate view and unique perspective (**Figure 7.17**).

Figure 7.17
This unique perspective was created by placing the camera at a low angle near the corner of the building.

Canon EOS-1 ·
ISO 100 ·
2 sec. · ƒ/16 ·
Sigma 14mm lens

By definition, an ultrawide-angle lens has a field of view of 84 degrees, which in more practical terms means the field of view of a 24mm lens, or wider, on a 35mm camera. But remember that the same lenses that used to provide an expansive, beautifully distorted view on a full-frame sensor behave similarly to a moderate wide-angle lens when you're using a camera in the APS-C format.

The Wide-Angle Lens

Basically, a wide-angle lens has a focal length with an angle of view greater than 60 degrees. That's usually a focal length as wide as a 28mm lens on a 35mm camera. As mentioned earlier, the focal length depends on the sensor size of the camera. The APS-C sensor makes a wide-angle lens behave more like a normal lens, so a 28mm lens behaves like a 45mm lens. Other sensors are much smaller but create the equivalent of a wide-angle lens, such as the lens on the advanced point-and-shoot camera used to capture the image in **Figure 7.18**.

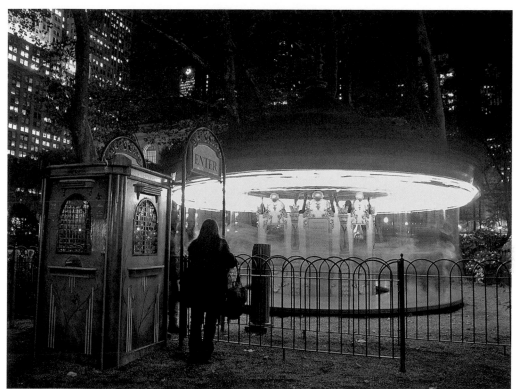

Figure 7.18
This small merry go round in Bryant Park was captured using a Nikon point-and-shoot camera that could capture a long exposure. The camera was placed (and leveled) on a trash can for stability.

Nikon 5000 · ISO 100 · 2 sec. · ƒ/4.0 · 7.1mm lens (equivalent to 28mm)

The Normal Lens

The only age-old question of "what is normal?" that doesn't require a philosophical debate is the one that refers to photographic lenses. Quite simply, a normal lens reproduces a field of view with a natural perspective, very much like our own eyes. In mathematical terms, that field of view is approximately a 50-degree angle of view from the lens when you're holding the camera horizontally. In the 35mm format, or frame sensor in digital speak, that is equivalent to a 50mm lens. When you're using a camera with an APS-C sensor, a normal field of view ranges in focal length between 28mm and 35mm (**Figure 7.19**). The reason is that a 50mm lens behaves more like a moderate telephoto lens in the 80mm range, as shown in **Figure 7.20**.

Figure 7.19
Street art in Philadelphia was captured using a "normal" angle of view. Because this photo was taken with a camera using an APS-C sensor, the focal length brought the subject closer than a full-frame camera.

Canon T2i · ISO 200 · 1/500 sec. · ƒ/10.0 · 20–35mm lens at 29mm (equivalent to 46mm)

Figure 7.20
This scary face made by using a shower curtain was taken with a normal lens, but the camera's crop sensor allowed the lens to behave like a moderate telephoto.

Canon T2i · ISO 1600 · 1/125 sec. · ƒ/3.5 · 50mm (equivalent to 80mm)

Bringing It Close with a Telephoto

A telephoto lens makes distant subjects appear closer to you. Besides filling the frame with more of the subject, a longer focal length can exaggerate subject distance by compressing the space between near and distant objects. The telephoto range begins with an angle of view less than 30 degrees, which is approximately 85mm. Here's a case where the limitations of the APS-C format become its strength, especially when you're shooting sports and natural scenes. A 100mm lens acts like a 160mm, and a 200mm lens behaves like a 320mm (**Figure 7.21**), immediately bringing you closer to your subject.

Figure 7.21
The crop sensor increased the focal length of this telephoto lens and brought the Two Prudential Plaza building in Chicago closer in the frame.

Canon T2i · ISO 400 · 5 sec. · f/22 · 200mm lens (equivalent to 320mm)

Employing Angles Effectively

When he was making the classic film *Citizen Kane,* director Orson Welles shot a low-angle scene by placing the camera in a hole to emphasize an unusual perspective. Although that technique is a bit extreme, it's better than shooting every scene at eye level, unless, of course, your intention is to bore the viewer into submission. Instead, varying the angles at which you capture the subject helps articulate the message you're trying to convey to the viewer.

Climb a flight of stairs and shoot downward or situate yourself on higher ground to shoot down on the subject. Or, take it to the other extreme and find a low position to shoot at ground level or upward (**Figure 7.22**). Many tripods let you widen the spread of their legs to resemble a three-legged spider, leaving you with a perspective inches from the ground. You can shoot also from overhead to get a flatter perspective, or tilt the camera using a Dutch angle, as mentioned earlier in the chapter.

Figure 7.22
Placing the camera on a road in Mo'orea produced a unique view of Mont Rotui.

EOS-1DS · ISO 320 · 1/800 sec. · *f*/13 · 14mm lens

When you add these effective angle variations to your photography, they provide a nice supplement to using a wide, normal, or telephoto focal length.

Here are some ideas for shooting at different angles:

- **High angle:** Raise the camera high on the tripod, or get to some high ground, and angle the camera down toward the subject to provide an objective view of the subject in relation to its surroundings. This elevated perspective can also show a graphical composition of the frame, as shown in **Figure 7.23**.

- **Bird's-eye view:** Alfred Hitchcock loved using a bird's-eye shot, and not just for his terrifying film *The Birds*. Positioning the camera high and directly above the action allows the viewer to dissect elements in a two-dimensional view, often making common objects unrecognizable. Although you won't always have the opportunity to use this technique, this perspective can also provide a two-dimensional overhead composition of the subject.

- **Low angle:** Shooting up at a subject provides another dynamic option for your pictures and can also change the perception of the subject, as shown in **Figure 7.24**.

Figure 7.23
Shooting from a high angle doesn't mean you need to stand far above the subject. This shoreline photo off a Bora Bora motu was captured by standing in the water and holding the camera down, letting the ultra-wide-angle lens take it all in.

Canon T2i · ISO 100 · 1/250 sec. · *f*/13 · 14mm lens (equivalent to 22mm lens)

Figure 7.24
When shot from underneath, the Seattle Space Needle takes on an abstract form.

Canon T2i · ISO 200 · 6 sec. · *f*/20 · 50mm lens (equivalent to 80mm)

Chapter 7 Assignments

Experiment with the Rule of Thirds

The next time you come across an interesting subject, try shooting it using a few different compositional techniques, but always incorporate the rule of thirds. Shoot the same scene several times but place the main subject in different parts of the frame, except, of course, in the center. With practice, you'll instinctively avoid including the main subject in the center of most of your images.

Look for Shadows and Reflections

Shadows and reflections are omnipresent, and make great compositional fillers as well as main subjects. Look for shadows from sunlight early in the morning or late in the day and incorporate them into your pictures. Finding reflections is not that difficult; just look for glass or shiny surfaces near a subject that intrigues you. You can also shoot reflections after a rainstorm or when the snow melts.

Experiment with Focal Length

Shoot the same subject with focal lengths that range from wide to telephoto while maintaining the same image size in the frame. Then observe the results that each lens provides and the relationship between the objects in the frame.

Same Scene, Different Angles

Creating great shots is all in the angles. They play a big part in the message you're trying to convey, so practice shooting every worthy subject using at least three different angles. Start at eye level; then position the camera near the ground to capture a low angle; and finish by shooting the subject from a high position. You can also tilt the frame to incorporate a Dutch angle, and if you have the opportunity, attempt a bird's-eye view shot.

Share your results with the book's Flickr group!
Join the group here: flickr.com/groups/timelapse_longexposure_fromsnapshotstogreatshots/

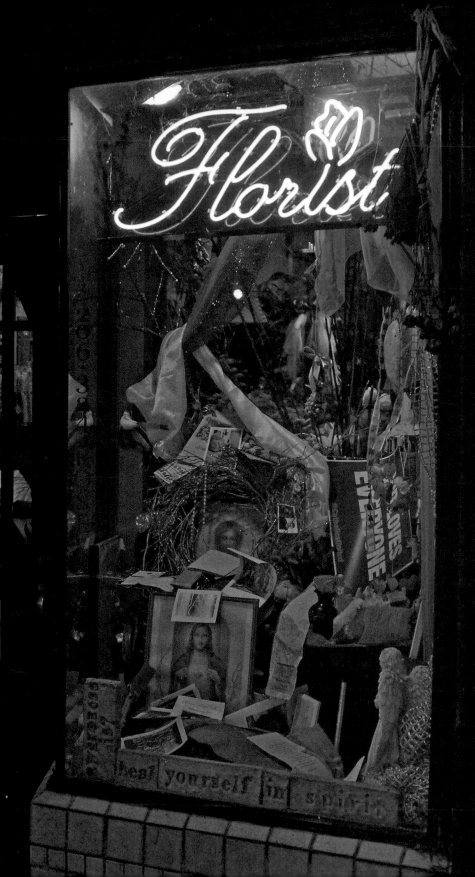

Canon T2i • ISO 800 • 1/3 sec. •
ƒ/4 • Canon 24–70mm lens at
24mm (equivalent to 38mm)

Appendix

Enhancing Your Time Images with Adobe Photoshop

Whether you've captured a long exposure, a very brief one, or a time lapse sequence, frequently, the image will render less than perfect. Sometimes a disparity will exist between the highlight and shadow details, and because you can choose only one, the other suffers. Other times the image might have a color issue, either because of a dominant cast or a white balance problem. Some other factors impede composition, such as extraneous objects or a tilted horizon. Regardless of your best efforts while capturing the subject, it's likely that one or more of these factors will influence your image, and not for the better. Fortunately, you can correct many of these issues, as well as many others, using Adobe Photoshop.

Dealing with Shadow and Highlight Issues

More often than not, problems with night images occur due to factors beyond your control. For example, exposure for the image in **Figure A.1** was based on the unique storefront display, so the rest of the scene was rendered darker, with little evidence of details in the shadow areas. Simply lightening the scene wouldn't help because it would deplete the detail in the window display, leading to a trade-off between improving shadow or highlight detail. But by using the Shadows/Highlights control in Photoshop, we can have both.

Figure A.1
Because illumination comes primarily from the neon-lit store window, the rest of this street scene is pretty dark.

Canon T2i • ISO 800 • 1/3 sec. • ƒ/4 • Canon 24–70mm lens at 24mm (equivalent to 38mm)

Let's use this image to walk through how to use the Shadows/Highlights control in Photoshop:

1. Open Adobe Bridge, navigate to the desired image, and open it in Photoshop. You can open the image in a number of ways, but here I'll suggest two: Control-click (Mac) or right-click (Windows), as shown in **Figure A.2**, and choose File > Open With. Or just double-click the image to open it if Photoshop is the default software you use to open an image.

2. Choose Image > Adjustments > Shadows/Highlights to bring up the dialog (**Figure A.3**).

 We'll make adjustments to the shadow area first. As you can see, the Shadows Amount defaults to 35% when you open the dialog.

Figure A.2
Control-click the image
to bring up the menu
options to open it.

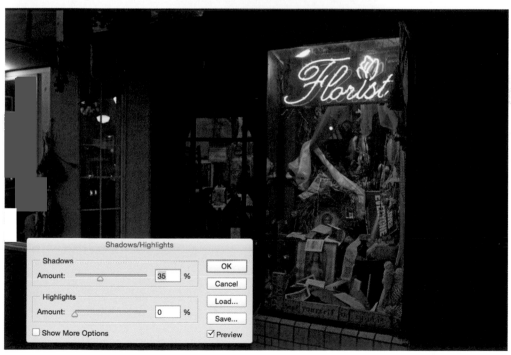

Figure A.3
The Shadows/
Highlights dialog

3. Increase the Shadows Amount to 40% to open up the scene and add detail to the shadow areas (**Figure A.4**). This will not affect the highlight areas.

4. Let's adjust the highlight area. Although the window display was properly exposed, we'll add a little more detail to the scene, as shown in **Figure A.5**. Slide the Highlights control to 10% to provide just the right amount of adjustment for this scene, and click OK (**Figure A.6**).

Figure A.4 After adjusting the Shadows slider, you can immediately see the details in the shadow area, providing the Preview box is checked.

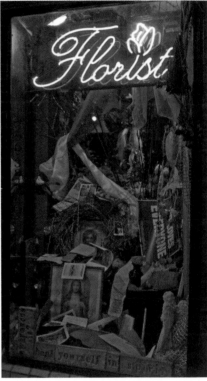

Figure A.5 Because the highlight area was properly exposed, a slight adjustment is all that's needed to bring out some additional nuances.

Figure A.6
The settings in the Shadows/Highlights dialog

5. We'll add some sharpness to the picture now. Although the image is fairly sharp, it can still use a little punch. Choose Filter > Sharpen > Unsharp Mask, as shown in **Figure A.7**. The dialog that appears contains several control sliders that allow you to adjust how much you sharpen the image. You can also preview the effect and see the result in the Mask Window. You can click in the window to see the original sharpness. For this image, we'll set the following: Amount: 125%, Radius: 1.5, and Threshold: 10 (**Figure A.8**). Click OK.

You'll see a much-improved image. The shadow and highlight areas as well as image sharpness are now more balanced (**Figure A.9**).

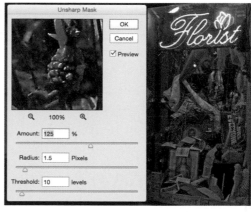

Figure A.7 Navigating to the Unsharp Mask

Figure A.8 The dialog shows the sharpness settings for this image.

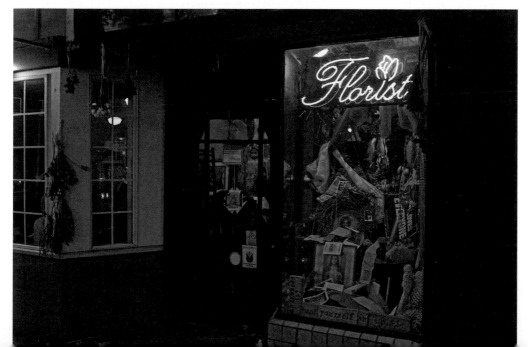

Figure A.9
After a few steps, an unbalanced image looks much better.

Controlling the Unsharp Mask

The Sharpness tools in Photoshop, or in any other image editing software for that matter, cannot make an out-of-focus image suddenly appear in focus. If that's your hope, you're simply out of luck. But you can enhance the crispness of a well-focused image by altering the contrast between pixel colors. This helps the image appear more dynamic.

Here's what the controls actually do:

- **Amount:** With a default setting of 100%, the Amount slider adjusts the level of density change you add to the image by lightening the lighter pixels on the edge between colors and darkening the darker ones. Don't set the Amount too high, or you'll lose detail and create excess contrast.

- **Radius:** The Radius control increases the number of pixels that are affected when you change the sharpness percentage using the Amount slider. The higher the number, the more extreme the end result. Setting the Radius too high will produce an unnatural appearance of the image. Using a setting of approximately 1.0 works for most screen-viewing needs, while using a setting of 1.5 for output printing keeps the effect within the normal range.

- **Threshold:** When the Threshold is set to 0, it sharpens every pixel. As you slide the control higher, it changes the amount of pixels sharpened, favoring higher-contrast sections. When you decrease the slider to less than 0, it affects the lower-contrast areas.

Enhancing Time Lapse Images En Masse

Time lapse images are subjected to the same issues as any other image but with one major difference: Instead of enhancing a single picture, you need to apply the changes to every image in the sequence, or at least a set of them. You can apply changes individually, but that is time-consuming. You also need to ensure that each image is altered in exactly the same way so they all conform. But there is no need to worry, because you can make uniform changes quickly and easily using the Batch function in both Photoshop and Adobe Bridge.

You start by recording an action, and then apply it to a folder full of images. You can replace them, or better yet, save them to another folder. But before you can batch correct color or exposure, or add an effect to a series of images, you must first create a specific action to carry out the desired effect.

Here's how you record an action:

1. Open an image from the folder containing all the images you want to change (**Figure A.10**). We'll prepare to record the action to tweak the density and transform it to black and white.

Figure A.10
This white seal and his buddies were frolicking on a rock at La Jolla.

Canon T2i · ISO 400 · 1/320 sec. · *f*/11 · Canon 24–105mm lens at 75mm (equivalent to 120mm)

2. Choose Windows > Actions. The Actions panel appears, which allows you to record all the changes you want to make to an image, and then apply them to an entire folder of images. In the Actions panel, click the small page icon (circled in **Figure A.11**) to begin recording every step you take while enhancing the image.

3. Name the action in the Actions dialog that pops up (I chose: Make Grayscale) and click Record (**Figure A.12**).

Figure A.11 Although the Actions panel has some default settings, you can add several of your own.

Figure A.12 Use an identifiable and meaningful name for the action.

4. Enhance the image by choosing Image > Adjustments > Levels (**Figure A.13**). Photoshop records every step you take. Move the slider on the left inward to the right (to create a deeper black), and then slide the pointer on the right to the area where the histogram begins to lighten highlights. Next, slide the center pointer a little to the left to lighten the middle tones. Click OK (**Figure A.14**).

5. Convert the image to black and white by choosing Image > Mode > Grayscale to remove color from the image (**Figure A.15**).

Figure A.13 The Levels panel

Figure A.14 The final settings in the Levels panel should look like this.

Figure A.15 Because the subject was a neutral color, it's more effective to show in black and white.

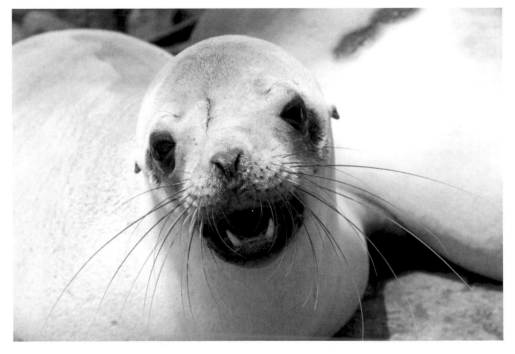

6. Save the image. This is an important step because if you don't add this step to the action, Photoshop will prompt you to click OK to save each image. And because that will defeat the purpose of the Batch function, it's important to build it into the action.

7. Stop recording the action by clicking the stop button icon on the Actions panel (**Figure A.16**) to save the action. The action is saved and can then be applied to any image by opening the Actions panel and selecting it.

Figure A.16 **The stop button icon is on the bottom left of the Actions panel.**

Batch Processing Your Images

After you've created the desired action, you can apply it to the entire folder of images. Make sure you include all the images you want to alter, and create a destination folder so you don't overwrite the original files or confuse the altered images with the others.

Here's how you batch process your images:

1. Choose > Automate > Batch. The Batch dialog (**Figure A.17**) appears.

Figure A.17
The Batch dialog offers a variety of settings.

2. Make sure you select the correct action. In the Play section in the upper-left corner of the dialog, select the Make Grayscale action (**Figure A.18**) if it's not already selected.

3. To select the folder of images for the Source option, click Choose and navigate to the desired folder. When you locate it, click Choose on the batch folder dialog (**Figure A.19**).

4. To select a folder for the converted images, select Folder as the Destination option on the right side of the Batch dialog, and navigate to the folder. If you didn't already create a folder, make a new one, name it, and click OK. The images will process and then after a few minutes will populate the destination folder.

Figure A.18
The pull-down menu offers many choices, including all the actions you saved.

Figure A.19
The Choose button is in the bottom-right corner of the Choose a batch folder dialog.

Image Correction Using Camera RAW

Regardless of how much care you put into your photography, not every picture downloaded from the camera ends up being technically perfect. Almost every image requires some form of tweaking, whether it's fixing exposure, adjusting color, or cropping for a stronger composition. It's just normal operating procedure when you're dealing with digital photography, especially night photography. That's why it's a good idea to shoot your images in the RAW format.

A good example is the rendering in **Figure A.20**, which was shot from the top of the hill outside the Seattle Public Market at twilight. Although the picture is colorful and interesting, it does need a few adjustments, and most of those can be made in the Camera Raw plug-in included with Adobe Photoshop CC.

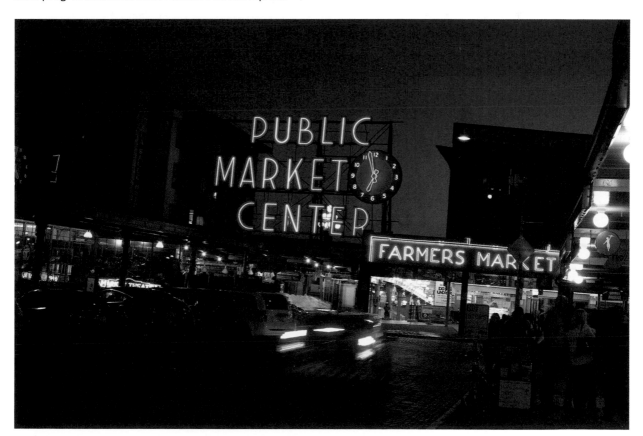

Figure A.20 The rich, colorful tones of this image taken at twilight were slightly underexposed, and its slightly tilted perspective may or may not have been intentional.

Canon T2i • ISO 100 • 1 sec. • ƒ/8 • Canon 24–105mm lens at 28mm (equivalent to 45mm)

The RAW Format Benefits Your Pictures

Normally, the camera applies a profile to the image that includes white balance, sharpness, noise reduction, and compression. When you make changes to the image, those changes can degrade it slightly. But because RAW files allow you to add this information later—to your own tastes and specifications—it provides more control over the image and less chance of degrading its quality.

Follow along to make some adjustments to this image using the Camera Raw plug-in:

1. To open an image in the Camera Raw plug-in, just double-click on an image captured in the RAW format. In the dialog that appears, you'll see many areas for making adjustments (**Figure A.21**).

 Because this image is slightly underexposed, the first order of business is to correct it by adjusting the exposure.

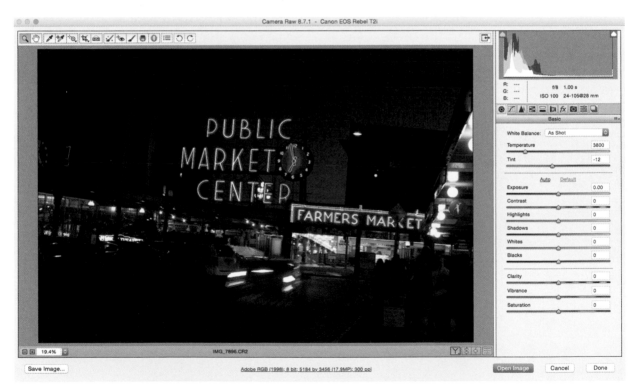

Figure A.21 The Camera Raw plug-in dialog offers a great deal of control.

2. We'll increase the exposure by one stop by sliding the Exposure slider to the right until it reaches the +1.00 position (**Figure A.22**).

3. Now we need to fix color temperature. Although the color balance looks pretty good, it's still a tad on the warm side. As you can see in the White Balance section, the camera recorded it at 3800 K (Figure A.21). Bringing it down to 3200 K, as shown in **Figure A.23**, will "cool down" some of the neutrals without affecting the brightly colored areas (**Figure A.24**).

Figure A.22 Although this section of the dialog contains a variety of sliders that affect exposure and color in the image, it's important to get exposure right before changing any others.

Figure A.23 The Temperature slider shown in the White Balance section of the dialog.

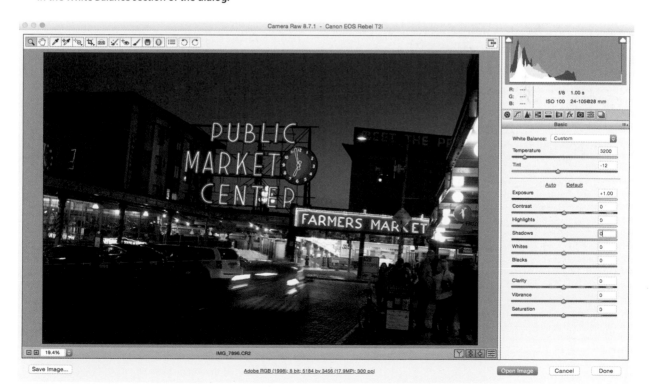

Figure A.24 The Camera Raw plug-in shows the color and exposure changes made to the image.

4. We need to apply sharpening to the image next. Below the histogram on the right side of the dialog is a series of buttons. Click the one that looks like a triangle to access the sharpening tools (**Figure A.25**). These functions are quite sophisticated, but we'll just make a simple adjustment to the Amount slider, increasing Sharpening to 100%.

Camera Raw allows you to perform many adjustments to an image, including cropping it.

5. Click the Crop tool icon in the upper-left corner of the dialog (**Figure A.26**). You can also access the Crop tool by pressing the C key.

6. To crop the image, just click on the image to draw a crop box. The cropped area appears (**Figure A.27**). You can adjust it using the anchors on the corners and edges. The composition appears slightly tilted, but instead of straightening it, let's exaggerate it. To do so, we click outside the crop area on the right side of the image and move upward to twist it counterclockwise (**Figure A.28**).

When you're satisfied with the changes you've made, you're done with the plug-in.

Figure A.25 The Sharpening tab

Figure A.26 The Crop tool is circled.

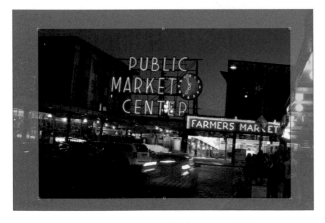

Figure A.27 The crop area is roughly drawn on the image.

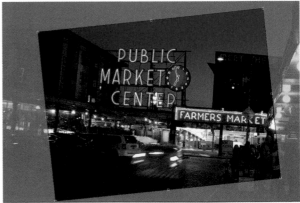

Figure A.28 By tilting the crop box and pushing the anchors inward, we changed the image's aspect ratio.

7. To open the image, click Open Image on the bottom right of the dialog. After a moment, the image will open in Photoshop, allowing you to make additional changes if you choose (**Figure A.29**).

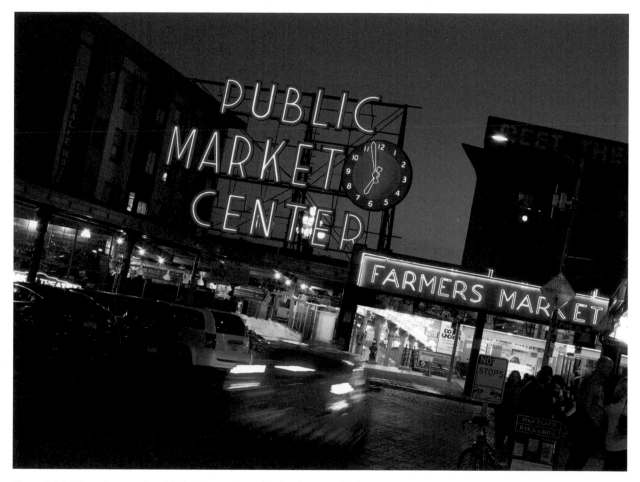

Figure A.29 After a few tweaks with the Camera Raw plug-in, the image looks significantly better.

Index

A

action
 freezing with flash, 97, 162–164
 freezing with shutter speed, 150, 155–162
 shooting continuous frames, 156–157
 shutter speed and, 150, 155–162
active light, 43–45, 61
Adobe Photoshop. *See* Photoshop
airplane trails, 84
ambient light, 60, 103–106
amusement park rides, 78
angle of view, 76–77, 188
angles, 178, 190–192
aperture setting, 39, 72, 103
APS-C sensors, 11, 12, 15, 16, 186, 189
APS-H sensors, 11, 12, 16
artificial lighting, 43–45, 60–63, 66–70
asymmetrical balance, 180, 181
automotive light trails, 76–78

B

B setting, 79
backgrounds, 161, 176
batteries, 126
beanbags, 21
bird's eye view, 191
blurring images
 considerations, 50–51, 132
 motion blur, 161
bounce flash, 100–101, 102
brightness, 151–152

C

Camera Raw plug-in, 205–209
camera stabilization, 8, 21–22, 131. *See also* tripods
cameras
 automated functions, 173
 considerations, 8, 9, 152
 for creating time lapse sequences, 127–128
 DSLR. *See* DSLR cameras
 equipment. *See* equipment
 filters. *See* filters
 handheld, 157–161
 high-speed controls, 152–154
 lenses. *See* lenses
 media cards. *See* media cards
 point-and-shoot, 9, 153
 sensors, 11–12, 128
 smartphone. *See* smartphone cameras
 types of, 9–10
card readers, 24
cards, media. *See* media cards
Cartier-Bresson, Henri, 160
celestial occurrences, 84
CF cards. *See* media cards
CFL lighting, 62
color
 as compositional tool, 182–184
 considerations, 60
 types of, 183–184
color balance, 62, 69, 94, 97
color temperature, 64–66, 94, 97, 111
colorcast, 43, 47, 60, 61, 111
colored filters, 111
colored gels, 44, 47, 97
composition, 167–193
 angles, 178, 190–192
 color and, 182–184
 Dutch angle, 178
 focal length and, 176, 184–189
 framing subject, 177
 overview, 167–171
 reflections, 178–179
 rule of thirds, 173–175
 shadows, 178–179
 shape/form, 180
 simplicity, 176–177
 symmetry, 180–182
 tools of, 172–173
computers, 23–25
contrast, 60

D

dark sky, 43, 71–72, 81–84
darkness
 focusing in, 72
 long exposures in, 71–72
daylight
 color temperature, 64, 94, 97
 long exposures in, 72–73
"decisive moment," 160